Tibet, the Last Cry

Text by Eric Meyer

Photography by Laurent Zylberman

BLACKSMITH BOOKS

Tibet, the Last Cry
ISBN 978-988-16139-5-0

Translated from the French by Jeff J. Brown, *jeff@brownlanglois.com*

Published by Blacksmith Books
5th Floor, 24 Hollywood Road, Central, Hong Kong
Tel: (+852) 2877 7899
www.blacksmithbooks.com

Also by Eric Meyer:
Pékin place Tian An Men, 1989
Sois riche et tais-toi, 2002
Voir la Chine du haut de son cheval, 2003
Les Fils du dragon vert, 2004
L'Empire en danseuse, 2005
Robinson à Pékin, 2005
Bon chat chinois prend la souris, 2008
Cent drôles d'oiseaux de la forêt chinoise, 2012
Tibet, dernier cri, French edition, l'Aube, 2013
Tibet, ultimo grito, Spanish edition, Icaria, 2013

This book is dedicated to the old Tibetan lady in gypsy dress whom we met at a humble bar in Lhasa – she never stopped sticking her tongue out at us that night, the local sign for "welcome" – as well as to her younger companions who serenaded us with drinking songs.

"In order for Tibet to be a part of our country and to experience prosperity and enlightenment, we have six tasks to complete: the first will be to scrupulously respect Tibet's ethnic autonomy…to let them be the masters of their own destiny."

Speech by Hu Yaobang, General Secretary of the Chinese
Communist Party, to 5,000 notables in Lhasa
29 May, 1980

CONTENTS

PROLOGUE

In September, 2008, at the end of our voyage to the Land of Snow, there were two ideas we could not get out of our heads:

— In these mountain monasteries and cities, Tibet's consciousness is perpetuated across two antagonistic discourses, two voices that come from elsewhere: one from the Tibetans who have left their country and the other the voice of the Han Chinese who have moved there. Between these two, the struggle remains passionate.

— In spite of these differences, we believe we can see a way to bring them together. Between old and new, local and imported, the wooden plow and mechanized agriculture, carmine robes and mobile phones, the high plateau is living a material and moral synthesis, building radical new tools and a renaissance that is audacious and refined – much like the Norman kingdoms in the Holy Land during the Crusades.

This future prosperity is almost palpable, but it will not happen until there is reconciliation between Tibetans and Hans, not to mention with the other ethnicities in Tibet – Kirgiz, Kazakhs and Kas, these Muslim Lhasans who have been there for 600 years. The future is in the acceptance of the others. By putting their resources together, they can all create vehicles for their common future. They can integrate the genius of their different origins with the constraints of their shared environment. For example, they could develop cities with glass to filter out ultraviolet light. Or, under its 350 days per year of piercing sunlight, they could produce greenhouse fruits and vegetables with unique flavors, grown with their water that is the purest in the world; or welcome visitors from China and the rest of the world to this dreamscape land, for one-of-a-kind cultural and spiritual tourism.

It seems to us that it is all there, the secret of Tibet, at once exposed and hidden: its only possible future.

Alas, during the three years following our voyage, *Tibet, the Last Cry* was met with a skepticism that recalls that kind of antagonism which extends across the world from on high. The scenario was always the same. Publishers read our book and looked at the photos, first with sympathy and sometimes with enthusiasm. But over the succeeding months, all of them opted to not follow up.

At heart, the reason is historical. The Western world's opinion on Tibet is a *fait accompli*. Since his eviction in 1959, the Dalai Lama, a humble salesman of his faith, has disseminated all over the world his call for aid for his lost kingdom. And in its corner, a ham-fisted China, looking slightly autistic, has shown over and over again its incapacity to communicate and its apparent conviction of the uselessness to even try. From all this, Europe knew where to hang its hat.

And our publishers have to earn a living. A book about Tibet can usually only be pigeonholed in one of these two camps, and all the better if it lands on the side of the exiles. But heaven forbid if there is a book that looks at both points of view simultaneously, which is what we did. There is of course freedom of expression to defend, but in times of economic crisis, this line of argument falters badly, such that we had to gloss over a number of polite refusals: for these publishing houses, the commercial risk was simply greater than they were willing to wager.

However, far from being discouraged, this resistance, which we felt the whole time we were in Tibet with the local officials, only steeled the determination of our convictions. Even if the Roof of the World is currently living through some dark hours, we are absolutely convinced that this "hell" has an escape route and we can contribute to helping find it. The Land of Snow will not get to rewind the film footage of its invasion, nor see a great return of the Han people to their lowlands. Something else will have to happen and it is this "thing" that we are so anxious to reveal.

Finally after three straight years of rejection and feeling our way through the mist, in the autumn of 2011, Laurent got the idea to promote the book on the website Kickstarter (www.kickstarter.com), which facilitates the micro-financing of private projects: solidarity to build a future outside the limits of nations and established structures, via social networks.

The results surpassed our wildest dreams. Two hundred and twenty-two friends, known and unknown, web surfers on four continents, chose to give us the funds to publish our book simultaneously in French, English and Spanish. Their contributions allowed us to co-finance its publication with three courageous publishers: L'Aube (La Tour-d'Aigues) in French; Blacksmith (Hong Kong) in English and Icaria (Barcelona) in Spanish.

Tibet, the Last Cry: this book is thus an adventure in itself, apart from our travels to Tibet, and it binds us all together. To give our book an even greater voice, we have decided to donate half of our authors' rights to two NGOs that we met during our trek: Global Nomad (www.global-nomad-tibet.com) and Braille without Borders (www.braillewithoutborders.org). We initiated this sponsorship in 2009, during a conference in Beijing, where I (Eric) gave commentary on Laurent's Tibet photos. Half of the proceeds from the sale of his pictures were given to these two organizations.

Happy reading and enjoy the discoveries!

Eric Meyer and Laurent Zylberman

On Board the High Speed Train #T-27
Beijing-Lhasa

The Han people

"Hello, Hello!" we hear, as we run into two strangers while walking down the aisle. By the look of their clothes, one in a vest and the other in a leather jacket, they are two small-time Chinese market traders.

You would assume they are rich, except that they are sitting in the "hard seat" section of our train number T-27, from Beijing to Lhasa. Hard (wooden) seats are the cheapest tickets that are available on Chinese trains.

As we move by and smile at them, Zhang and Wang invite us to sit with them, ecstatic to spend five minutes talking with some foreigners. This is a rare occasion and quite an honor in Chinese culture.

They are both undoubtedly in their 40s and they are of the Han race. The Hans are the ethnic majority in China, representing 96% of all Chinese citizens. Athletic looking, Wang appears a little younger. He has energetic features and that kind of thick, stubborn hair which always looks good, even when unbrushed.

With his chiseled, somewhat pock-marked face, Zhang looks less confident and a little on the shifty side, sometimes giving us bizarre looks.

As can be seen by their appearance, they are what are known as "Getihu" in Mandarin, or street vendors. For the sake of survival in a life of exile, they work in tandem. Both are natives of Lanzhou City, about 1,500 km north of the Yellow River. The first thing they tell us is that they are returning to Lhasa, their new home since 2004.

Tibet, Wang told us spontaneously, is the land where they hope to live out all their dreams, dreams that will pull them out of the poverty they grew up with in Gansu province.

"In Lanzhou, where we were kids," Zhang tells us, "there is nothing to do, too much competition, not enough business and lots of corrupt cops and thieves everywhere. Lhasa is the new Eldorado. The place is rolling in money. It is full of immigrants, all of whom are potential customers, since they are restarting their lives there from zero. So, for us, all these newcomers are our customers."

But the train didn't start going to Lhasa until the summer of 2007. Why did you two go so early?

"Together with Wang," Zhang says, "I wanted to be sure to beat the crowd. Because you know in business, not everybody can be the seller."

However, it must be said, Tibet is really big...

"Yes, you can even say 'huge'. But the air is really thin and it freezes eight months out of the year. So, it is not like there are tons of people to make ends meet. It is obvious that one day the Chinese government is going to close the

doors on migration to Tibet. But we will already be there, well established. ”

“You know,” says Wang, “we live quite well in Lhasa. We have enough to feed our families. And we have lots of friends who have made their way up there like us.”

And do you have any Tibetan friends?

“Of course, and we have work for them to do. It really is a friendship between two peoples. We are all Chinese and live by the same laws.” And Zhang adds warmly, with a flourish, “It is one, big happy family!”

Zhang and Wang are coming back from Chengdu, in Sichuan, where they went to stock up on goods: clothing, stuffed animals, pots and pans, bowls and bottles; these are the odds and ends that are the foundation of their business. Their purchases are arriving in Lhasa by truck, two days behind them.

“In the beginning,” says the robust Wang, “it took us five days by bus to go the 3,300 km.”

“Now it only takes two days, and that has changed our lives,” adds Zhang, “and it has also gotten a lot cheaper. To go from Chengdu to Lhasa is now only ¥300 (US$45), and this is over halfway across China.”

I cannot help but find their optimism a little strained. As we speak, it is just a few months after some brief, but exceedingly violent, social disorder which cost the lives of over 200 people, mostly Hans in Lhasa and elsewhere on the Top of the World. For the last six months, their new home has been under very tight government control, cut off from the outside world, except for those, like them, who are authorized to come down off the plateau to replenish their wares.

Were their street stands among the 300 shops that were burned down by rioters during those dark days surrounding 14 March, 2008?

“No, no,” replied Zhang, nonchalantly, “nothing happened to us.”

So, they were lucky, if they are telling the truth. It all sounds a little too rosy and exactly what the government censors would want to hear. For foreigners, these two gentlemen represent the heart and soul of China’s mobilized, migrating Hans. It is no exaggeration to say that like American or Boer settlers, they are on a conquest of the land and against everyone in their path. This gold rush must be rationalized in the eyes of the outside world, because it really is a war for resources and riches. And their verbiage sounds like the kind of contrived slogans that hide the intensity of the battle at hand.

…And the Tibetans

While we are gabbing away like friends, I suddenly sense that people are peering at us. In fact, sitting across from us, with fixed gazes, are four young men and a woman, all about 20-25 years old.

They are obviously so different from our new neighbors, starting with their fiery eyes, and also their body language. One guy is holding his friend by the neck while the other responds by holding his buddy at the waist. This casual maneuver appears quite natural for them. Their look is so unlike the Han. The third young man has high, sun-

darkened cheeks and the last one has curly, raven-black hair. These five young adults are our first direct encounter with Tibetan people.

Without getting up, Laurent, my photographer friend and I turn to these people and, speaking Mandarin, introduce ourselves. With a well-polished manner, the woman answers back in Mandarin, introducing her friends and saying, "Welcome to Tibet!"

Their little group, she explains, is returning from a fun weekend in Xi'an. Two of them are students and three of them are working. The young woman, who has not told us her name, mentions that they are in fact childhood friends.

We are dying to learn more, but will not get the chance.

So far during this conversation, our Han businessmen have kept quiet, staring at their feet. But suddenly from behind our backs, Zhang interrupts us. The bitterness of his tirade is not lessened by the monotone cadence of his voice. It is one of a man filled with deep resentment: "The Communist Party treats the Tibetans well," he says. "The Party offers them rights. It is spending a fortune to improve their lot. Without us Chinese, the Tibetans would be living in misery.

"This is unlike the Dalai Lama who, aside from his royal airs, is doing nothing to enrich the region. On the contrary, he incites secessionists and foments revolt. He was the one who was behind the March riots, they have the proof. You know, the Tibetans should be a little more thankful for all that we are doing for them. And for me,

these guys here just don't seem to have a sense of gratitude, deep down."

Laurent and I are stunned as we witness this brazen insult. So, we turn back to the young Tibetans, not sure what their reaction will be. But, in a flash, they have already disappeared, leaving their seats and moving four rows away.

Out of sorts, Laurent and I cut the conversation short and go back to our compartment, avoiding further contact with the Tibetans. We are embarrassed that we may have put them in a difficult situation, and we certainly do not want to be responsible for a fight on board.

But in any case, we understood enough. By fleeing this verbal attack, these Tibetan youngsters sent us a clear message: there is no way they could reply in kind without risking a rumble in a train car that was 90% full of Han, or being arrested by the dozen police officers on board, all of whom have little patience nor a sense of humor when it comes to ethnic conflict.

The frustration of Zhang, this shopkeeper, is also quite edifying. On the question of their having Tibetan friends, Wang had added to his answer quoted above, "In fact yes, lots of friends. We are friends with all our employees!" Yet, the outburst that his acerbic companion made must be considered his own answer to our question. Its bitterness spoke volumes about the frustrations and hand-wringing both these populations have for each other. It is safe to say there is not much cross-cultural amity in this thin, mountain air.

Laurent thinks that Zhang, the less good-looking of the pair, let loose this tirade to compensate for his feelings of inferiority, not to mention to enjoy the emotional rush of a good insult. We can also glean a form of crude, reactionary racism: maybe Zhang did not want to share this prized exchange with Westerners with these inferior beings.

Wang was better behaved. But that does not necessarily mean he has any more appreciation for Tibetans than Zhang. He was simply conforming to the first rule of Chinese culture: always put on your best appearances for China, when in front of foreigners. And rule number two: do not hang out your dirty laundry except in the privacy of your family.

And so it was thus, on our way to Tibet and without having even set foot on its soil, that we experienced our first cross-cultural exchange between these two peoples. It was a message of shared dislike and mistrust, even hate; a message that augurs ominously for the remainder of our journey, as well as for the future of the region.

INTRODUCTION

On 20 September, three French people and one Chinese person went to Tibet. We stayed there for two weeks.

It was a rare privilege. Since the riots of 14-16 March, 2008, we were among the first westerners authorized to enter this forbidden, traumatized region, which was under military guard and armed to the teeth.

The surprise was relative. Even before these bloody events, the administration of this "autonomous territory" has always been averse to giving out travel permits, except for rich tourists, sympathetic Euro-Chinese faithful and business people – and even then, not to all of them.

Tibet is a country still being brought to submission and Beijing is always leery of keeping it under control.

Since the insurrection, the Top of the World has battened down the hatches. Apparatchiks and soldiers, Tibetans and Han (or other minorities) and sheep herders from the steppes seem like a swarm of hornets, where a clumsy visitor has to stick out their head. Still, in such trying times, we got our special travel permit – a miracle which I will explain fully later.

So, our visit was going to take place in a tense environment. These two weeks gave me the feeling of watching the great wheel of time grind to a halt, a screeching melody of badly lubricated gears piercing my eardrums. The hands of the clock seemed to start moving backwards, plunging us again into the nightmare experience on Tiananmen Square, twenty years ago. This was a Petri dish of fear and mistrust, denunciations and propaganda. During these two weeks we were almost always under surveillance, limited in our movement and in our ability to talk to people and be heard.

A multitude of experiences on this trip not only made us laugh, but also bite our lower lips. Throughout this book and from our experiences, I wanted to make sense of this question: How has Tibet changed after 50 years of development under Chinese administration? Socialist China and exiled Tibet are engaged in a cold war, challenging who has the moral authority to run the high-altitude mountain range. For weapons, each side has its own history (both mutually incompatible), as well as its myths, its vision and its blood price. Take a deeper look and you will see that this cold war precedes the 1959 invasion by the (Chinese) People's Liberation Army. There is also a division among the Tibetans themselves, on what kind of relationship they desire with China and the social model for their future. And China struggles with this same kind of debate as well: How much freedom to give to its citizens? What limits should be placed on the powers of the state? How much of a role should its citizens have in the affairs of the country?

Today, it is quite clear that the Chinese are not about to leave the Top of the World. Their establishment here is final, unless an unimaginable upheaval of their entire society occurs – and it would take a lot more than the fall of Communism for that to happen.

Tibetans and Han are two ancient and venerable cultures that do not understand each other. Yet, both have equal legitimacy to bring ideas to the table. Under these conditions, the only thing left to do for these people who are destined to live together, is to work at making it less arduous.

And we, visitors, witnesses and readers, as outsiders can smooth the edges by helping to make the mirror in which they gaze less sectarian, and refusing to accept the two polar extremes: of Beijing and of the Dalai Lama's entourage.

Beijing, September 2008-December 2011

FIRST & SECOND DAY
SATURDAY & SUNDAY, 20-21 SEPTEMBER, 2008
HIGH SPEED TRAIN #T-27

After four months of effort and 21 years of waiting, we are finally going. Our group is composed of Laurent Zylberman, a globe-trotting photographer; Mr. Li Feng, a soft-spoken Francophile intellectual; Brigitte, my wife, who has shared my joys and trials in this country since 1988; and myself.

I am writing this chapter on board the high speed train Number 27, a daily line from Beijing to Lhasa that has only been open for the last 18 months.

This railroad connection is both monstrous and magnificent at the same time. It brings to life a dream that has captivated the imagination of everyone who has been in power in China for the last 150 years, from the last Qing emperors to Mao Zedong, as well as Chiang Kai-shek: The dream of anchoring this rebellious land of Tibet to the Motherland, using a two-railed steel umbilical cord. Some 4,500 kilometers separate the capital of the empire from that of Tibet, affectionately known as the "Top of

the World." And the T-27 chews up this distance in 46½ hours. This train line also serves an important role: to unfurl the lands of Tibet to the vibrant nation of China, a veritable ant colony seeking to expand its boundaries. Under the guise of an internal visa, this convoy, almost forbidden to foreigners, is "free" to any Chinese ready to put their back into this crusade of assimilation. So, many poor people, homeless, runaways, students who dropped out of school, unemployed white collar workers, all these failed people full of hope and ambition, the left-behinds in China, are welcome to get on board. "Go West, Young Man," as they used to say in previous centuries, like the English filling their sailboats with "Her Majesty's Passengers": pickpockets, hookers or debt prisoners en route to Australia, with a chance to turn a new page in life, seek one's fortune, start a clean slate.

When things heat up, as happened on March 14th 2008, it was by this train that regiments of soldiers made it up here, effortlessly climbing over the foothills of this plateau.

And coming from the other direction is lumber, along with the ores of iron, copper and zinc, in thousands of rail cars whose numbers are increasing by the day, as the wealth of the Himalayas and all its peaks gets drilled away.

Shaanxi – impoverished cities

So, here we are at sunrise on Sunday the 21st, inside our cozy train compartment with four "soft" sleeper beds. Just an hour ago, passing through a small station, we left Shaanxi Province behind us and started to penetrate towards the West. Through a number of dynasties, its boundaries fluctuating like an accordion, this is as far as Chinese empire ever got.

For a long time, starting yesterday evening, we have seen along the tracks a motif of the urban working class: a whole network of villages and suburbs, made of cracking, flea-bitten brick and concrete. Before us are public housing projects, windows covered in blue-tinted Visqueen, a cruel symbol of new riches to protect their inhabitants at the lowest cost possible from the heat of the sun.

These urban valleys regularly narrow down to almost nothing and suddenly get very dark, ensconced in shade. But the demographic pressures remain intense, as is attested to by the farmers' conquest of the eroded hill slopes, scaling steep faces and leveled by force of hoe and plow, cking out cultivated terraces, each barely bigger than a small bedroom. At these scaled heights, the labor of seeding and weeding is done without tractor. It is only by the back-breaking work of men (and women), who carry on their shoulders irrigation water, that it can succeed. Those who are a little better off are lucky enough to use donkeys.

Here is a sign of voluntary cooperation and the hunger of modern-day life: entire valleys are covered by long assemblies of bamboo in the form of stretched-out igloos and covered in translucent Visqueen, giving the impression of parks full of giant turtles. These low-cost greenhouses are warmed up in the winter by covering them with straw at night and exposing them to the sun during the day. This allows the villagers to steal an extra harvest each year.

Quite a few of these plastic covered pergolas are without plastic. You can see the exposed bamboo frames and new seedlings inside. The wheat has just been harvested and before the first freeze, a last crop of tomatoes, green peppers, cauliflower and broccoli is being planted to feed the city.

We pass Baoji ("Valuable Rooster"), a city of 3.6 million inhabitants living in hopeless suburbs built out of roughly poured concrete. They surround a stylish nucleus of villas for the nouveaux riche. The national highway is a strategic East-West thoroughfare that snakes into two lanes, on both our left and right. Like on the coastal highways twenty years ago, it is backed up with thousands of semi-tractor trailers, all stalled for tens of kilometers in either direction, as far as the eye can see, paralyzed by an accident or breakdown. There is no shoulder on the highway. This poor road has been pitifully overrun by its current needs. This is a nightmare traffic jam created by courageous and desperate people: they are a generation behind their brethren in the more developed coastal regions.

We are only in the first third of our trip, but already see a difference in the extremely arid climate and the manifest drop in wealth. It is not for nothing that geographers call this central region "Yellow China" compared to the "Blue China" of the maritime provinces. Here, "poverty" is worthy of the name. As far as the eye can see, the sky is murky and full of the dust kicked up from agricultural cultivation, burning trash, the greasy dust of burning coal spewed over garbage dumps, where, with the slightest breeze, it is all kicked up and collects on our train window panes. These windows have to be religiously cleaned every night, at one train station or another. Sometimes the dust is actually cement, blown from the hundreds of work sites which are crawling with the humanity of common laborers. Other times, the sky takes on the hues of ocher or violet. It is smoke from the thousands of calamitous factories that surround us. This pollution also carries the recognizable stench of sulfur, spat out by coal-fired stoves and hot water heaters. All around us we are seemingly followed by the breathless song of millions of souls who scratch the soil for their daily pittance. Baoji is not exactly a rooster as valuable as all that!

Gansu – already in the desert

After 18 hours of non-stop "shake, rattle and roll" in the train, we enter Gansu, one of China's poorest provinces. It is in stark contrast to the hustle and bustle that we left behind in Shaanxi.

Gansu: fewer mountains, fewer people, more drought. Yet, everywhere we look we see rows of fruit trees, tall corn plants and yellowing soybeans, and sorghum, as red as the robes of the Buddhists, and a profusion of vegetables. This 21st of September, the progress of the harvest is measured by the number of large mounds of straw (under the rain, not covered up) in the fields, and by the laced rows of eared corn, or by the braids of onions and garlic hanging from the balconies. Here and there among the yellow cliffs we can see the entrances of deserted cave dwellings, as well as abandoned mines. We get the impression that what is unwinding is an agricultural system in transition between

two epochs: the long-standing struggle for survival etched in the people's minds from famine, and the voluntary action of the Communist Party and the state to bring this rural society into the orbit of modern technology.

Half carried away by the flash rains, the huts made of earthen bricks are in stark contrast to the odd modern factory. Their flat roofs made out of bluish sheet metal are near towering wind turbines that cut and slice the sky along the hilltops along the horizon. These gigantic turbines are financed by Beijing in its quest to launch the world's most developed renewable energy industrial sector.

High altitude trains – a technical feat

How much did this flight-of-fancy train line, with its political overtones to boot, actually cost? Only ¥36 billion for the 1,300 kilometers that connect Golmud to Lhasa. Five years of work by tens of thousands of shovel-bearing laborers.

Keeping in mind the difficulties associated with record-setting altitudes, the droughts and the flash storms, it is truly a feat of technological bravado. The train cars had to be redesigned with better insulation and air conditioning, each one equipped with an air-to-oxygen separator, for the passengers suffering from hypoxia. The big national corporations could not come up with the concept. It took the Canadian train and airplane manufacturing company Bombardier, which adapted its current designs with its Chinese factory of Sifang, in Qingdao (Shandong), to pull it off.

Each sleeper cabin has its own private air conditioning and, with soft sleepers, individual televisions. Another luxury for the pampered traveler: the volume knob on the loudspeaker allows you to turn off the on-board radio and get a couple of hours of extra sleep after sunrise, sparing you the public announcements, the arias of Chinese opera and the obligatory military marching music played before every upcoming station stop.

In its other features, the high speed T-27 succeeds rather well in blending in with all the other socialist trains of China. Spinach green in décor, it offers the standard four classes from the comfy soft sleeper bed down to the rock-smooth "hard seats."

These seating classes were scrupulously mulled over in the fifties, when it was de rigueur to hew Communist principles to the realities of the rail system. The revolution already had to face up to a serious dilemma. It was all about class struggle versus unequal comfort when the privileged rode the train. So they had their four classes, but they massaged them with a slight verbal hypocrisy: just remove the word "class" from the trains, all the while piously preserving the feudal reality of tufted comfort for the apparatchiks' buttocks!

It was during that crazy period in Chinese life when they still fervently believed in the future of Communism. During the annual National People's Congress (legislature) the most ardent zealots even proposed switching the colors of traffic lights, so that "red" meant "go." If it meant marching towards the Revolution through radical audacity, then so be it. Never mind that comrade drivers

would have to pause and think about green being red and red being green, as they careened through humanity-packed intersections… Luckily, Zhou Enlai and Deng Xiaoping were alerted by their experts about how much this absurdity would plunge China into isolation, vis-à-vis the outside world. So, they interceded to block this visual form of proletarian poetry, this unintentional tribute to John Dalton.

Before even beginning construction on the Beijing-Lhasa rail line, the Chinese Academy of Sciences worked for years on various techniques to protect the permafrost, this frozen subsoil that has existed for millions of years. I can see the results during our trip. The train track is frequently elevated several meters above ground, anchored in a bed of rocks, frequently pierced by tunnels for the through passage of wild yaks (*Bos grunniens*) and Tibetan antelopes (*Pantholops hodgsonii*), the latter called "chiru" in Chinese and on the CITES endangered species list. In order to traverse the many wetlands and mountain brooks that crisscross the region, a biome that supports a flora of splendid bronze hues, the rail line travels over long sections of elevated viaduct on its way to Lhasa.

In order to take advantage of the countryside and to take in as many vistas as possible, I sit down to write at last in the panoramic dining car. Facing me is the young cashier, who keeps looking at me out of the corner of her eye. She is wearing a crisp and clean uniform with a red corsage, white-striped blouse and sporting a little hat like you would see on a waitress in a 1950s American diner. She is having nothing to do with the last customers on her shift, who keep hanging around, nor those who are trying to infiltrate her territory: "We're closed, we have nothing left to serve you, it's our rest time right now," all the while adding the standard rhetoric of courtesy, "OK, guys?"

Reluctantly, most of those seated get up and go. The failed infiltrators turn back and join the others, wearing sheepish faces. The last holdouts are playing poker. They are surely bigwigs in their own right and so they confidently turn a deaf ear. So, a sort of vague compromise establishes itself, according to the unwritten rules: the old-timers can still stay, on the condition that no more orders are taken. And me, at my corner table, I am protected by the double trump card of being a foreigner as well as a working stiff with my laptop computer.

Twenty years for a trip

Outside my immaculate panoramic window (many thanks to the highly efficient hands that cleaned it!), I see rows of hay bales and three languid yaks under intense sunlight which is reflecting off the pools of several brooks. This is a prairie full of running streams and organic life.

Why this fascination with Tibet in China, Europe, America, the whole world in fact? The famous comic book by Hergé, *Tintin in Tibet* (1960), would it have the same influence on today's generations of youngsters who now hold rein: journalists, business people, politicians? That image of its character Blessed Lightning, the Lama priest accustomed to séances of trance and levitation, would he still haunt our collective conscience like he did in the 1960s? Is it the attraction of Buddhism in Europe that

comes to the forefront for the Land of Snow? The blind search, among their confessions, by all the world's peoples for some sort of ecumenical harmony; is it a globalization of faith? Whether it is the sects with the yellow, red or black hats, tantric Buddhism in Europe and America is enjoying a surge of popularity and already has several million faithful.

Maybe it is also, deep down, the thrill of extremes and for setting records that beats in the hearts of all humanity, all children. It is possible that we are also captivated by the imagination of a country with its purity and its poverty, by the lightness of its atmosphere or its cuisine and what it needs. This is a country where water boils at 60°C and one is sustained by a fistful of barley flour mixed in a bowl with yak butter tea. Meager fare, but it nourishes the body and the soul at the same time through the smile of the host who offers it…

I see a yurt as we roll by, that ephemeral lodging of the herdsman, searching pasture for his goats, sheep and dozen or so yaks. This plateau with no end, with its migrant population is far from being homogeneous and is not exclusively Tibetan. Other shepherds might be Mongols (in this case), Uighurs, Kazakhs, Hui, Sala, Kirgiz – all distinguishable by their shirts or tunics, bonnets and felt hats. Right now the train is going by a chorten; in this case a huge pyramid of rocks piled up and coated with white lime. From it are flying dozens of multicolored, but rain- and sun-faded ribbons, ragged from the wind. Behind this monument is installed a small hermitage with high walls made of mortar-less stones. It is guarded by a Tibetan mastiff that is on a chain, undoubtedly ferocious. His full-throated, long barking howls at our train's passage are smothered by the double-paned glass I am gazing out of.

On 27 September, 1987, 15 days before my arrival in China, there was the first insurrection in Tibet. In Lhasa and Shigatse, monks revolted by the hundreds, pouring out of their sanctuaries, marching down streets and brandishing the national flag of Tibet – with its red and blue stripes behind the sun perched on a snow-covered mountain which is blazing with two emerald-maned, heraldic snow lions hoisting the Three Jewels of Dharma.

The reasons for this uprising, as well as for the one in March 2008, 21 years later, were the same: For several months previously, police control became suffocating in an attempt to crush the influence of the monks among the populace, as well as their ties to the Dalai Lama in exile. Suddenly, a thousand things became punishable and punished, like carrying a picture of the Dalai Lama or praying in public.

In China, an officially secular state, this kind of imposition of public law is respected. For thousands of years, the "Sons of Heaven" (the subjects of the empire) have followed orders from on high in the name of family survival. Patiently, they bend their backs and wait for better days which, through the prism of liberty, never happen. But this fealty has never worked in Tibet, a spiritual land that believes in other values, in other human relationships.

This crackdown of discipline in 1987 marked a turning point for the directives of Hu Yaobang, China's General Secretary, who had traveled to Lhasa in May, 1980. In a celebrated speech, he promised to offer the Tibetans the decades necessary to integrate themselves into Chinese society (see the epigraph at the beginning of this book). The freedom of religion should have no bounds. Chinese (Han) migration would be restricted. The Tibetan people must remain "masters of their own destiny." This path to wisdom, which was later applied and respected in Hong Kong, should have been enough to keep the peace.

We are now in a deserted valley lined with yellow scree that crisscrosses in torrents down the mountainsides. I see a village spread out in low, gray cement colors: these are the residences of settlers and soldiers. Lifeless, colorless and held together for the sake of survival, this is a grid-like hamlet of one-story concrete barracks, with its arteries of tic-tac-toe dirt streets in the style of a Roman camp: Running north to south and east to west. Behind the village, I can make out pale green fields of wheat and rye. Along the horizon, the mountain range is carved, with peaks covered in an eternity of snow. The skyline looks chiseled with hard angles and contrasting colors: intense royal blue and gray-white.

Where are the inhabitants? In the fields? Practising a few rounds at the shooting range? Exuding boredom, this place reminds you of neighboring Xinjiang's *bingquan*, those military farms full of soldier-farmers that were founded by Mao, starting in the 1950s on China's Muslim soil in order to maintain the country's peace on a day-to-day basis while fulfilling their own needs: on the one hand the plow and on the other a Kalashnikov.

It took one "Hu" to start it and another Hu to bring it to a halt, seven years later. In December 1987, the then newly promoted General Secretary of the Tibet Autonomous Region, Hu Jintao[1], was a young unknown, but brilliant in his government service. He was known for his reliability and impeccable loyalty to the Communist Party. Discovered by Deng Xiaoping, this young ladder-climber was put into this high level post with a certain amount of risk. But he confirmed his worth and Hu would be named the future supreme leader from the "Fifth Generation": he was called to take the reins of the People's Republic 15 years later. Being called the Patriarch is as good as becoming it.

However, in the vast machinations of China's *nomenklatura*, Hu was all alone. Among dozens of high level leaders in their forties and fifties who were eligible to become the supreme leader, his promotion in 1987 caused teeth to grind. Hu was nothing but a senior official and they dreamed of tripping him up. This looked all the more easy since Hu was now exiled from the confines of the empire and would be incapable of defending himself. His only protection would be his capacity to walk the straightest line, to amaze his sphere of contacts with an impeccable rectitude – at least from a Communist point of view.

Therefore, when the revolt erupted in Lhasa, Hu, being a political animal, did not hesitate to ditch the "altruistic" and "father-like" policy of Hu Yaobang, now an old cadre

who was perceived by all to be in decline and increasing isolation. So it was thus that this young Secretary ordered troops to open fire on sight at the monks marching in the center of Lhasa. As a result, he was able to quell the rebellion in a matter of days and acquired the reputation of a man with an iron fist, totally unfettered by Western-style humanitarian concerns. Through this sacrifice of several dozen lives, he assured his seat as President.

In December 1987 I could still go to Lhasa to be a witness to all this unrest. There still reigned in China the idea of an ideal administration, with black-and-white rules, but they were often not applied. Alas, just as I was planning on traveling to Tibet, it was closed shut like a vice. Thereafter, every time I requested a visa by telex to Lhasa, I invariably received the response "The weather is still too cold." This message was as terse as it was elliptical. But it did not even try to hide that my presence, as that of all journalists, was undesirable.

Visa kabuki games

In the spring of 2008, after Tibet's explosion of violence, this reflexive closure of the borders exacerbated itself: the last thing Lhasa wanted was to show the world's media its humiliated metropolis packed with soldiers, with its blackened shops and plumes of smoke from fires still not extinguished after all the looters' attacks.

But I was still looking for an opening. Trying to enter as a tourist, I went to see CITS, the national tourist agency. I played the straight game, declaring my status as a journalist, but promising not to do any writing or reporting. I just wanted to see, with family and friends, a land that had been shut off to me for over 20 years.

Maybe I was a little naïve. Such a deal was in fact intolerable to both sides. For myself, as a reporter, I was giving up everything by renouncing my profession to go to this place, one of the most isolated in the world. Of course, I never abandoned my dream to write an article or a book about such a voyage. But no matter what, I was prepared to keep my word, not interview anybody nor take any notes. I would have to write from memory, cataloguing each evening in my head what I had experienced each day. But the value of such a work risked being weak: how precise would be my recollections, what leads would not be followed up, what about those questions asked on-the-spot, from gut feelings of intuition? Which Tibetans could overcome their fear to talk to me, to give me their account of things, in the middle of a tour group? The more I thought about it, the more the whole idea seemed a pipe dream.

In any case, CITS had no margin to maneuver. Courteous to a fault, the Beijing employee first gave me some rays of hope. She proposed a limited itinerary selected by them and strictly limited to visiting temples, all with a price tag to make anybody take a step or two back! Even under these terms, she called me back the next day, eating her words and putting the kibosh on that minimalist proposal. It only took 24 hours for Lhasa to see my name on their list of banned media foreigners, forbidden by default. There was no point in trying this route again.

The fault line

The idea that worked finally surged into me from an atmosphere of total disarray. I called the information desk at the Wajiaobu, the Ministry of Foreign Affairs. To my contact man[2], I revealed my project, and my sense of disappointment. With all the sincerity of a desperate man, I stipulated (and even promised to myself) that I was going to Tibet to write a book.

To my big surprise, and in denial of the fact that Chinese government employees never get excited about anything, he replied tit-for-tat, "But you are wrong, Mr. Meyer, journalists are always welcome in Tibet. All you have to do is place the request in the right place, not at a tourist agency, but at the Waiban, the Bureau of Foreign Affairs of Tibet, in Lhasa."

In retrospect, I think I now understand that through the good offices of the local security bureau, the ministry got wind of my plans to try the tourist route as well as Lhasa's refusal to comply. So, his department had already studied my case and made its decision. It was just waiting for my call.

The aftermath went like a well-oiled machine. On June 30th I mailed my request, with all the forms properly filled out, to the proper address. The fact that this Waiban in Lhasa, with its 80 employees, only communicates via fax and not by email reveals a certain style of monastic rules and relative self-protection. Of course, in reality, Lhasa was linked with Beijing via the internet. But the fax gave Lhasa the opportunity to follow its most precious imperative: to take as long as possible. Because in a place so charged with political tension, to not communicate, to not commit oneself too quickly, is the best guarantee for long-term survival. Otherwise, unforeseen blowback is always possible.

On July 15th I got a call from Lhasa on my mobile phone. It was a friendly employee, asking me anxiously in Chinese if I still wanted to come to Tibet.

Everything was swinging into action. Several exchanges followed at regular intervals before I was bestowed with the lodging permit and notified by telephone on August 15th. Then on September 15th, five days before the departure date, I received the travel pass by fax, while at the same time Laurent, who had been hanging out for weeks in Paris, was invited by the Embassy of China there to come and pick up his visa.

It must be said at this point that the travel pass sent by fax had zero administrative value. The real thing would arrive to us by messenger, six hours before the train's departure; thus providing a brilliant example of the unrivaled capacity of this administration to educate foreigners in patience.

Even buying the train tickets was done in an atmosphere of suspense, since bookings only open two, at best three, days before the train's departure. So, two Chinese, including Li Feng, one of our group, went on a big hunt for tickets at two different ticket offices. The hope was that one of them would get in line and make it to the window before the tickets were all sold out. Officially, no government office would help us.

But the reality is surely something else altogether. Hiding in the shadows of power, like some fairy tale, good little invisible fairies were watching over our voyage, fighting valiantly against any evil witches. This Lhasa Waiban wanted us to make it there about as much as they wanted a hole in the head. But the Ministry of Foreign Affairs had our backs, and other entities, such as the bureaus of Public Security and China Railways, were keeping score. Even the Office for the Organization of the Olympic Games had a hand in the deal, as a friend of a tourist agency explained it to me. This being their all-powerful year of 2008, they had block-booked a huge number of seats on the trains and planes going to Lhasa. The aim was to satisfy the demands of foreign athletes and trainers, who were dying to visit Tibet after the games were finished.

All of this hidden, Byzantine palaver went right over the heads of our group: Brigitte (my wife), Laurent, Li Feng and myself. We had just won the chess match of the decade, something that no one else had been able to do for such a long time: Let's hit the road!

And so it was the previous day, on the evening of September 20th, that we piled into a taxi to go to the Beijing West Train Station. This is a bombastic example of architecture, adorned with a pretentious, fort-like façade. It is topped with a huge, curved roof and at the top of this great wall, as if an afterthought, it is crowned with a Sinified arc de triomphe. It was built in 1999 for the 50th anniversary of China's founding as a republic. However, it has not aged well. It only took eight months to build, which is ridiculously fast. But no sooner was it finished than all of its construction problems came to haunt them.

When it came time to pour the foundations, the above-ground architectural plans had not even been done yet. But the rush was on. So, the order for the materials resulted in endless slapdash work and mismanagement. There were, for example, the 10,000 water faucets that all dripped together, like a water concert, and had to be changed. But they did not get changed fast enough, so all the walls ended up flaming red with rust. The Hong Kong press had a field day reporting on the bay windows they forgot to seal into their frames. With the first gusts of wind, they went flying out of their holes, careening to the ground below and smashing into thousands of shards among the crowds. It was a miracle that no one was killed.

There were also the concrete railway ties, poured on the hardened clay ground, that crumbled under the weight of the trains. Thousands of problems piled up. Small things like realizing that they forgot about a metro station to serve this huge monstrosity or not installing a taxi ramp for arriving and departing passengers. The taxi ramp was added at the last moment and ended up being over a kilometer long. Wheezy motors frequently cut out during the last 200 meters of a very steep spiral climb. So, it is constantly plugged by immovable traffic jams, causing hordes of passengers to miss their trains.

We briefly found ourselves traversing a waiting hall crammed with thousands of passengers destined for every corner of the empire. We saw a Tibetan musical group that was returning home after their tour. They were sporting

their turbans, baggy pants and shimmering blouses and were encumbered with their stringed and wind instruments.

From a scratchy loudspeaker the signal was given. With hundreds of fellow passengers in our convoy, we ambled up to the control turnstiles and ran our bags through the scanners, along with many bundles, baskets of food and gifts. With our infamous travel pass in hand, we filed in behind the others. And not a single guard bothered to ask for it!

This gave us the opportunity, all things considered, to honor the efficiency of the police, who knew exactly who was who. So, there was no need to even look at our ID cards. It must be said that among the 1,000 passengers boarding the T-27, just six foreigners (including two German tourists and Li Feng traveling on a foreigner's permit) were constantly followed by dozens of security cameras, which are tied into a huge computer for facial recognition. No one will ever get lost on the face of this earth.

Third Day
Monday, 22 September, 2008
Train #T-27

Short of breath

The altitude is already playing tricks on us. This evening was even more difficult than the previous one. We are suffering from aches and pains, lost vision, diarrhea and other classic symptoms of altitude sickness. The embassy doctor warned me of some general pain, discomfort in the upper chest and light headaches for whomever ascends more than 500 meters per day. Beijing, our starting point, sits at only 45 meters above sea level. Last night, we slept at Xining, which is 2,200 meters up. Then this morning, eight hours later, the train broke the three kilometer barrier. It was here that the train opened up the oxygen system. Each passenger in their sleeper can individually turn on and control this precious stream of gas.

It has a simple, somewhat amateur design, so this unique type of distribution does not wander far from the laboratory from whence it came. We can see a system of trial and error, as doctors and engineers tinker with the circuits so they are capable of helping the masses to

confront the voyage's biological challenge. There are in fact two ways to get the stuff: one is the classic airline emergency mask and the other is like in a hospital, with two Neoprene tubes to insert in the nostrils.

These hardworking helpers reduce the shock, but we arc impatient to overcome feelings of constantly being out of breath. This sensation of gasping for air never leaves us, like fish out of water, even till the last night we are at high altitude.

The Tibetan plateau

We wake up in the middle of a huge plateau. We see either a linear horizon with its vast emptiness or huge, broad valleys. Every 100 km or so, there is a rail service station with several side tracks, all invariably crowded with convoys of goods awaiting our passage on this mono-track carrying us to Lhasa.

Like a huge slab of tofu with continental dimensions, this high altitude desert is sundered by a raised bed of sand and rocks, over which we pass. Sunken alongside the track is a green, metal-grilled fence to discourage small wildlife from crossing. But it's not for the antelope, which are capable of jumping over obstacles up to 3.5 meters tall.

The ground we are traveling across is spongy and covered here and there by tufts of low-lying plants and faded moss. The permafrost lies a half a meter below what we can see. And circulating across this icy carpet is a cross-linking tapestry of little brooks, ponds and mazes of wetlands.

Since Qinghai, 1,000 km to the east of us now, our convoy has traded its electric power for the locomotives' diesel engines. High-power electric pylons have disappeared here. There are just not enough people and traffic to justify such an investment. In any case, they would be vulnerable to blizzards and freezing rains. The smallest tornado would bring down the lines, twisting and crumpling the pylons like folded paper, immobilizing the rail line for weeks.

A double-edged slogan

While leaving a city, we see a factory wall with this cryptic slogan:

The market determines our future
But the price determines the now

What a bizarre political advertisement compared to what onc might expect on road sides in Europe, bragging about the latest model Fiat or Renault.

This expression especially seems to me to express the poignant poverty of this province and its determination to escape it, whatever the cost. Since Deng Xiaoping swore off Mao's egalitarianism, everyone can dream of becoming rich in industry or commerce. In this tortoise and hare race, the blue China, those rich alluvial plains along the coast, were better situated than the yellow plateaus. These disinherited regions, like Qinghai, which we are crossing, only recently shook off the most abject of poverty and still lag far behind. The great national plan for the future is to displace the coastal factories to the western plateaus (the "market" in the above slogan). But in order to do so, these regions now have to make products of equal quality for

less money, thanks to lower-cost labor and cheaper costs of production (hence "price" in the slogan). In reality, this slogan is simply retreading a tired old Stalinist formula: "Work hard, roll up your sleeves and the future is yours!"

Li Feng sees things about the same way. It reminds him of his childhood and schooldays growing up in Xi'an. "They made us memorize by heart the sayings of Marx, like, 'from everyone their capability and to everyone their needs'. They promised us we would overtake the West in industrial capacity in 20 years' time and in the meantime we had to break our backs at work."

But Laurent objects: "Might it rather be a protest against the constant rise of price tags? The 'price' shown that you are talking about could be for pork, rice or eggs, which are getting more and more expensive by the day and forcing the masses to cut back on their food purchases."

My take on all this, I conclude, is that the local Party leader is daring to complain, obliquely, about the government policy that still favors the big cities and rich coastal zones, while sacrificing the interior of the country. You see, as soon as they believe the outside world is not looking at them, China's regions are not as unified as all that, and the unifying umbrella of the Party can conceal lots of conflicts.

At times the plateau rises up to become mountains. They are flanked with the same brown or green vegetation, which can turn pink or violet depending on how the sunlight reflects off the rockfaces. Once in a while we see a farmhouse or a monastery pass by, with fairly high, solid walls to protect against robbers and wolves. Seeing the surroundings, you have to ask yourself how they can even survive.

Off in the distance we can see white, square or rectangular tents. This signals nomadic herders, with their itinerant herds of yaks, goats and sheep; they will hang out in this area for a few weeks until the pasture is eaten down and then move on. The ground already looks worn down and devoid of much grass…

Snow barrier contraptions

On board the T-27, China's pet project, we can see a very convincing effort to try to protect the environment. Yesterday, we saw how they are trying to protect the permafrost (with the train line running on raised viaducts). But right here in Qinghai, across great expanses of ground along the track, in strips of 20-40 meters wide and going for kilometers on end, we see a network of scree laid out by human hands. Thousands of railway workers patiently collected all of the rocks and stones from the neighboring prairies, and all are neatly worked together in squat walls about 15cm high, creating a lattice of diamond shapes about one meter long each.

After just two years exposed to the wind and temperature fluctuations, we can see in places that the latticework is already frayed and falling apart, as if to remind humanity of its futility in trying to subjugate nature. But in other places, this work of Myrmidons shows amazing signs of rebirth, a change of eras: on the inside of the diamonds we can see the desired tufts of plants that have taken root

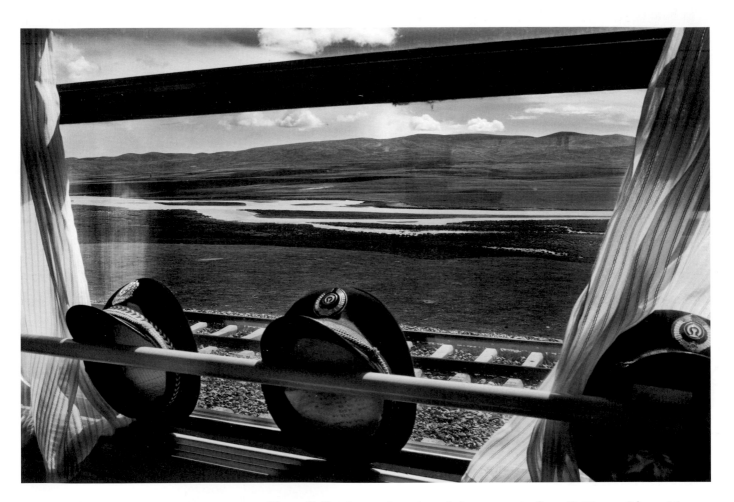

Hats of officials traveling aboard the new train from Beijing to Lhasa. Nagqu.

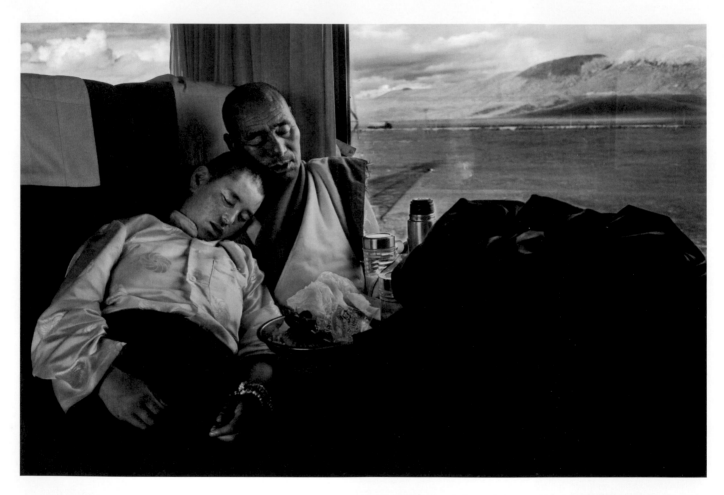

Monks fall asleep aboard the new train Beijing-Lhasa. Nagqu.

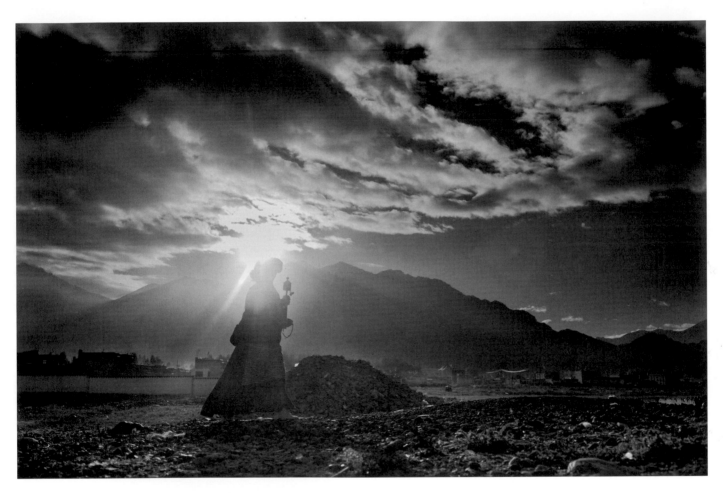

A Buddhist pilgrim travels to the sky burial cemetery. Lhasa.

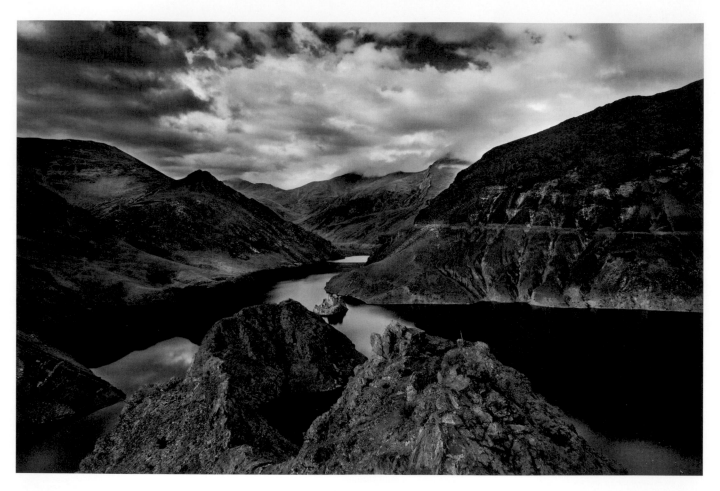

Waters of the sacred Yamdrok-Tso lake feed hydro-electric turbines. Ruins of an old monastery can be seen in the middle of the lake.

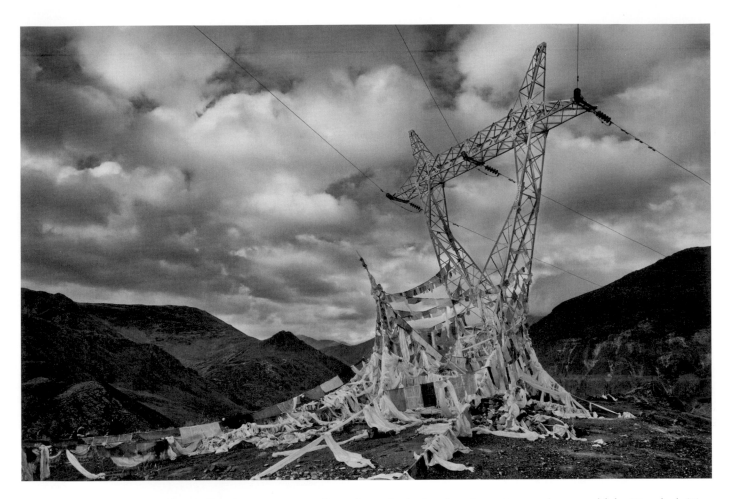

Prayer flags hang on power lines from the hydroelectric project at the sacred lake Yamdrok-Tso.

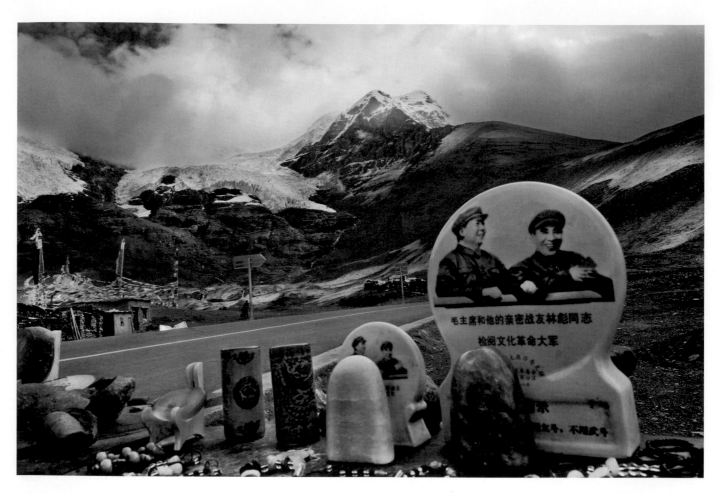

Portraits of Mao Zedong and Lin Piao at a souvenir stall by the roadside. Karo-La Glacier, altitude 4976 meters.

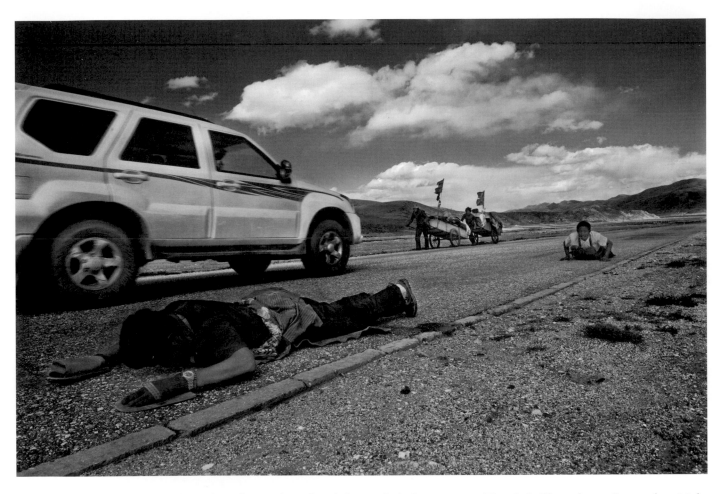

Pilgrims travel to Lhasa from Chamdo while regularly kowtowing. They left Chamdo on September 10th.
On the road between Damxiung and Yangbajing.

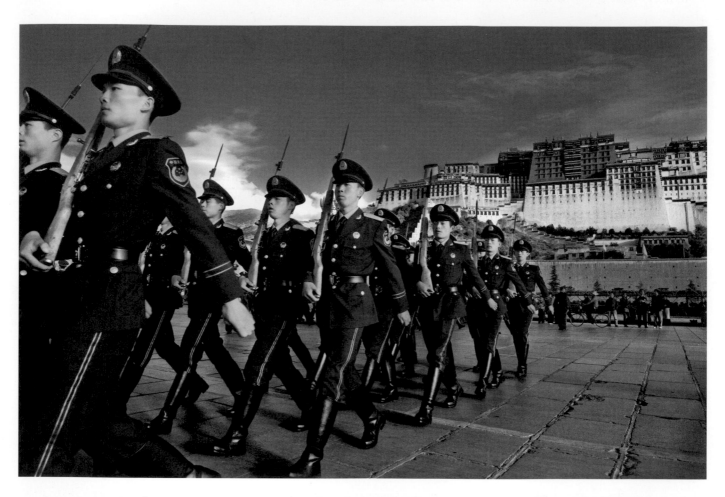

A military parade by the People's Liberation Army (PLA) in front of the Potala Palace for National Day, which celebrates the Communist liberation of China in October 1949. Lhasa.

and are protected from the vicissitudes of the harshest blizzards.

Elsewhere, there are concrete panels hanging suspended from heavy chains, not connected but parallel. They hang together like the sails on a corvette that has tacked its way towards the sky, far from the ground where the yaks are. In other places there are semi-round concrete tiles, connected together like wreaths hundreds of meters in size. They look like some kind of trap set for the snow packs of winter's blizzards. There are all kinds of open-air science experiments that have been invented and are being tested by the Chinese Academy of Sciences (CAS – the overseer of this rail project). They dot the landscape as we progress forward on this strategic line.

After several hours, I begin to understand what's going on. These projects are concentrated right along the border of the track and follow its contours, with its bare mid-slopes. They are there to play the role of copses, since trees here are non-existent due to the high altitude. Like copses, they are there to block and dissipate the snow-charged winds. They are also there to stop the formation of snowdrifts and keep the track passable, even when the blizzards are at their coldest and most bitter.

We can also see in sections that are completely exposed to the sun, where there is not a spot of shadow to be had, there are freakish looking devices: like a beveled tube system that runs along the embankment. It is a thermosiphon, whose reflecting mirrors send the sun's rays back into the sky. The hope is that they will help preserve the permafrost and they were also invented by the CAS. In the summer of 2009 however, a study in the magazine *Scientific American*[3] cast doubts on their capacity. They are supposed to stop the permafrost's temperature rising by 0.2°C in the ground and 2° in the air by 2050. However, it appears that these goals, benchmarked in 2003, have already been surpassed. UNEP (the United Nations Environmental Program) says the permafrost has already warmed up 0.3° since 1978 and +0.6° where human activity has taken hold. Zheng Guoguang, national director of China's meteorological center, adds that due to a magnifying glass effect of light and heat in altitude, the permafrost's warming effect will continue to increase by 0.32° every decade, compared to +0.2° elsewhere in the world. "In the worst case scenario," says Zheng, "the permafrost will melt and render the train line unusable in its current state." It is no accident that China just installed 16 automated heat trap stations along its route. We should know in a few years if China will be able to save its rail line to Lhasa.

In this fashion, which is symptomatic of a totalitarian state, the research bureaus have done an incredible work of precision and technical efficiency. But they forgot to communicate with the passengers and explain to them the goals of all this work and why they are important to them. This is different compared to Europe or America, where our public transportation and road systems are validated by the taxpaying public. But this is a symptomatic omission here. The opinion and collaboration of the public does not count for much. All that matters is the order from on high and its technocratic implementation.

Work on the rail line is going on even today. Along huge sections of the line, gloved trackmen, wearing chapkas (wooly hats with fur-lined flaps on all three sides) are digging a narrow trench and lining it with slabs of concrete, to act as a drainage ditch.

In the afternoon we are riding across the hundreds of kilometers of expanse that separates us from the Promised Land. Our fatigue lets up a little and we can admire this amazingly beautiful, high-altitude land: we pass over a half-dried-up lake and are surrounded on both our left and our right with crystal clear waters. It is like looking at a series of artworks as we are suspended in midair. The spongy landscape is covered in mysterious lichens. Off in the distance are high-peaked mountains, forever covered in snow. Here, the mountain chain, looking violently carved and chiseled, has peaks hitting 6,500 meters.

Tangula, the world's highest train station

Almost without even realizing it, we have crossed the Tangula mountain pass, which sits in the middle of the same named mountain chain, and which rivals the Himalayas. We were holding out hope for some relief from the tortuous and extreme incline we were climbing, like some phantom blizzard train with its switchbacks and valleys of fire. But there was nothing of the sort.

In fact, this mountain pass does not even live up to its namesake. It is more like a high-altitude landing in an uneven area with huge open areas interrupted in the distance by chains of peaks with their eternal snow caps.

We have stopped in wide open country next to a little deserted train station. On the new and clean platforms, signboards soberly announce in blue marine Chinese characters the name of the place, "Tangula Pass," and its elevation of 5,073m, more than five kilometers above sea level!

Nobody gets off the train. No traveler was waiting for us, no bundles nor suitcases were piled up. Stricken with sickness and less dashing than the day before, the passengers prefer to conserve their energy, laid out in their compartments, fighting for their biological adaptation to arrive. The temperature looks cool and not glacial, maybe 10°C, judging by the looks of the barely insulated vests and pants on the men hoisting picks and shovels outside.

Li Feng thinks this station was only built to flatter the egos of national glory. Here they can hoist into the trophy case the "highest train station in the world," even certified in the Guinness Book of World Records[4].

Mrs. Fan, a good Communist in the compartment next to ours, vehemently disagrees with Li's tendentious interpretation. "You are ill-informed. It was not built to break the world record, but to serve the hamlets, the nomadic vendors and herdsmen in the area. They know the train exists and arrives here and that it generates jobs. Restaurants, post office, souvenir sales, dormitories for the rail men shepherds, all this rides on and serves this train station. Later there will be a medical dispensary, a hotel, a mobile phone store, a greengrocer and a market. Within 2-3 years, for sure, you will see a city grow up..."

The thin air is really manifesting itself with our altitude sickness, but also the lack of vegetation. Trees and bushes have long ago disappeared. A few small shrubs and patchy tufts of grass here and there is all. The rest of the land is nothing but a wild expanse of rocks, a souvenir of life's origins on our planet, maybe a cousin of lunar landscapes and worthy of the rock gardens in Hangzhou, Suzhou and Kyoto. Is there any local fauna that can survive at this altitude? Or are there any animals from the middle altitudes that wander up here sometimes? It is impossible to know. Following the laws of instinct and evolution, owls, antelopes, foxes, vultures and hares all disappear at the first sound of the train.

Liu Weiqiang, a photographer, is paid to know. In February 2006, when the line was at the technical test stage, he hid out near one of the viaducts where there was an established trail for antelope, the celebrated chiru. He was hoping to take pictures of the antelopes alongside the passing train. But after eight days under the snow, freezing in his observation point with his biscuits and water thermos, he finally had to admit it: the wild animals fled the trains. Liu did not want to admit that the animals would be terrorized by the approach of the iron monster.

So, when he got back and worked on his pictures, he got some help from Photoshop. "Following his heart", he composed the picture of his dreams, marrying a photo of the antelope with a photo of the train. What he did not take into consideration, and way beyond his imagination, was how popular his new picture would end up being. The photo had weight and carried an ideological message:

Communism could be reconciled with Mother Nature. Communism overcame the fear of death and was more powerful than capitalism, to be sure. Several months later his picture won the first prize in CCTV's national photography competition. This was quickly followed by the fall of Liu: losing his honor and gaining a reputation as a fraud. After being intensely covered by the media for several weeks, Liu was unmasked by a computer nerd who analyzed the photo and revealed the conflicting angle of light rays and the relaxed, fearless posture of the animals. To top it all, this computer guru even showed online the "glue line" between the two joined photos and how to do it with Photoshop! The scandal caused Liu's editor-in-chief to resign and he had to return the prize money.

Exploring Train #T-27

In order to shake the cobwebs from our legs and observe the quiet society of the travelers, Laurent and I take off to explore the train. It was here that we experienced what was presented in the introduction of this book, the incident between the Han street vendors and the young Tibetans.

Our "soft sleeper" car is full of rich Beijingers: retirees, well placed people, state travel agency employees, workers from international firms, small business owners or high-ranking government employees. When they opted for a means of transport from the lowlands to Lhasa, money played less of a role than the criteria of esthetics (the unforgettable scenery) and health (slower, hence better adaptation to altitude). Like us, they chose the slow way, out of nostalgia or for a vacation. It also gives everyone

the chance to adjust to the change in altitude and enjoy the magnificent countryside. Riding the train is a relaxing distraction, punctuated by the shock of the wheels on the steel rail connections.

Among the people of good standing, a friendly and wealthy class of society, we can see their money spread out before us: heavy gold necklaces and bracelets for the women, hanging over Italian or French made blouses. For the men, Rolex watches and real Lacoste shirts, fancy branded sweaters, fashion designer jackets with the obvious name brands, of course, and bedecked with the priciest cameras and most up-to-date movie cams.

Three cars back, the sleepers become "hard," with six to a room. In this area we see windbreakers, jackets and T-shirts of Chinese manufacturers with the thick, lower-quality sweaters of the semi-rich.

Even further back, we go down to another social class. These are the "soft seats." At this level, lying prostrate is a luxury already thrown out the window, not to mention any privacy of any kind.

Then come the "hard seats." They are full of people with nylon windbreakers, unpleated pants replete with spots and ill-fitted oversized shoes. We can see by themselves a few here, like Yang and Zhang, our street vendors, draped in the dignity of their social standing, with coats, ties and leather vests.

In this humble universe wafts hints of hard boiled eggs, dried fish and stale tobacco, since smoking is expressly forbidden since we passed Golmud and they opened up the oxygen breathing system. One can also detect the ripeness of humanity, which is inevitable after being cooped up in a train for thirty hours.

It must be said that the most outcast candidates seeking their new life in Tibet are not even on board. For half the cost and taking two-and-a-half times longer, they rumble up the plateau crammed into overpacked buses, dazed and confused in rolling tombs. In exchange for not being heated, they are well ventilated by all the broken windows and holes in the corrugated sheet metal, allowing the lucky passengers to quaff by the bucketload all the smog, rainfall and cigarette smoke.

On board the T-27, I estimate that the Tibetan passengers do not exceed 5% of the customers. Among them, I see three nuns and two monks, small and thin in build. They are sleeping in their seats, each arm in arm with the other, fraternally protecting their money belts. We stop and admire the touching scene. There is absolutely nothing fake about it, nor is it ridiculous, inappropriate or erotic.

At the Xining train station last night, we saw them get on board, preceding the horde of newcomers, because the station police had let them walk into the closed area in advance. Usually, low-level apparatchiks like these are renowned for blowing off people of the cloth, out of their respect for their proper secular roles and historic materialism. But here, our lamas, nuns and monks seem to be honored like some notables from the heavens, and offered priority seating for the best places left. Maybe it means that workers, when they think we are not looking,

can rein in their ideological principles and swap them for tradition, or maybe for a pinch of humanity!

Descent to Lhasa

Descending into Lhasa (1,500 meters lower than where we were five hours earlier), we go back through the cloud line and fog on our way. Life begins to come back to the way we know it. First we start to see trees, softwoods and then hardwoods. Then we begin to see enclosures and hamlets. We see more and more yaks and goats grazing, side roads and walled villages. First, we see plots of sparsely seeded rye and local wheat, which begin to multiply in number. Thereafter, we go by the neighborhoods along the Lhasa River, white and green, translucent, bubbling, roiling and magnificent.

We stop at Nagqu, a county seat three hours north of the capital. Still undergoing construction, the station has been super-sized, with a dozen platforms for three trains stopped there and the equipment for a weighbridge to accommodate 40-foot containers. There are several large projects shimmering below with the valiant effort of thousands of Han and Tibetan construction workers. They labor under the sway of foremens' whistles, who are blue in the face from the cold and all their straining. Churning in their tracks are frontloaders with tires that are two meters in diameter. They are trying to excavate veins of rock and silt and quickly dispose of it into dump trucks that are waiting in line. In three directions from our train we can see concrete trucks with their 20-meter-tall articulated sluice gates pumping and pouring away. They

are building huge hangars that are still uncovered, so it looks like we are gazing into forests of exposed beams.

Nobody on the train seems to know what this unknown investment is destined for. A Shanghai tourist assures me that it is going to be a slaughterhouse for yaks and sheep, as we gaze out at ever greater numbers of flocks as we pass. Another, a Beijinger, wildly speculates that it is going to become a textile plant.

Several days later, the Dutch owner of a tavern unique in its style whispered in my ear, like some state secret, that Beijing was preparing "one of the most important logistical hubs in all of Asia, for raw materials." It will be designed to stock and roll out lumber, wool and the one hundred mineral ores found under Tibet's surface, to supply the lowlands, the "mother country." The goal is to compensate for at least some of the import needs currently being supplied by Australia, Africa and Latin America. It will be like a supermarket of global dimensions, formidably supported by government subsidies and discreetly managed by a Canadian multinational. This company was attracted by the chance to explore and set up mining facilities in Tibet, which has the largest proven reserves of lithium (a crucial input for electric car batteries), not to mention healthy quantities of oil, coal, copper and a hundred other riches. But since this exploitation of the Top of the World is frowned upon outside of China, Beijing maintains a heavy shroud of discretion over this strategic project.

In fact, from an economic standpoint, this connection in the form of an umbilical cord is already playing a crushing role. From now until August 2009, this rail line

will have transported, coming and going, 62.5 million tons of goods and 8.3 million passengers.

Around us, the ground is flooded by a rain that intermittently beats down on our cabin windows. Prevented from making it over the Tangula Pass, the clouds coming from the east build up and burst open on this side of the mountain. Heroically, the peasants try to harvest their crops with sickles, laying down their stalks of rye and wheat on the drenched ground. They try to stand them up, forming little round or oblong teepees. But we can see stands that were just put up in the last few days showing signs of rust and rot. Their winter hay crop appears lost, as well as the grain. Li Feng says it is the result of an autumn that was too warm, and with its rapidly melting glaciers, Tibet has front row seats at the spectacle of global climate change.

As we go down further towards Lhasa, the rain subsides. Each of us is occupied with reconstituting our bags, whose contents are spread out all over our sleeper room after two days of use. We can see suburbs, obsolete military barracks and above all, in every direction, a frenzy of investment. Everywhere we look we see cranes, construction sites, roads being built, residential additions and factories popping up like mushrooms. Looking in every direction, concrete is being used on a colossal scale. After we cross a suspension bridge dressed in white and hanging over the Brahmaputra River, we await our glorious arrival in a train station which is modestly sized, but of model design. Its décor is martial, in marble, glass and ceramics. Before finally stopping, we see the platform is full of armed police to welcome us. As soon as we alight, they courteously guide us the length of the platform, through the hall and all the way outside into the open air. Shadows of night are falling like a stage curtain. All the passengers are carrying their bags on their arms, along a 500-meter walkway bordered by white and cherry-red street lights. It is impossible to even consider leaving this flux of humanity to take a quick photo. A humorless young man in fatigues keeps us moving with one hand, while his other paw is poised on the huge truncheon hanging on his thick belt.

The atmosphere around the station is like a fantasy, some visual hymn to the glory of the regime and to post-modernism. All around us we see soaring bridges, huge, brand-new boulevards going to unoccupied neighborhoods, sprouting out of nothing. This is the Lhasa of tomorrow, today. We get to the barriers, where parents, friends and business contacts have come to pick up their arrivals. It is very clever the way they have set up the train station. If a traveler at this instant could somehow overcome the many security measures already put in place, and could set off a bomb worthy of the name, the destruction would only occur right in the immediate area. By putting the entire train out of sight in quarantine, no one there would know what happened. Well thought out. Here already, Big Brother is watching you.

First steps, first conflict

At the exit of the lighted walkway we wait for Sanmu, the agent from the Lhasa Bureau of Foreign Affairs. Twenty-five years old, hair done up in a bun, Sanmu is

a well-dressed young woman, gracious in manner, almost doll-like. She cultivates a smiling disposition, although a little on the sad side. "Welcome to Chinese Tibet," she says, extending her hand to shake. Her first words are already revealing about her hectoring style as a guide. In fact, even though she is a local girl, she has bought into the language of the new master, and throughout the trip she studiously avoids any expression that might suggest Tibet existing without China.

We board a Jinbei minibus, a Toyota clone. Sanmu takes us straight to the Shengjiang Hotel which is situated right on the edge of historic Lhasa. It is a serious-looking building, quiet and comfortable, neither more nor less. Shengjiang means "Sacred Flower," which is the Chinese translation for the Brahmaputra, into which the Lhasa River flows.

We put our bags in the hotel rooms and go out, with the lit Potala following us in the background. We make our way to a restaurant with some vague notions of being American. Under a shower of halogen lamps, we see a sign that says, "Lhasa Tibet Steak House."

Despite its tasteless outer appearance, the interior is decorated with taste and discretion. It is like a mini-museum of local art. On the walls hang "tangkas"[5] and on the ceiling are yak skins. The cabinets and sofas are covered in multicolored, dragon-skin Naugahyde. The feet of all the furniture are sculpted to look like the paws of snow leopards. Absolutely nothing is Chinese. There are batiks and colored fabric reminding us of India or the Himalayan kingdoms. All in all, it is a welcome diversion from the cloned Qing look that blankets the rest of the empire.

The menu is also more locally authentic. They offer "momo," which are round raviolis, with vertical edges and more firm than the Chinese "jiaozi." Momo are either filled with yak cheese or grilled ground lamb meat, seasoned with parsley. There are little meat buns, golden baked in the oven and of course, "tsampa." These are deluxe quality little balls of barley, kneaded with butter tea and seasoned with paprika. Except for the last one, all these dishes have a Chinese equivalent. Another one is little balls of fried yak yogurt that are sprayed with concentrated sugary milk. This one also probably came from the lowlands. But they all had their important nuances, suggesting a separate path of evolution. It is as if Tibet has lived from time to time closer to its Chinese neighbor, taking advantage of an alliance or an invasion. But it has never, even today, accepted being a part of the Mandarin melting-pot universe.

While we are dining, Sanmu gives us a presentation about our program. Eight days ago, when we finally received our journalists' residence permit, we were able to tell them what we wanted to see, who we wanted to meet and the subject of our reporting, which would replace the tourist schedule that was originally submitted.

Of our requests, only the most trivial were granted: quashed were our hopes to see what military barracks, prisons, factories and state farms looked like. All that was left were government buildings and monasteries, as many as we could desire. To make sure that we do not know too

much about what our program is and where we would be going, the Waiban tactfully did not offer us copies of our program.

None of this does anything to build our confidence. All my suspicions that I harbored before we left are being confirmed. If Beijing pushed for our trip to happen, then Lhasa has decided to fight us tooth and nail. So, in face of this cold resistance from our hosts, our dance has changed its stance to a stiff-armed waltz.

The battle begins over the minibus that they offer. The fact that it is brand new allows them to claim three times the price that we found online in Beijing. We put our feet down and stubbornly refuse to accept their proposal. So, Sanmu calls her director on her mobile. The phone call lasts no less than twenty minutes. We wait through long gabs and even longer silences (a scene that we will relive again and again in the coming days!) We are finally granted the right to choose our vehicle. In order to save face, we receive this warning: "as a result of your decision, we decline all responsibility if anything happens to you while traveling on the roads of the autonomous territory of Tibet."

Once the dust is settled and both parties are able to brush clean their clothes, so to speak, we are able to go back to the hotel and consign our tired bodies to our beds. Thanks to our respiratory oppression, we are subject to a litany of ailments: throbbing jabs of pain around the eyes and foreheads, aching joints and sore throats. But, on the threshold of our amazing voyage, these manifestations are almost a welcome sign. Heart and soul, we are captivated by a sense of enthusiasm and hope: enchanted to be here, fleeting participants in this world of gods and soldiers, of the material and the spiritual, across the millennia. The altitude sickness is intensified by the sensations of high mountain drunkenness. There is nothing in the world that we would trade to be here. We would have to be whipped like draft animals to drive us back to Beijing, 3,600 meters below.

where everything is at once rarified and intensified: the light, colors, air, temperature, liberties and theological conscience. This is what it is like to be intoxicated at high altitude.

FOURTH DAY
TUESDAY, 23 SEPTEMBER, LHASA

When we went past Xining, we started taking a two-culture dose of high-altitude medicine, both Chinese and Western.

It makes no difference. Our first night at the hotel is painful and pulls us out of sleep gradually from 06:30 onwards, in stages, as if we were in a recovery ward.

Our morning thus is a bit of a waste, finding our legs, trial and error, going between the hotel and a neighboring supermarket. On our hesitant way, we see gleaming advertisements in Mandarin, an imperialist symbol of Tibet's new masters.

Our time seems to be spent controlled by our bodies, trying to find our senses and learning how to breathe again, in this empty and windy air. We are also having to get used to being bombarded by such dramatic sunlight. So, we kill time until our rendezvous at 13:00. Once we had severed the oxygen umbilical cord we had on the train, we were biologically destined to spend one or two days passively suffering. It is like an open-air decompression chamber and we have to go through it to adapt to this new universe

Welcome to the Brahmaputra Hotel

Our hotel is rated three stars, but this is a very generous ranking on the part of the tourism bureau. Occupying the center of its dark, empty reception area, a little altar is there to justify the Brahmaputra's sacred name. Made of gold-painted, sculpted wood, this tabernacle is invariably full of fruit and a handful of old, odorless incense sticks that are never lit.

The entry is far from a fantasyland and the stairwells look second-hand with tired, worn-out carpeting, which is just how we feel! The furniture in the rooms looks like it is at half-mast. This place lacks the punch of marble and breathtaking perspectives found in the hotels on the nouveau-riche east coast.

In spite of it all, we feel really at ease. Maybe it is because we were not even expecting this much simple comfort in such an austere setting, nestled next to mountains and transfixed by the elements. We are also comfy because cozy China likes its comforts. There is not a hotel in China now without heating and showers. No more rooms now without a huge thermos of hot water 24/7, snuggly beds, lounge chairs and tables. So, the Brahmaputra is a decent property. From the central heating to internet in the rooms, its interior is in good shape and the employees are attentive and alert.

It is also a good example of Tibet's local economy under the heavy Mandarin hand. The owners are a Han family and the managers are Chinese too. But all the rest of the staff is Tibetan.

To be a boss here, you have to be Han. It is not only a question of education and savoir-faire, but also a hunger to get rich. This is a philosophical choice that understandably irritates more than just one Tibetan. Already, walking on the street, several exchanges give me this feeling. It is a question of trust. Even if you are Tibetan and you have the means, is the state going to give you the license to run a business that could serve as a cover to finance back-door terrorist or secessionist activities? There is no favorable prejudice afforded the Tibetans, so they are considered less trustworthy from the get-go. Tibetans are like blacks portrayed by the stand-up comedian Chris Rock. You are automatically the face of crime, "not yet guilty, but already really dark-skinned."

As can be seen all over the world and across all epochs, the Siamese twin of Settler-Native can be found in Tibet, with its values projected like a deformed mirror: "I am technically superior to you, therefore I am worth more than you." All through our trip, those who will speak to us will be the Chinese, with their dominant culture, and those who will keep quiet are the subjugated Tibetans. The Chinese have a laundry list of complaints. The Tibetans don't wash, they don't know the job and they don't like it. They are too innocent. They cannot even hang onto what little riches they have, preferring to share them with their family members, which flies in the face of capitalist principles. All sorts of prejudices that tend to prove, to me at least, that people (or cultures) don't ever learn from the mistakes of others.

On our hotel floor, there is a small army of housekeepers who are under the direction of a young woman from Sichuan, who just came from Chengdu the year before. Her name is Haiyan. She has a plump, healthy body with stiff, windblown, high-altitude hair. She has a little of a punk look about her and is very attentive towards us foreign customers. But, boy, she sure is curt without even thinking about it towards her local workers. She is nasty to them even in front of me.

Haiyan graduated in 2004 from a hotel and restaurant management school in Chengdu and with her diploma, she was to be the floor boss of a modern three-star hotel. After three years, she was seduced by the legend of Tibet, a story that wafted her way through the good offices of a friend who was already there. She took the train, knowing that she was promised a job at her exact old salary, ¥3,000 per month. It sounded good, but she came out with the short end of the stick in Lhasa, where the cost of living is higher than in Chengdu. Now she is burdened with having to buy almost everything she needs outside the hotel and she has to pay for heating eight months out of twelve.

But, when you love adventure, you do not care, do you? In China, it does not matter where you live, you frequently have nothing to lose. And this is the secret, at least for a few more decades, of China's mobile workforce. For Haiyan, living in Lhasa is a bit like living in a Chinese Garden of Eden. Here, she can forget about pollution,

promiscuity and the risk of petty crime. Down there, 60% of the Chinese live in extremely crowded conditions; 40,000 to even 80,000 inhabitants per square kilometer under stressful conditions we have a hard time imagining. In China, over one million people die each year from cardiovascular disease because of air pollution. You become inured to the day-and-night din of humanity and the take-your-life-into-your-own-hands craziness of walking around town. Not to mention, God-knows-what is even more insidious in your food products, as well as the marauding pickpockets. Maybe what really inspired her to come is the tacit right to say her piece when she wants to, finally freed from the non-stop surveillance of her family and friends.

It is here in Lhasa, like the stroke of a magic wand, that this circle of constraints and dependencies, the dog-eat-dog disappears, replaced by the natural state of Thoreau's Walden…

"Here," she says, "the climate is really nice in the summer and quite supportable in the winter." Above all, the air is so clean and the spaces so wide open. It's the exact opposite of her China. For her, it is a change that is just as marvelous and unexpected as it is for us, whatever the reasons are for any of us coming. In Lhasa, Mother Nature is so omnipresent. The rustiest taxis in the country, motors pissing out oil and having already humbly ended their careers when no other city would allow them on the streets, end up here. Even all their backfiring and evil clouds of smoke cannot come close to sullying the air.

The alpine wind is invigorating, freezing and just as easily sweeps away these miasmas.

Our housekeeper who Haiyan has entrusted to take care of my laundry has a thin, angular face, black eyes like burning coals and the furtive look of a cat. She takes my order with an impenetrable obedience, mixed with submission and anger, as if waiting for better days.

The housekeeper makes ¥1,500 per month, which is enough for her to take care of her household needs. Her father is unemployed, her mother sick, her brother a gambler. This is what she has time to confide in me during the few minutes we are alone, chatting in unlikely Chinese. But under the firm hand of Haiyan, and with five other Tibetan girls on the floor, our housekeeper maintains a mixture of admiration for her boss's obvious competencies, as well as the humiliation of her people. This hotel is in the hands of "foreigners," hands that ape her culture, and the division of the spoils is unequal. I imagine she is harboring a roiling fire, by the look of this young Tibetan, a look that is biding its time to even the score with the dominant Han.

The historic city center

13:00 – Sanmu takes us to downtown Lhasa, the religious and royal soul of Tibet. The downtown is laid out in front of the sublime hill of the Potala. This palace seems like a diamond fixed on a screen of cliffs and greenery. We leave our taxi to go to the temple's market street and the Barkhor shops on foot, on up to the Jokhang temple. The Jokhang is crowned with the Wheel of Dharma, around

which are kneeling its two golden deer; these being a reminder of the first teaching of Buddha. This is where he set the wheel in motion, an event which took place at the gazelle park at Sarnath, near Benares. The Chinese, with an obvious political afterthought, say that the deer are the wives of Songtsen Gampo, the 33rd son of the Yarlong dynasty, the founder of the Kingdom of Tibet, around 640 AD.

A rabid warrior, Songtsen was obsessed with strategy, including the choice of his official companions. He chose both of them from outside the realm, for maximum political value. His mistresses and one-night girls were Tibetans, picked up on the monarch's errands across the plateau, so he did not need to marry them. These two wives were different. Princess Bhrikuti was from Nepal, the most northerly kingdom in India, as well as the cultural flagstaff and birthplace of Buddhism, whereas Princess Wencheng was of the purest Chinese extraction, being the niece or natural-born daughter of Taizong, a Tang emperor.

Each union sealed a political alliance, which in turn strengthened his kingdom. Curiously enough, it was Songtsen and not the Chinese emperor who seems to have imposed this alliance, for which neither the ruler nor his advisers seemed to show much enthusiasm. And even less Wencheng, the sacrificed virgin – we may understand her, forced as she was to give up the coastal China, with its pleasures and city lights, for a degrading exile, the bedroom of a warrior famous for drinking unappetizing volumes of fermented yak milk from the skulls of his defeated enemies.

But Taizong had no choice, having lost a series of key battles to Songtsen in 639 AD. The barbaric fighter had come too far down the mountain into the western confines of the empire to go home empty-handed. The emperor also had to fight on another more strategic front, against Turkic tribes, and therefore had to offer a pawn to stop the Tibetan in his tracks. Neither man would suspect that 14 centuries later, this marriage would serve as an argument for Mao Zedong to justify the capture of the country. The offering by the Tangs of their nubile heir demonstrated once and for all a Tibetan acknowledgement of their vassal status. This decision, in modern China's view, is evidence that a virgin of pure royal blood was worth three times the area of France in acres of snow!

Tibet's military superiority was confirmed two centuries later in 763 by the conqueror Trisong Detsen who marched down with 200,000 men, took Chang'an, the then capital of China, overthrew its emperor and installed his son in his stead. Twenty years later, he signed with him the treaty of Chinghui which established recognized boundaries ("The west goes to Tibet, the east to China"). It also tied the leaders into an equal alliance and a sharing of the world. Each side found itself endowed with a specific power, which leaves in modern times a bizarre impression, considering that the winner was the Tibetan and the loser the Han Chinese. The Tibetan defined himself as the theologian master of the religious world, while the Chinese assumed the role of ruler of the Earth, the material realm. Why? My own take is that realistically, Songtsen could see that over the centuries, Tibetan military superiority would

prove impossible to maintain over a China with such vast demographic potential.

Four centuries later, there was a new step in the process of the plateau's subjugation. Having taken Beijing and the whole of China, Genghis Khan dispatched emissaries to claim tributes and submission. As Tibet turned a deaf ear for 17 years, Genghis' patience wore thin and he sent his grandson Kadan to bring the Land of Snows back into obedience. In 1244, Prince Kadan pillaged and ravaged Tibet until a man of high moral fame, the theologian Sakya Pandita, impressed him, enlightened him and took him as his disciple. Thus relations were again changed for the better. Pandita had been able to cut short the disaster and save his country while reiterating the alliance dictated by Trisong Detsen.

This arrangement was still recognized eight centuries later when in 1652 the Dalai Lama accepted, with a 16-year delay, the invitation of the Manchu conqueror Shunzi, the first Qing emperor. He was installed in the "Yellow" temple built just for him (the actual "Lama Temple" in Beijing). Ngawang Lobsang Gyamtso would not bow down in front of his counterpart, but the two men did shake hands and sat in chairs that were equally high off the ground.

Each and any of these dates are, in modern China's view, evidence of the legitimacy of its own sovereignty over Tibet since ancient times. That such "proofs" are contested by Tibetans in exile does not matter. What matters is that the independence of the Dalai Lama's country was

intermittent. It was conquered and was on the defensive before it disappeared.

The statistical reality of confronting forces and the capacity of the respective realms to populate themselves prevailed in the end, reversing Tibet's superiority on the battlefield.

After this fragmentary flashback, I thoughtfully replay the sequence where Songtsen Gampo chose himself two wives, both from far away. This reveals that from its birth in the 7th century, Tibet was well aware of India and China, and straddled the influences of both. One thousand four hundred years later, in 1951 and 1959, calamity would flow from the forgetting by the last century's Dalai Lamas of Songtsen Gampo's lesson, and their failure to seek alliances with all powers, at their borders with Delhi and Beijing, and in the world with the UK, Russia or France. Seeking retreat in their mountains and faith in tradition, instead of embracing technology, modernity and opening up to the world, was their fatal error.

The Jokhang Temple

We go around the monumental gate that is permanently locked, except two or three times a century for really special occasions, such as the passage of a millennium or a visit by the president of the republic. We go through the side gate where we pay our entrance fee to a hoary monk sitting on a throne-like rostrum.

We start out on a patio of whitewashed stones surrounded by wooden galleries and balconies that are sculpted and painted gold. According to the style of the

yellow-bonneted order of the "Gelugpa," the central wall is enhanced with a blue-and-white dais that floats in the wind. It recreates the eight spokes on the Wheel of Dharma, which are symbols of a path to perfection or suffering, depending on which directions you follow: outlook, intention, speech, actions, etc., or in the other sense, materialism, greed, miserliness, gluttony…

The Jokhang's construction was started in 642 by our good and great warrior Songtsen and is the oldest Tibetan temple of them all. Its architecture even betrays the rivalry between his two wives and their respective countries, Chinese and Indian. Its conception started out in the style of *Viraha*, with ramparts of thatch and columns coated in bronze. But later, Wencheng got permission from her royal husband to plug up holes for windows and doors, only to reopen new ones according to the dictates of Tang dynasty geomancy. The result is a lofty and unique style in Tibet: tall, black-framed, trapezoidal windows cut into white and ochre walls[6].

In the main courtyard, monks are waiting their turn to go inside the refectory. Dressed in a blue robe on top of his carmine tunic, a well-intentioned brother plays the role of policeman. He lets the hungry go inside in accordance with the number of seats being emptied, and firmly keeps out tourists who try to gain access, cameras in hand, hoping to steal a second of their private lives.

These dozens of lamas are laughing and joking, pushing and knocking each other around like a bunch of big-horned sheep, acting like the schoolboys that they really are and pretending to ignore the evident tension in the place. At the gates of the sanctuary, like everywhere in Lhasa, there are heavily armed sentinels in khaki, laden with riot shields, ensconced behind sandbags replete with gun slits, on guard and tense.

The lamas may be playing around, but it is not as if they are not thinking. Browbeaten by these authorities of another ethnicity, they implicitly refuse to accept Chinese nationality, the country where they were born, since the power grab by the People's Liberation Army in March, 1959. Several weeks after the riots in March 2008, twenty or so foreign correspondents were urgently brought from Beijing. The goal was to present to the world an unlikely image of a Tibet returning to normalcy. They found themselves at the Jokhang to hear the travesty of an official press conference, when several monks in tears caused a brouhaha for denouncing, some in English, others in Chinese, the violence of the soldiers. Petrified, the authorities did not dare do anything. But, on the day this book was published, these desperate believers are maybe still in prison.

The prayer hour nears. I share a few words with a pockmarked young monk, starting out in Chinese, but in vain. Dorje pretends he does not understand this language. Then in English, which poses no problem for him, and which he is studying on a daily basis. His English lessons are nestled under his arm like a psalm book.

Dorje shows me their regimen: three meals a day, one at sunrise, noon and at 23:00, which is an hour before the last prayers. The rest of the time is devoted to applied studies, including divining tomorrow's weather and using

the power of prayer to influence people's politics. There are of course chores to do, including the collective washing and rinsing of their robes.

After that, they apparently have quite a bit of free time in spite of it all to go outside and spend their donations, write to their parents, play some ping pong, call their lay friends on their mobile phones; in other words, act just like kids of their own age.

In the obscure nave, where discolored taffeta cloth hangs, darkened by the smoke from the candles and incense, the service begins. Numerous pilasters obscure the view of the *tangkas* and the 1,000 Buddhas, some depicted as luxurious, others as meditating *rohans*[7] or secular saints. Across the rows of low tables is the acrid smell of chandeliers and votive candles, constantly being resupplied by a brother who has large ladles to dispense the rancid butter.

The lamas are seated in the lotus position on top of their cushions. Chanting very quickly, they recite their litanies and crown the end of each one with a deep breath and the chime of a small bell or rattle. A little jaded, they also chat in ten different directions at the same time. Smiling all around, they give impish winks to clots of Chinese tourists. These visitors are not listening to the comments shouted by the guides and are totally unfazed by the pathos of the ceremony.

Payday

The prior arrives. He is an old man in a worn-out, well-used robe, accompanied by his cashier. Both of them are handling heavy bundles of money. Going from row to row, lama to lama, they throw handfuls of the stuff on the knees of each brother. They in turn express vexation, using mime-like grimaces at the horror of being contaminated by the impact of these diabolical bills. They touch it as little as possible as they flick it onto the ground; all the while the prior continues with his psalm chants, as he looks towards heaven with his hands blindly working the bundle of cash. He throws a total of 20 yuan at each lama in the form of two 10-yuan bills. His assistant follows up by throwing to each monk two bills of five yuan each. It is a strange sight, almost miraculous. All I have to do is take my eyes off the ceremony for a couple of seconds and the money covering their robes disappears from their laps like vapor, quickly and discreetly appropriated with a voracious legerdemain.

This time, as they receive their alms, the clergyman is not the only benefactor. There are two lay people, one man and one woman who are following right behind him. The skinny man draws from his package and hands each lama three yuan. The woman is better dressed than your average Chinese citizen, in a western-style outfit. She could be a businesswoman or a tourist. She bows in front of each lama, with her hands in the Buddhist lotus position. Each monk reacts when they receive her alms: stolid, yet we can see an almost imperceptible glint of gratitude in their eyes.

According to Sanmu, this woman is in the process of investing. She pays for a round of prayers, hopefully to receive the group's wishes for her protection, just like we

do in our churches. For a traveler wanting to return safe and sound, mission accomplished; so that she can come back to her religious heritage, so that the man she loves loves her back. Or maybe she is hoping that her stock portfolio is profitable and she prospers. She could also be praying for a recently departed family member, in anticipation that this beloved passes without harm into the next afterlife as an honorable reincarnation.

I see a little monk at his low table, pale and haggard. His money is under his knees. He keeps his left hand on his heart and his right hand behind his back. This position is clearly different from all the others, almost atypical, and I really have no idea why. So, I move closer and can just make out, hidden in the folds of his tunic, a kitten that he is stealthily caressing. He never betrays himself by stumbling on his chant. Like all the other felines that teem in this monastery, this critter is mangy-looking, with a rough coat. Does the cold weather, the dryness, the low atmospheric pressure cause these "guard cats" to lose their instinct to lick and groom their fur? Whatever the explanation, I can see a manifest lama-feline symbiosis: they are keeping each other warm.

From the terrace roof we soak up the blinding, limpid sky as we scan and discover the old city. A testimony of this unique Tibetan architecture, the tall houses in plain stone along narrow lanes have been selected by UNESCO as part of world heritage. Next to us are four women merrily cackling, while less convincingly hammering the concrete floor slab prior to repairs. During the dark years of the Cultural Revolution, the Jokhang was desecrated, literally almost brought down by the Red Guards, who even included Tibetans. I guess there is a fringe population here, maybe the least fortunate among them, who are not exactly enamored with nor devoted to the clergy. In the 1980s, the Jokhang was totally renovated. Entrusting these women to redo part of the job, hardly twenty years later, doesn't speak highly of the quality of this rebuild.

At the cardinal directions of the sanctuary we see machine gun toting soldiers protected by sun canopies. Each of these elite troops ceaselessly scrutinizes their respective quarter's angle of vision. We try to take pictures of one of them, but are stopped by his sidekick, who is standing two steps behind, armed with binoculars and a Kalashnikov. In the background, a group of Dutch tourists fearlessly sip their Heinekens on the terrace of a café.

Later, we escape into a small Sichuanese fast food restaurant, cameras at the ready, perched on our tables and precariously mixed among our soup bowls full of oily noodles, in hopes of catching a shot of the passing troops. On the sidewalk across from us, behind a heavy chain that is blocking the access to an ancient alley, we see four GIs camping out. They are wearing helmets, ammunition vests and military-style belts cinching up their martial gear: billy clubs, bazookas, machine pistols, field radios, walkie-talkies, you name it. Every ten minutes a patrol passes by, with the recognizable sound of their boots, exchanging military salutes. They look nervous and never smile. The city is under control.

One city, two spirits

After several hours among its walls, we begin to get a mental picture of Lhasa's layout. Two genies appear before us, like some kind of twin-headed capital, Tibetan and Mandarin. I try to distinguish the two influences. At this early stage, it is premature to try, but a risky attempt must be made. We have to if we are ever going to understand this or that character of the city.

The Chinese city: China has imposed its modernity. High-rise urban housing, running water, gas, electricity and pavement. The streets are like a checkerboard, aligned with the four cardinal points and replete with stop lights. There are also telephones. Portables are incredibly popular here. We cannot see one inhabitant, Tibetan or Chinese, who is not toting a mobile. Even pilgrims in their horsemen's tunics and felt caps walk around with a rosary in their left hand and a GSM phone in their right.

There are scads of shops selling everything under the sun and every service imaginable. Alongside are craftsmen and street vendors on the pavement. We can see that the ancient Tibetan taboo against money has been shattered. It seems like every trader from the lowlands has set up business here, from bakeries to supermarkets, from apparel to manicures; there are plastic surgery clinics abutting antique shops selling replicas.

One side of the coin: all these businesses' signs are in Mandarin. The Chinese characters are in a pervasive font with loud colors. These signboards apparently have two announcements to make. One is to sell what needs to be sold and the other is show off the dominant language under this Tibetan sky.

There are the rare shopkeepers who respect the laws about bilingualism. They add the Tibetan translation below, in small font. This logic breathlessly trudges on the Tibetans' dignity, in the same way as the soldiers who are armed to the teeth.

Juxtaposed to the Potala, we see the small, sacred "Royal Medicine Hill." In days of old, it was dedicated to the Healing Buddha and protected by a wall. Before 1959, anyone who dared traverse the wall would be executed for sacrilege. Today, these kinds of preoccupations are undoubtedly more limited, but not by much. It is coated with antennas and pylons and serves as a logistical base for military communications. In modern Lhasa, anyone who now tries to climb its walls will be arrested for being a spy.

Thus, China has accorded itself a double mandate over these highlands. One is to enrich the daily life (starting with all the new immigrants) here, as well as subjugate it, make it forget its past independence and the hopes of instilling a nationalist conscience. I get the feeling I am seeing before me a big socioeconomic lobotomy being performed, where the locals must lose the memory of their past. They are participating in this grand project of new boulevards piercing through stressed-out neighborhoods that are baptized with Chinese names as ironic as "Beijing Street," "People's Avenue." It is a place where Tibetans can no longer recognize themselves and the young are growing up "in China." It is no different from the Algerians who

found themselves abruptly in France in downtown Algiers, or the Shanghainese who suddenly discovered themselves in various parts of Europe, according to the architectural style of the concession that they were walking in.

China is paying a high price, without begrudging this program of integration. Remodeled and reequipped, Lhasa demonstrates that the nation wants to give itself every means of succeeding. Every year billions of yuan course all across the province, drawing on the public treasury, which so far has not been compensated by (emerging) exports of raw materials, nor yet any of the few local agricultural products available. Eighty percent of the local administration, they tell me, is Tibetanized.

Beijing applies the same "republican" rules to the Top of the World as it does to the other 30 territorial entities that make up the country. And here may be where the problem lies. When the Hans arrived 60 years ago, the Land of Snow, like next-door Muslim Xinjiang, was ethnically pure and very different than lowland China. To submit is to disappear. Both the Tibetans and Xinjiang's Uighurs reject this domination because it comes with a dismantling of their ancient social orders. And from a religious point of view, for these peoples (at least those of the older generations), this is sacrosanct. Unfortunately for them, the Chinese state, the regime in its current form, does not tolerate these protestations. In the face of their dissidence there can only be one response: force. This is in spite of the fact that – according to the most enlightened experts – just a symbolic concession, a token hand towards self-

rule in the spiritual realm would be enough to reconcile everybody concerned.

The Barkhor Market

The Tibetan city is what is left since the advent of the Chinese tsunami. Its foundation is built on architecture, beliefs, traditional craftwork, and above all their faith that has slowly and stubbornly developed across these centuries of rarified air. The best example of this in Lhasa is the Barkhor market, where we are spending the end of our afternoon. The inclusion of old Lhasa on UNESCO's list of world heritage sites has not stopped a considerable amount of destruction and reconstruction. We see wild architectural styles, apartment houses, villas for high-level officials and captains of industry.

Hundreds of little shops and boutiques form an enchanting labyrinth where Tibetans pile in to buy and sell thousands of vegetables and local products and, above all, handicrafts. From tailors to coppersmiths, goldsmiths to leather shops, there is everything necessary to make and repair horse saddles, pack saddles for donkeys and handmade boots. Milliners work on fur and felt bonnets, caps, chapkas and cowboy hats. Replicating the atavistic motions of their medieval counterparts, the weavers sew tunics and jackets necessary to survive on the icy plateau.

Around the sanctuary are also camped artists who are making a huge effort to revive the past. Some of them dream of making their fortune and to follow in the footsteps of their Chinese homologues, who are very in vogue right now in the galleries of Paris, London and

New York. Others are chasing a chimera to recreate the collective soul of the place and are attempting to translate on their canvases, in this age of Tibet-on-the-internet and trains to Beijing, *tangka* paintings. The techniques are unevolved and archaic, but they are looking to capture once again the grand emotions of spirituality, the terrors and 107 tortures of hell, and states of ecstasy immersed in materialism, languor and peppered humor. Others still, more craftsmen than artists, are left stranded without any clients, holding onto thousands of dubious antiques. These include alms bowls, lathed out of walnut burl wood, silver plates or objects, votive statuettes freshly pulled out of their molds and put on sale. In brief, whatever fell out of the truck!

The soul of Tibet is frozen in this religiosity where theology intermingles with the specter of death and spectacle, theatrical oaths and pilgrimages. Pilgrims come late into the night, often from very far away. Their processions are without end, filing around us with their celebrated swaying march, where they fall flat on their faces (of course breaking the fall with their hands) and pull themselves forward with their arms, then curl to stand up again, only to repeat the arduous, humbling process three steps later. They come from the mountains all around, from all the counties of Tibet, accomplishing distances of more than 1,000 kilometers, replicating again and again this inch-worm ballet that can take weeks and months to finish. We can see some of them with their wasted and shredded tunics, as a result of scraping their bodies along the ground, as was observed at the beginning of the 20th century by Sven Hedin[8]. They wear white, wooden blocks on their hands, kind of like sandal clogs, and they are worn thin from the shock of pounding the pavement on the hard clay paths. These shock absorbers must be of little consolation for their joints and ligaments, what with the pounding repeated many thousands of times. Yet at the same time these souls on their long march, with their spindly bodies, seem to be extremely fit. One of them tells me they have no backaches, stiff necks, colds or flu and that their pilgrimage is a recipe for tip-top health: a Lamaist trek for hundreds of kilometers, three to four kilometers high on the Top of the World!

From a theological point of view, I was told, their prostrations have nothing in common with the Chinese kowtow, which is a sign of submission. The prostrating Lamaist approaches a statue or a Lama master as a philosophical symbol of what they embody. They are actually addressing their own spirit through the achievement of sagacity. To put it another way, the prostration actually ensures their freedom. Arriving in Lhasa with that faith that moves mountains, they finish their journey by going through three hallowed circuits, around the Potala, the Jokhang and Barkhor. These routes are punctuated with a series of prayer drums. They are shaped like big cylinders, made out of brass and vertically mounted so they spin from right to left. They are lubricated with *dri* (female yak) butter and propelled by the faithful, who spin them on their steel axles mounted in porcelain hubs. Indeed, the hubs can also be made out of a tibia or femur bone, sawn to form. Each gyration counts for one "Om mani padme

hum[9]," which is the mantra of compassion. It is chanted for the benefit of the deceased, offering them several days of indulgence.

The pilgrims can expect to be stopped by beggars with every sort of unimaginable deformity. Each mendicant controls a section of their route and imposes on the passers-by, with groans and mumbling, the granting of an offering. Right in front of me I can see a well-dressed, attractive Lhasa woman of good standing come forward and hand out to these poor wretches one-mao[10] bills. She pulls them from a bundle specially prepared for the effect: thusly demonstrating a long experience in the exercise of charity.

I try to follow her, but one of the supplicants blocks me, demanding his due. However, not having the foresight to be put in this situation, I have nothing to offer him. I work my way around him, holding off assault. It is a legitimate defense, but a little tacky. For several dozen meters the wretch pursues me with revolting gurgles and avenging grunts, cussing me out and looking for retribution. A true connoisseur of Tibet, Jean Paul Ribes, assures me that this kind of marauding panhandling did not exist under the old regime. This is just one of the undesirable facets in the face of money's ascension under the new one.

To finish our brief visit to the spirit of Lhasa, I can already divine what separates these two communities, each cause being mutually to the exclusion of the other. The Chinese side has its conformity, its spirit of discipline and it's *a priori* sense of ethnic superiority. On the Tibetan side, we can see desperation, growing in unison with the Hans' rising economic and social control, with their hands on salaries and prices. Tibetans are suffering a loss of their self-esteem, the disease of every conquered culture on Earth. A certain section of Tibetan society, the best educated, are working for these new masters. It might be for political ideals or because the life offered by the Chinese is acceptable, with a job, salary and social security. In short, all things that were unknown to them in the past, they can now add up on their own account. But this does not necessarily denote cowardice. In fact, it could be just the opposite, a form of heroism. In the case of Sanmu, our interpreter, I do not see abasement, but the aspirations of a promising career and a chance to better serve her people. Her job is probably her best opportunity to make up for centuries of postponement.

Placing their bets, these Tibetan collaborators are making compromises and developing a sense of loyalty to the occupiers. Within the bosom of their community, they may be looked upon as traitors by those who hope one day to regain their freedom. And you can understand how they feel. This afternoon at the Jokhang, I saw for myself some hostile looks by the monks for Sanmu, as well as an embarrassing ennui, on her part, of someone who would rather be elsewhere. I can feel in her soul a painful divide. This gash will remain as long as there is this civil war. This division will remain alive for the king in exile, the absent pope who is still living in all their heads, the Dalai Lama.

FIFTH DAY
WEDNESDAY, 24 SEPTEMBER, LHASA

Today, we start bright and early by visiting various local administrations and some of the projects they have carried out. We begin at the University of Tibet, five of us in two rustbucket taxis. The place is well guarded. We wait for a quarter of an hour at the front gate, in front of a little table with a couple of Cerberuses in khaki, checking out our travel permit. One of them grabs their little black landline telephone to give the director's office the heads-up. An employee comes to meet us and signs the permit slip. He can now assume the responsibility of watching our every move in a sanctuary of socialist wisdom.

Inside, the campus follows the tradition of a thousand other universities in the Middle Kingdom. The vast campus has wide grass lawns and long rows of flowerbeds, with walkways where cyclists are lollygagging along with seemingly no specific goal in mind. We also see the unavoidable morning lovers, the compulsory she-friends, hand in hand. The building that houses the language department is a six-story, angled affair, with no elevator and sporting the color of badly aging concrete. It is not unlike sister edifices that grace the Celestial Empire, exuding a studious, be-a-good-student and impecunious air.

Caidun, a university under surveillance

Our mentor for the day is Caidun Zhaxi, professor emeritus and president of the faculty. In other words, he is one of the political leaders of the place. Our interview takes place in a little reading hall obviously designed for small official functions, furnished with a wire-latticed bookshelf taking up one whole wall, a conference table and a few display stands that shine down on selected precious incunabula and antique manuscripts.

In the hands of Sanmu, I can see on her agenda "Preserving Ancient Culture", the theme of our meeting today, as decided together by the bureau of foreign affairs and the university administration. We only really wanted to take a tour of the faculties, and talk in an impromptu fashion with professors, assistants and students; whoever luck would let us bump into. But in Tibet, with its constant obsession with security, the system fears nothing more than improvisation. Today's agenda is emblematic to say the least. It shows just how much they want to divert us from living, breathing human beings and to isolate us in a safe womb of inoffensive and historical research.

A hard body type, our orator sings without soul-searching his master's lesson. Caidun is small, stocky and swarthy, in a clean, inelegant suit. He is Tibetan, one of thousands of faithful upon whom the regime can depend. Because of people like him, the state can invest

so heavily in a comprehensive education program, from elementary through secondary and onto university level, which did not exist before 1959[11]. All the ambiguity of the system rests on this point. China pays a heavy price establishing in Tibet an integrated system of education that did not exist before. And the state does it according to its own methods and values, with absolutely no freedom of thought or any leeway allowed. It is understandable, since any kind of permissiveness would be exploited for separatist aspirations. They are just not ready to take the chance, at least not now.

In 2007, the 2.8 million inhabitants of the Autonomous Region[12] were offered at the University of Tibet four faculties for 3,000 students. In 2008 a new campus was established at a cost of ¥530 million, bringing the number of faculties up to eleven. Along with the previous standard areas of study (language, history, liberal arts), they have now added bachelor's and master's degrees in business, engineering, hotel and restaurant management, plus tourism. It is on these kinds of diplomas that the region hangs so much hope. Now, there is room for 10,000 students to go to university. The plan is that 8,000 are destined for Tibetan boys and girls, with the balance for Hans, Huis, Uighurs and other ethnic minorities.

In addition, according to Sanmu, more than another 1,000 aspirants, among the most promising from the province, leave each year on full state scholarships to the country's best universities. They will come back with sought-after diplomas and, in all probability, be fully assimilated into Chinese culture.

For all Tibetan university students, the classes come in three languages: Tibetan, Chinese and English. Of course, the history classes, one of which we attend an hour after our introductory meeting, are in Tibetan. When we arrive, a talkative assistant professor on the stage is filling up the blackboard with phrases and concepts in their language.

Caidun clarifies that the Liberal Arts department offers four faculties: two in language (Mandarin and Tibetan), one in journalism (in Tibetan) and the last in Tibetan history. Of the 1,562 enrolled, 70% are Tibetan. The vast majority of them study their mother tongue. They are looking towards lower-paying but immediate employment as teachers and professors in elementary and secondary schools. This faculty is rapidly developing and taking wing. There are only 192 seniors. All the others are freshmen, sophomores and juniors. This summer, having just started in 2008, the Liberal Arts faculty got the green light to start doctoral programs in literature and Tibetan history.

One detail intrigues me. Why does the University of Tibet have 20% of its students who are Chinese? Where do they come from and why are they learning Tibetan? "They come from all over," he replies, "to find a job more easily."

But the jobs and the economy are in the hands of the Hans. And in the administration, in this "China of the West," Hans hold huge sway in daily life. Here, all the jobs that count are based on being able to speak Mandarin. Caidun's explication just does not add up. Several days

later, a young professor finally gives me an answer that makes more sense.

"These young Hans are here because they barely got their high school diplomas. They are the leftovers from the admission process in China. Those who have the means and who can afford to go back and retake their senior year and entrance exams do so. But for those who are less well off, which helps explain their scholastic struggles in the first place, their only recourse is to slough off to Lhasa or Urumqi (in Xinjiang), where nobody wants to go. Not that our schools here are bad, or that our student life is any less desirable, if one likes nature and local culture. But Tibet just does not have that cachet. We are not welcome here, and we suffer from a sort of siege mentality. And from an extracurricular point of view, you know, stores, bars and cinemas, it's Dullsville. No student from the big eastern cities, even from the interior provinces, wants to voluntarily come here, be buried under a mountain of snow and live 4,500 kilometers away from civilization!"

In his praise of China's educational advancements in Tibet, Caidun sounds genuinely convinced and sincere as he defends the choices he has made in life: the old Stalinist strategy of pulling his motherland and people out of secular backwardness into the 21st century, while suppressing the liberal bourgeoisie and the theocratic class order.

"The Dalai Lamas never offered us anything," he says, "but 16 centuries of bloody oppression." The mass has been recited. The guy hates the lamas just like there are some in France who detest the clergy. And on the other side of the coin, at least for him, he sees modernity, capital, technology and even contact with the outside world. All of this offers hope and a future, generously dispensed by the Chinese mother country.

I am willing to believe in the reality of this generosity. At this stage however, I do not understand why, in spite of all these efforts, Tibet remains statistically in the cellar among China's 31 provinces in gross domestic product.

Then, I take up the sensitive but inevitable question of how the university reacted to the "3/14" (March 14th) riots.

"We deplore this kind of violence," the rector says, "which put a rapid brake on our economy and on the construction of the new university, because credit dried up. But, the university was not involved in the riots. The students stayed away."

When I ask for clarification, he does not reply in a dishonest fashion. Yes, they stayed away by virtue of force. As soon as hooligans started to torch the stores and the first Han Chinese were beaten to death, the campus was shut down and the students were quarantined, cutting short any temptation to offer help to the rioters.

"These events really worry me," he admits. "There are Hans and Tibetans, two ethnic groups on the same soil. So, we have a new society to build. We have so much to do. The motherland sent us quite a few Han professors who have thrown themselves into their mission, giving everything they have to help us build this motor for our future prosperity. The separatists want to run them out of town. Even if they do succeed, who is going to replace

them? Today in Tibet, we do not have the workforce to replace them. Intellectually, it would be suicide."

The answer is reasonable, but I still object: "Your university is majority Sinophone. It teaches your local students Mandarin in huge doses. What do you say to the Dalai Lama's accusations that you are paving the way for a cultural genocide, where in two generations you will lose your language and your customs?"

"How do you think that our language will give way," he tartly replies, "when we make up 80% of the population? After all, it was when we walled ourselves in our borders under the Dalais (in classic Chinese fashion he insultingly leaves off the second half of their title, 'Lama'), that we came near death. The antidote to acculturation is to open our doors, adopt multilingualism and become cosmopolitan. At the University of Tibet, we are laying the groundwork for all of this."

I save my most uncomfortable question for the last. Do students and teachers have the right to go to the monasteries, to practice their religion? I can see in Caidun's eyes a flash of exasperation.

"If they are members of the Party," he hammers away, forgetting to smile while furrowing his eyebrows, "we advise them not to go. We do delve into religion within the framework of cultural studies. Personally, my intimate conviction is not to believe. We have no business at all to waste ourselves in friendships and closeness with the lamas. On this, indeed, instructions to students have been further strengthened since the incidents of March 14th."

Well, at least things are clear. By the end of our trip, Caidun will end up being the most anti-clerical Tibetan that we meet, but also the most logical and constructive in his defense of the ideas of Chinese power! During our long interview, there is a dominant impression of that ancient conflict among the Tibetans themselves concerning the Chinese question. In the 1930s, the Panchen Lama was master of Shigatse and the second-highest prelate of his Lamaist clergy. His clergy was mixing alliances and spreading its loyalties between nationalist China and the Dalai Lama. And of course, this was the same Dalai Lama who was his political and theological rival. Back then, the rivalry was also between these two cities, Lhasa and Shigatse.

Today on the Top of the World, a minority dreams of independence and the return of the Dalai Lama. However, during our entire trip, I never hear anyone pleading very hard for the return of his 115,000-strong entourage. And for good reason. They were well-heeled and rich, and arguably the most hated class of Tibetans among the folk of herders and farmers.

At the other extreme is the faction represented by Caidun, placing its bets on China.

Between these two the immense, amorphous majority is keeping tabs and trying to get ahead, or at least surviving.

Needless to say, during the entire trip, our dear Cerberus Ms. Sanmu, following her orders, is taking copious notes. When we are outside on the sidewalk, we ask ourselves how we are being graded on this entrance exam given by

the local apparatchiks, nervous wrecks all and obviously on edge because of our impertinent yet fundamental questions.

We pass back through the guard gate with its vigil. We reflect on the students. Except for those glimpsed in the little amphitheater being harangued in Tibetan, we have not seen, in this temple of study and knowledge, one single student.

Dianba, a prosperous farmer

Between this faculty and a local school that we are promised to visit after lunch, we have three hours to kill. We wave down two taxis and cruise along the road parallel to the train track that heads down to China. We are looking to pick out a village of our choice, where the peasants have not been given their lines to serenade us with sweet pabulum. Laurent is also crying for a train to shoot.

And there comes our chance: 40 kilometers from Lhasa, in a wide, sumptuous valley surrounded by dark, snow-peaked mountains, the sky is full of rough-hewn clouds showing off iridescent, mother-of-pearl colors. Here comes Laurent's train, on the move. We have enough time to get out of our cars, jump over a bank and ditch and run up onto the prairie to take a picture of its two diesel engines, fifty freight cars and three passenger cars. The conductor makes us beam like little kids as he blasts his horn several times for us. The noise resonates in echoes from one cliff face to another.

Back to our original goal, Laurent orders his driver to stop in front of a farm. He is attracted to the mountains of harvested grain that are being threshed.

Due to many years of wear, Dianba has wizened skin laced with wind-blown, chiseled wrinkles. He is being helped by a neighbor as he flails away with a wooden, articulated thresher paddle. Rhythmic, pounding sounds ricochet off of a small concrete platform as he slams pods of dried soybeans to draw out and separate the beans. Two women in grey pants and double-layered blouses of vibrant colors (mauve and indigo blue) are at the ready. They sport canvas hats against the intense ultraviolet light offered by the high-altitude sun. They winnow the seeds as clouds of husks fly, oscillating full sieves made out of split bamboo.

Dianba is 55 years old. He owns 2,500 m² of cropland cultivated with wheat, soybeans, rapeseed and barley. I note that our farmer, while speaking Tibetan, mixes in words of Chinese when using numbers and expresses the size of his farm in "mu," the Chinese unit of measure equaling 666 square meters. Apparently, it was about ten years ago that Tibetans jettisoned the use of their language when doing math. "It's normal," comments our young guide, "the money is Chinese and at one point or another all the transactions end up being finalized in Mandarin." Wow, it's unstoppable. Here is another example that does not dissimulate in the face of acculturation.

Other than the land he inherited from his parents, Dianba has some chickens, five pigs, two cows and about 20 yaks and dris. He sells butter from the dris to monks

who in turn sell it for a profit to the faithful for the filling of the temple's butter lamps. This fat is also the indispensable complement to the local tea. Floating on the bowl's boiling surface, it coats your lips and is the best sunscreen against ultraviolet light.

In front of the harvesting site is Dianba's newly built house. His is an example, like tens of thousands of others, of a very controversial provincial program to help housing construction. It was started in 2006. For the anti-Beijingers, it is proof of the capital's duplicity. Then there are others, like our guide, who see in it signs of wisdom and generosity. Every Tibetan resident, provided that they comply with esthetic norms, which are strict but in keeping with the local style, can get provincial financing for half the cost of home construction. It is through a local credit union that the money is loaned, interest-free and to be paid back within three years. Of course, behind the credit union, you can feel the grip of a central government that intervenes throughout the whole country, bailing out rural credit at the cost of tens of billions of dollars per five-year plan[13].

Detractors, especially overseas, reproach China for its real estate investment program. They claim the real goal is to make the herdsmen and shepherds sedentary, to better control them and to reduce the movement of arms, messages and secessionist teachers.

Lhasa and Beijing each reply that they only want to provide the nomads with a lifestyle that is more comfortable. All the while, they are embellishing their campaigns to invest in a future kind of tourism: to sell – to rich Beijingers and Shanghainese today, and tomorrow to Osaka and Sydney – this Tibetan mirage, this mythical paradise and symbol of natural purity for the soul.

With its two stories of heavy stone and its belt of multicolored wood around the balcony and two extended wings, Dianba's house does have an allure of pride.

Any way you look at it, his lot is evidently better than living in the neglected and pitiful environment that too often meets your eyes in Chinese rural areas, betraying like a Freudian symptom their lack of resource, of hope in the future and in themselves. After seeing ten, 20, 100 houses like Dianba's, all tastefully done and built carbon-copy in the exact same model, a new impression begins to complete the picture. It is a picture implying a public intervention that is going too far. This gigantic housing program comes across as overwhelming and indiscreet. Even if the beneficiaries are a homogeneous ethnicity, I have a hard time convincing myself that these farmers and ranchers are so conformist and not wanting to escape from this impersonal program, these identical houses rising out of the Top of the World.

It is easy to criticize the cost of this program. Each house costs ¥50,000, according to Dianba, which is a lot of money for this territorial enclave, an area lagging in last place in China's list of wealth. Dianba admits that his monthly payment is ¥1,700 per month, which is four times the average Chinese farmer's revenue. So where do these sums of money come from? Even adding in his wife's unpaid work and the sale of dolls, alms bowls and prayer drums (the same ones we can find in the market

at the Jokhang), all handmade by the family during the long winter months, how can this farmer honor his debt? He replies curtly in a sibylline fashion, telling me that he "does not have any problems." There might be another explanation: during these times when the economy is at low tide, due to economic activity dropping off dramatically since the March riots, the province may have received orders to not foreclose on farmers who are in default on their mortgage payments.

Things are going so well for Dianba and his wife that they look forward to investing in a small tractor to work the land and transport their crops, vegetables and yak butter to market, like the one we see going by behind us, carrying winter forage on its hitch. Taking it all in under this autumn sun, Dianba and his wife seem to be a happy couple and an economic success story. This is so different to what we saw 48 hours earlier, an hour's distance from here, where thousands of farmers were losing their harvest. Tibet is big and its conditions change from valley to valley. Dianba's prosperity could also be because he is a "suburban" farmer, being so close to Lhasa. He may get a better price for his products compared to his brethren in the hinterlands of the province.

This visit leaves me with mitigated feelings. I must truthfully admit that the farmers I have seen during all my travels across rural China, with their progress in technology, legal rights and finances and who have started from the lowest levels of society, are getting better off. Of course, behind all this are the efforts of the regime, in its national plan, to bridge the growth gap between the cities and the countryside. They want to avoid any massive, angry peasant revolts. Thirty years after the fall of its Soviet and Eastern European older brothers, Chinese Communism is having a try at implementing its own "goulash democracy" of credit and equipment programs for farmers, while since 2006 abolishing all rural taxes.

But there is another side of the coin. Tibet lives with crushing censorship and surveillance along with almost daily arrests of monks and laypeople, which we can follow on the internet. These shortcomings scream out about a model of growth that is fragile and artificial, with the locals never being consulted in the process. Its genesis comes more from state or party fiats than from the demands of the people. In the age of sub-prime debauchery and the specter of a worldwide depression on the horizon, can these subsidized projects make a go of it? The carrot offered by the state to renounce a life of nomadism is to give these shepherds and herdsmen land and credit so that in turn they will build farms.

It is at this exact juncture of thought that another train rolls by at rather high speed. Its apparition reinforces the ambiguity of this program. The train rumbles by and lets out a blast from its horn. It rends this plateau lying at the base of snow-covered mountain chains before disappearing like a mirage. The universe slowly returns to its wall of silence – and to its past too?

Zhuoma, the model school

After the morning in a university missing students and then agriculture in the countryside, we start our afternoon

at the Experimental School of Lhasa. Its ambience is altogether less distant and formal. We are greeted by its director, Zhuoma, who is a comely woman sporting curly hair. She greets us all, smiling and voluble, like a professor from the West who has nothing to hide.

Zhuoma is 50 years old and spent 19 of those in front of a blackboard. She is the daughter of parents who rallied around the new regime. She was one of the first here to be sent to a university outside of Tibet – to Lanzhou in Gansu, 1,500 km to the east. Once she got her teaching diploma, she returned to Lhasa in 1981, a pioneer teaching a new bilingualism at the behest of the Sinified masters of Tibet.

Her school was opened in 1962, three years after the takeover. It is spacious, modern and well equipped, as well as experimental. It is also a showcase for Chinese socialism, something that can be shown to visiting guests.

The classrooms are of modest size and chock-full of kids aged six to 12. The rooms are well lit and well equipped: modern desks, nice notebooks and overhead projectors. Some classrooms have one computer for every student, with internet connection.

The playground is big, but not that big, and always occupied by teams of children wearing turquoise blue uniforms, red neckscarves and yellow baseball caps. They are spaced out in checkerboard fashion filling up the space, following the movements of a whistle-blowing instructor. We feel here an absence of the joyful brouhaha of all school playgrounds in the world, even of playgrounds in China. This scene is unexpected in a territory that is almost twice as big as Texas. The school is way too small and cramped. There are no playing fields and in order for all the classes to get their obligatory exercise time, the students must go in shifts. But in fact, this is the same all over Lhasa. The city is squeezed in between its mountains and protected areas. The city center is dominated by the Potala, sitting on a precipitous peak. So, in fact, the city has pretty much exhausted its virgin spaces.

At the Experimental School, the number of students has risen in hyperbolic fashion, from 600 in 1995 to 2,185 today. This explosion is the result of primary education being declared free all across China. The act was signed by president Hu Jintao in 2003 and it was one of his first directives. The cost of classes, breakfast, lunch and room and board are paid for in regions that cannot bear the cost. Since the 2000s, China has been rich enough to launch this kind of social investment, the same that France instituted under Jules Ferry, and the United States did country-wide in the late 1880s.

But this school, built in downtown Lhasa, has no place to grow. The classroom we are visiting is designed for 30 students, but now welcomes 60. Hans and Tibetans, eight years old, struggle side by side on the Tibetan alphabet. Each one is sitting behind his or her tiny desk, anxious to save their motions in studious ergonomics…

The kids are well behaved, but discipline is imposed with an iron fist. There is no impertinence, no independence, everybody obeys. It is the price paid for this unique education to be found in the province. These Hans and Tibetans who are thrown together must be credentialed to

get in. And keep up they must, starting at six years of age, in three languages: Chinese, Tibetan and English, just like at the university.

For the nearly 2,200 students there are 154 teachers, pretty equally divided by their respective ethnic groups. Tibetans and Hans receive the same pay according to grade and years of service. Salaries start at ¥3,000 for first-year teachers up to ¥7,000 for the director.

According to national education standards that follow economic dictates, the mantra of "march or die" is no joke. From first grade onwards, 20% of the students are sent packing through the winnowing process of a brutal end-of-year exam. Their places are just as quickly filled by new arrivals who, according to their files, are qualified to attend.

To carry the load, like everywhere in China, the tradition is pitiless. The only choice is to hit the books as soon as you get home and burn the midnight oil, only resting to eat dinner. Even the youngest students go to cramming schools where competitions like "Math Olympics" lead to even more "voluntary", complex and arduous after-school studies. Crybabies need not apply and this Spartan system just gets harder as you get older. In Tibet, it is even more ferocious than in the rest of the country. The mentality is like a boot camp or kibbutz.

For the Han students living here, the hope is to go back down to the lowlands and end their punishment of exile. Keeping the pace, at 12 years of age 100% of them pass the admission test to get into middle school, compared to only 50% in the rest of the country. Like in the university system, the cream of the Tibetan crop hits the jackpot: a full scholarship and room and board at the best schools in Chengdu, Beijing or Shanghai. For the Tibetan students, their future employment for the nation will be assured when they return to the fold. And there is an added, cost-free benefit. This flowering of local intelligence will grow up separated from parents and monks. They will be vaccinated in a Communist hatchery, resistant to all the pernicious influences of religion or secession, and even invigorated with a strong sense of Chinese nationalism. Sanmu, our guide, is a good example of the fruit borne by this educational tree.

I notice here a perception gap among the immigrants. The newcomers see in Tibet job opportunities. But students and cadres tend to lament their exile as a kind of destitution comparable to the Hebrews' slavery in biblical Egypt. Civil servants have commonly been here for 20-30 years without having chosen to come. Their children neither. Though endowed with perks, they resent the loss of their homeland like a lost paradise. As for the latest migrants, they are often close to illiteracy and were underdogs in their home provinces. Here in Lhasa, they may hate the locals (who pay them heartily back – no love lost here), but they welcome this new chance in life.

I repeat the same question that I asked in the morning to the president of the faculty: "Did the children experience at all the riots in March? Have you detected among your brood of Tibetans and Hans any ethnic tension?" Of course, the expected answer is "no", but a no that is reflected upon, professional and quite plausible.

"We have not seen anything like this. At this age, their hearts and souls are no different. Even we teachers, we don't see Han or Tibetan, just students who we teach together and who we all love equally." It is an authentic reply from a saint of a woman who is all professional. For her, the ideological bent is of course ever-present (otherwise she would have failed the test that got her this position in the first place), but the light of humanity that she emits transcends the point.

I have another difficult question that intrigues me: "Tibetan or Han, is there a group that separates itself as more intelligent, more studious or even better artists than the other? Is there a distinct genius for either group?" Again, Zhuoma comes through with a smile and the benefit of doubt: "No difference. For each subject, the best fall in one camp or the other. It is unpredictable, and much better so. Can you imagine if we found ourselves with one intellectually superior race, what a nightmare!"

However, carried away with her enthusiasm, Zhuoma shows a slight sign of indiscretion with her irresistible and contagious sincerity: "The Tibetans are maybe a little better at languages, since they have to learn three languages from the ground up. Whereas the Hans are not required to take the final exam in Tibetan, which *de facto* makes the course easier for them."

We are invited to hear the chorus class for the next-to-last-year students (10 years old), who treat us to a song. Not at all lacking in pride, the teacher pulls out of the ranks their star singer who interprets for us a romantic piece. The boy emits a number of squeaks, due to the key being way too high for him, as well as his nervousness of performing in front of us.

Here is a pretty curious detail. The singing in the Tibetan monasteries that is cultivated among the men, even among adolescents, is extraordinarily bass. It is a timbre that is never heard in western countries. We were allowed to hear on several occasions during this trip the songs of children or women. And in every case, the key is so high as to seemingly damage their vocal cords given the strain applied. The pitch is insufferably sharp, inharmonious and at full volume, hardly likeable even in small doses. In any case, that is the important thing to notice: for both women and children, the style of singing and its phonic traditions are decidedly Chinese and not Tibetan.

No matter, in the music room we savor a delicious moment of innocence and for the kids, a kind of honor greater than singing in front of the academic judge. Just the thought of it: to perform in front of strangers in this province that has been cut off from the rest of the world for six months.

I relive a last detail of this precious souvenir as I write. The music room was full, with two-thirds of these curly, black-haired heads being children of the Land of Snow. Yet, the two solo songs that we heard were from the Middle Kingdom – Chinese tunes and Chinese vocal techniques being sung by Tibetans. No doubt about it, what we have here is a case of cultural erosion.

At the end of our visit, and according to the immutable rules of Chinese and Tibetan politeness, the director herself accompanies us all the way out to the school gate. There,

she personally ties around each of our waists a *Hada*. It is a white rayon scarf given as a goodbye gift and is a sign of good luck.

It is 17:00 and time to leave. Several hundred students in turquoise jackets and saffron caps scream and run in every direction, finally able to vent their energy without being slowed down by their pioneer red scarves. For one brief moment, they have the freedom to be children like everywhere else in the world. They snort like bucking bulls and unload from their young backs the heavy workload of long hours of formidable obedience.

But not for long. The grownups perform their last task of the day. To keep safe this unfurling sea of children floating towards the traffic-packed exit, they make a human fence, locked arm-in-arm, guiding the students along their manmade passageway, the length of the sidewalk. After their brief eruption of freedom, the students instantly line up with a serious and composed attitude, pouring themselves back into their casts of discipline. Walking side by side in pairs and holding hands, they gab under their breaths for the next 50 meters, where they finally split apart and return home alone.

"But where are the parents?" Brigitte asks surprised, exhibiting the reflexes of a mother. Good question. Very few mothers and fathers are here waiting for them. This is in spite of the fact that the traffic is anarchic and risky to the students, many of whom probably live far from here, since the school recruits all over the city. We have to suppose that they are unable to apply themselves to this natural born task, to come and keep their children out of harm's way: overworked, at the factory, the office or at the store shopping. Also here, there is no free seating, so to speak. To keep a stable job, you have to know how to make sacrifices and prove at any moment your ability to keep your place. To do battle with the high cost of living, no one in Lhasa is master of his own free time, which by chance also plays to the advantage of those in power. It is the "dictatorship of the proletariat" in another manifestation of control, this time using money!

Evening calm

Evening has arrived. Our group is together as our guide has returned to her parents' home, task accomplished.

After a quick dinner, we go back out for an evening stroll. Under wan neon lights, the souk spreads out its treasures of Ali Baba, thousands of clothes, hats, dyed rabbit skins and caps for next to nothing. We see all kinds of teas and local cakes. This is opulence on a small scale.

Under the night cold 3,650 meters above sea level, this hall 100 meters long only vibrates from the shouts of street hawkers playing cards, or their feet pounding the pavement. Besides us and a handful of regulars, the place is deserted.

Four police officers on patrol stop at a stall full of Tibetan shopkeepers, asking them not to play for money. They are teaching them Chinese law: not gambling is a challenge as great as flying to the moon!

SIXTH DAY
THURSDAY, 25 SEPTEMBER, LHASA

We attack our third day in the Land of Snow with a frenetic pace and never let up. Starting out with an opaque sunrise, we hit the ground running. Between our planned program and the side festival we have organized on the sly, hold on to your hats!

The celestial cemetery

7:30 – This morning we slip out unnoticed, following a plot we carefully hatched the evening before for an unscheduled trek: the cemetery.

For a place that has such importance for all the peoples of the world, this spot and its function are structured in Tibet like no other. On every continent and during every epoch, humankind has confided their remains above all to the earth, just like the ancient Egyptians, Chinese, Aztecs, Greco-Romans and Mesopotamians. India and modern China practice cremation, the former by ritual and the latter by Communist discipline and to save precious land.

Tibet has 1,500 years rich in meditation on the exchanges between the soul and the material world, between the living and the dead. They believe in reincarnation, where the deceased is transformed to nature and into other lives, so that the soul goes and occupies a new body that is born. In the case of princes and prelates, a little infant demonstrates to his loved ones the proof of his transmitted identity, the transfer into him from the soul of the dead person concerned, by spontaneously adopting their things and their familiar tics.

As explained by Alexandra David-Neel[14], *Bon*[15] envisages four forms of return to nature. This altruistic restitution is accorded based on what you were lent in your (previous) life. It is a return to your vital self, to the melting pot of life and, in a blindfolded fashion, it distributes among this melting pot the other forms of existence. There is fire (cremation), Earth (burial), water (the body decomposing in water) and air. The latter is called *tianzang* in Chinese ("sky burial") and to work, it needs some help beyond the assistance of humans. The dead body is dismembered, the skull is cleaved open by an expert lama and it is all left for the vultures. This destruction that we find so cruel and devoid of any respect is, on the contrary for Tibetans, the ultimate release towards the heavens and at the same time a passage of energy to other beings. It also affords a final "raspberry," a humorous and truculent snub towards the vices of greed and egoism, human weaknesses both, via the destruction of the bodily materials[16]. The reconciliation hits home in a verse by François Villon:

As for the flesh, that we have fed too well
Is at places devoured and rotten
And we the bones become ashes and dust.

In this Tibetan death rite, only the soul subsists, in its glory of immortality and reincarnation.

We cross by a number of patrols and military posts that luckily leave us alone. Our rustbucket taxi winds its way up the heights, going through suburbs with smoke-plumed shacks, cracking apartment towers and run-down barracks. We go through more and more deserted neighborhoods, and unexpectedly see a mosque and an Islamic seminary, before crashing to a halt in front of a dry riverbed. Its two banks are joined by a bridge with a chain blocking its passage. Written in Chinese, Tibetan and English, a sign has been waiting to tell us that beyond this point, access is forbidden to all non-Lamaist persons, whether Han or foreign.

Several times over the years in China, I have remarked on how much the regime buttresses all the religious minorities. In 2007 at Dujiangyan, Sichuan, a clot of houses cloistered between a cliff and the Min River had been expropriated in order to expand a park registered by UNESCO. The neighborhood was a recent one and had no style to speak of other than all its recycled materials. It had been built, I was told, without the proper permits. From a Chinese point of view, in sum, once the expulsion order was pasted on their walls, the neighborhood was on borrowed time, like "a fish swimming in the bottom of a cooking pot."

But its 50 families made an appeal, which moved up the channels to Chengdu, the provincial capital. It then continued to ascend to Beijing via various channels such as the National Forestry Department and Ministry of Public Security. It landed on the desk of the Prime Minister, President of the State Council and finally went to the Standing Committee – the supreme institution that governs the country. It nixed the decision to extend the park. Why? These families were Hui or Sala, Muslims all. Not that the leaders of the PRC are converted to following Allah. They merely expressed concerns to avoid giving their minorities (ethnic Muslims) the impression of religious discrimination.

Here in Tibet, the government of the autonomous region has found a low-cost way to make the Tibetans feel that their culture is being respected. They protect their funeral sites from voyeuristic Hans, foreign tourists and their cameras.

Laurent and I walk across the bridge and travel several minutes to the foot of a rocky outcrop which is sparsely covered in bushes and scree. Ahead of us is a little hermitage that is at the trailhead. In front of its door are two cauldrons on a bed of coals, broadcasting their vapor – some kind of votive cuisine. We cannot say.

The way is clear, but we do not go that way. Not for fear of official reprisals; our journalists' permits partly absolve us for transgressing minor rules like this. No, it is more that we want to respect the other culture's belief, its longing for peace and private gathering.

We spend quite a while looking at the cliff face and its rocks decorated with egg-shaped multicolored frescos that represent Tsong-Khapa. He was the founder of the sect of Buddhism that wears the yellow bonnets. We make out a series of oblong shapes posed like eggs in a line on the rocky crest. These are the vultures, warming themselves in the pale fire of the sun. Some take off in flight, hanging a few moments in the intense blue sky before disappearing behind a wall for another round at a bloody banquet.

To the right of our viewpoint, a mysterious-looking hanging monastery stretches out along the curve of the cliff face above. Listening to Li Feng, who has the driver's ear, it is an ancient hermitage that was converted during the 1940s and '50s into a prospecting base for the French and British, who had reopened a gold mine that had been abandoned for centuries. After control of Lhasa was taken by the PLA, the site was returned to its former silence, until recently, when once again a handful of monks began to live here.

At the end of the valley and through the morning haze, we can see further onward brick chimneys and stovepipes covering an ugly chemical factory. It is blocking the view of Lhasa's rooftops and the Potala's slotted, proud lines.

Up here, I meet two drivers in 4x4s, waiting on their tourist customers. I introduce myself by saying "Tashi delek"[17], the local "Greetings," and then move right into speaking Chinese with this discreet aside, "We are here to write about your land. How are things with the Chinese? Would you like to talk to us?" They immediately stiffen, smile awkwardly and proceed to take off. I went too fast.

They have too much to lose and nothing to gain. They have surely already suffered enough, learning to never trust anybody again.

Ba-Yi, a huge khaki market

9:30 – We return to the city center after this escapade, stopping at the forecourt of a big store called "Ba Yi," which means "August 1st." This date evokes the founding of the People's Liberation Army in 1927. In fact, the building is owned by the military. This kind of relic used to be everywhere in the big cities along the coast. The military could not resist jumping on the bandwagon of business success. But in 1997, the government ordered the military to divest itself of its lucrative business enterprises. All across the empire this directive was respected[18]. It was only ignored in backwaters like Tibet and Xinjiang, where it is the army that is truly in power and the mentality of the people continues to collect dust.

Here, we can savor the scene of a delicious anachronism. In the history of China, we are now 20 years in the past. Several minutes before the cash registers open, the 80 little tellers, who by the look of their faces are majority Han, go through their obligatory morning calisthenics. None of these ladies are more than 25 years old. In sky-blue blouses emblazoned with name badges, they look like they have still not gotten out of bed. They are all yawning, half awake. Flowers of the province, they exude an unbelievable innocence as they unthinkingly execute their movements. They are doing so in time with the strident cadence of a whistle blown by the nasal-voiced leader, who is counting

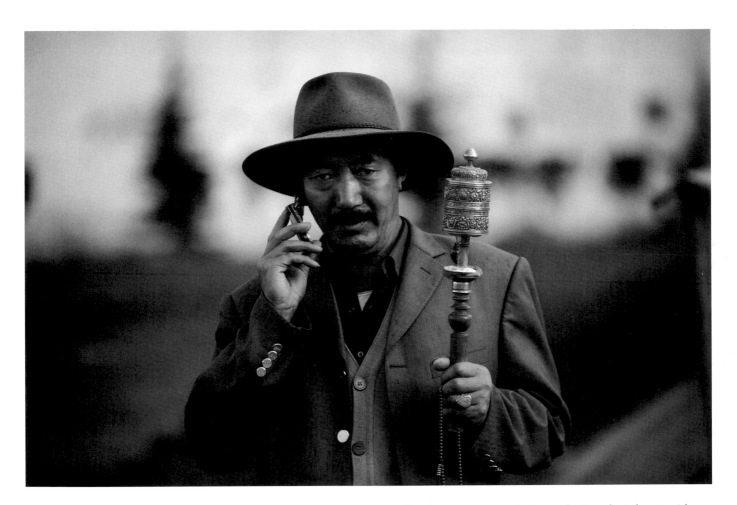

A pilgrim circumambulates the Potala Palace in Lhasa.

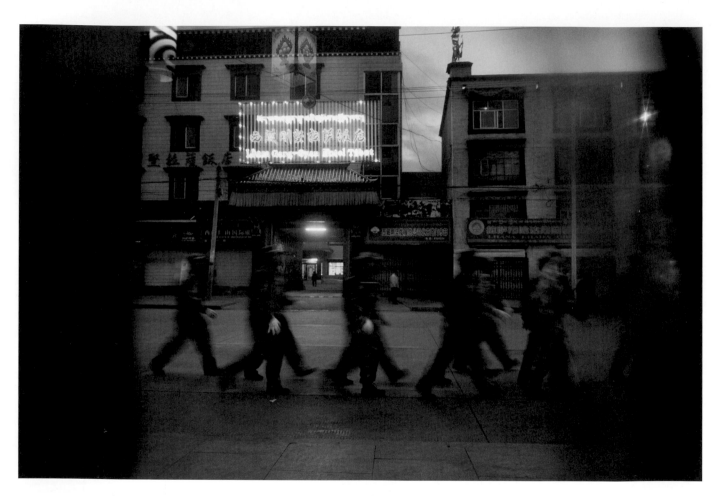

Soldiers make a dusk patrol through parts of Lhasa's Barkhor where shops were torched during the 2008 demonstrations.

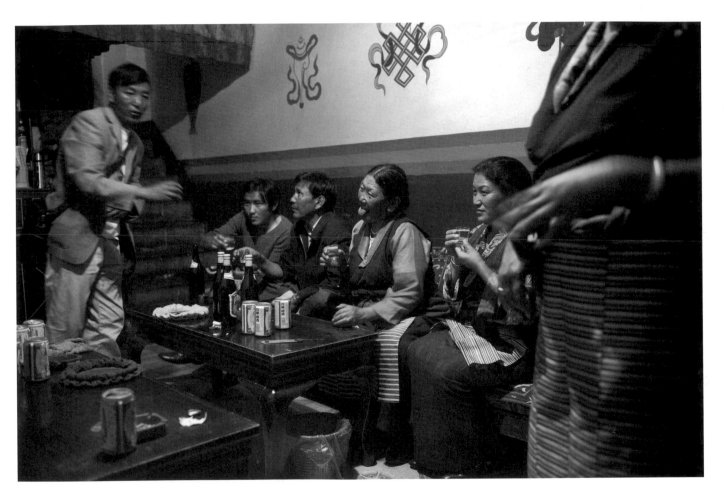

The landlady of a back-alley Tibetan bar sticks her tongue out as a sign of welcome. Lhasa.

Norbulingka Palace in Lhasa, residence of the Dalai Lama before he fled to India. Furniture and plants are kept in waiting for his return.

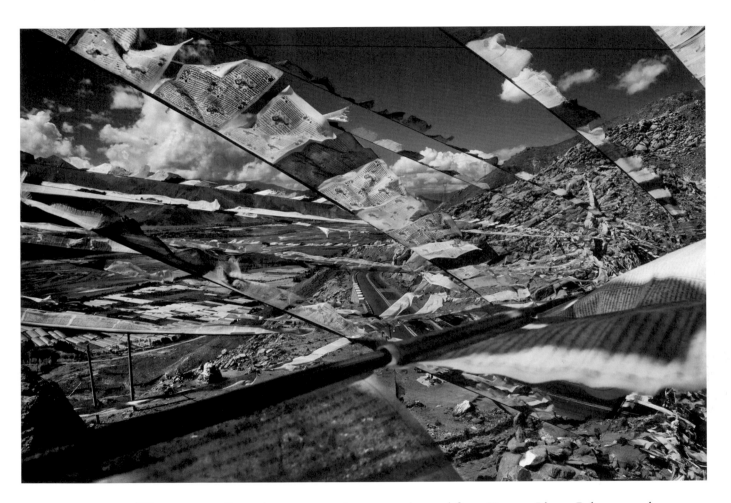

Tibetan prayer flags adorn a mountain pass on the road from Kapa to Lhasa. Below, greenhouses are built on land irrigated by river dams.

A young pupil takes a Tibetan course at Lhasa Experimental Middle School.

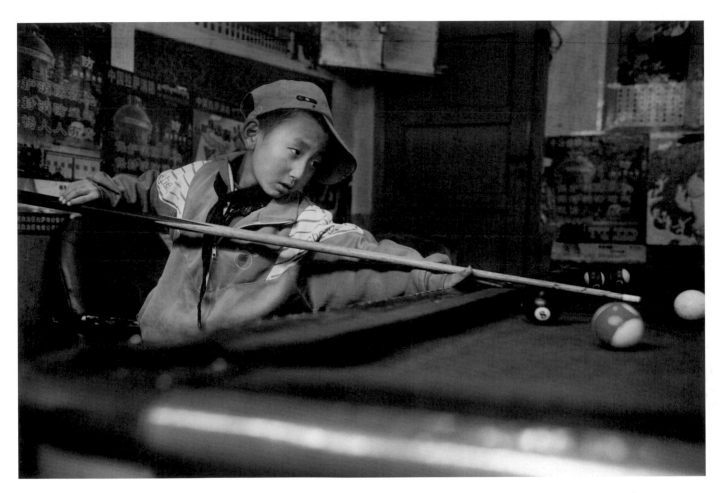

A schoolboy relaxes in a Barkhor shop on his way home. Lhasa.

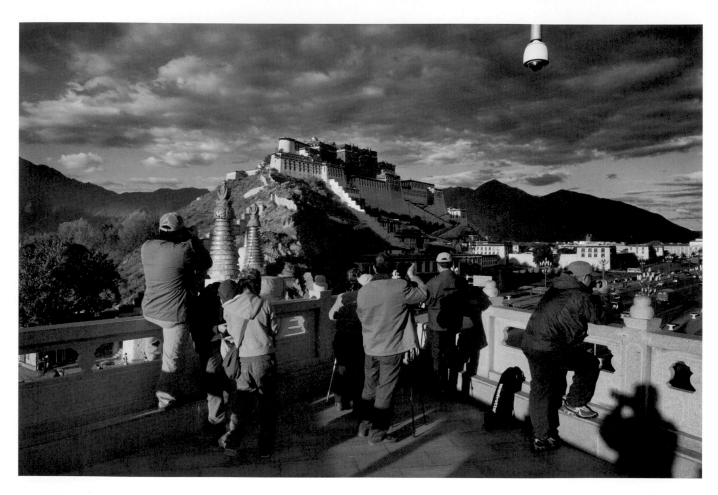

Han Chinese tourists near Lhasa's Potala Palace are watched by a police camera.

from one to eight. They lift their legs and knees, clap their hands and stretch their shoulders in 20 rows, four deep each.

This is the moral rearming of the occupying community here in Tibet. *Mens sana corpore sano.* We conquer because we are better. It is also due to benevolent and reasonable paternalism, the boss taking care of their health, who really has nothing to gain here financially. This is simply Communist morale.

It is also a luxury from another epoch. All over eastern China, this practice has been abandoned. Facing competition from private firms that have jettisoned this kind of unprofitable paternal investment, the state-owned companies no longer have the means to keep it up. In any case, except in Lhasa, the young sellers have no desire to tone their necks and hips. If you ask them, they will tell you they would rather sleep an extra quarter of an hour every morning. But gosh, what a pity that this forced gymnastics has disappeared.

The Water Bureau: "always more"

10:00 – We meet up with Yi Yuanfei. He is a handsome man in his forties, very at ease in his white dress shirt, Ray-Bans (real or fake, who knows!) at the ready in their case. Yi is the boss of the Water and Electricity Bureau. He is accompanied by Huang Jincheng, his colleague from the water department of Lhasa County. Once together, we take off in two 4x4s to go to a district called Dazi. We travel across valleys, arid mountains and over many rushing streams. The road appears to be recently built and is of good quality. It takes its daily beating from the intense sunlight.

What is really remarkable about this valley is the number of greenhouses. They are growing watermelons, cabbage, tomatoes, onions, peppers and potatoes.

"This is a vegetable paradise," Yi tells us enthusiastically, "one of the few places on Earth where the sunlight and water are absolutely pure. We grow cash crops, unlike the old days. Three harvests per year, even one in winter, since the sun is so intense. Three layers of Visqueen afford the farmers excellent insulation from the cold. At night, they roll out a cover made of straw over the greenhouse frames and all they need is a small charcoal burner to keep the temperature above zero, even when it goes down to minus 15 degrees Celsius."

And where are the Tibetans in all this? "It's true," he admits, "most of the greenhouses belong to Hans. But not for long. Five years ago the locals wanted nothing to do with this kind of farming that offended their ethics. In their traditional ways, you should only grow what you need and not make money. And it must be said, it took some time to integrate all these new methods, to go out and find financing. Today, they are ready, they borrow money, sign up for our training programs and with their own greenhouses they are starting to get rich."

Livestock farming is less favorable, given that the animals have to be housed for the six to eight months when it is really cold, and given the difficulty in finding adequate forage on these high mountain prairies. Under these conditions, Tibet can only hope to produce enough

animal protein to feed itself: poultry, lamb and yak meat, eggs, dri and cow's milk.

Yi Yuanfei tells us that Tibet is in the process of getting a special certification for its fruits and vegetables, like the "AOC" system (geographical branding) for wine classification in France. This will enable Tibet to market its produce as "green" when the perishables are shipped to the lowlands by plane or truck. "We are just getting started," pleads our host, "but the market potential in the future is huge."

There are still two limitations: capturing and transporting irrigation water to the greenhouses and the fragility of the ecosystem. These greenhouses are built on the permafrost, soil that is frozen year-round. And as they sit there in the intense sunlight, they are bringing the permafrost temperature beneath them to above zero, with as yet unknown consequences.

At the foot of a mountain outcrop covered in scree, we see a herdsman halfway up taking in the sunlight. He is watching out for his goats and passes his time spooling wool. We finally see why we were brought here. There is a brand new project: a dike that sluices the flow of the Brahmaputra River to take part of its waters into a side canal. It is from this canal that they can irrigate all of this flowering agriculture under plastic.

Between the conquest in 1959 and 2008, the regime has spent ¥13 billion in various construction projects like this, especially in the south of Tibet where the population density is highest. Sixty-five reservoirs and 5,000 ponds have been created, according to Huang Jincheng's calculations. As a result, they have been able to establish 18,500 hectares of irrigated crops. Eventually, there is ten times more land than this that can be irrigated as well, so expansion of these high-quality crops is assured.

Hydropower also provides 80% of the territory's electricity for its 2.7 million souls. Two-thirds of them are urban inhabitants. The others are villagers, and further out they are not on the grid. Tibet's 6.08 megawatts of annual electricity production seems paltry when one nuclear power plant can generate 1,000MW. This is because 80% of local generation is produced by mini-plants. They are numerous (167,000 of them), but of very low capacity.

This could be the keystone for agricultural reform in Tibet: consolidation. In this district hundreds of farmers have combined their land resources and have created 35 cooperatives of more than 660 hectares. This allows them to mechanize their farming as well as put in large-scale greenhouses. But elsewhere on the plateau you mention consolidation and they see a stop to rights of passage (for their herds). This is a huge shake-up of their traditions and our hosts are careful when they talk about it. But we will come back to it later.

Another local problem: the rivers and streams flood each spring with the melting of the snows. And it is only getting worse with global warming. As a result, 557 control dikes have been built via tried-and-true Chinese fashion: the state provides the materials and as a form of drudgery, the inhabitants do all the work.

For potable water, Tibet still has not gotten past the 1.4 million mark, or a little more than half of the population,

and of course most of these citizens are in the cities. According to the plan, every village was to have potable water by 2010.

When it is time to say our goodbyes, Yi suddenly looks like he has something to add. Beyond the image of a competent and dynamic technocrat, he also gives us the impression of someone in love with his life and his land. He divulges an unexpected surprise. He is Han through his father, where he gets his name, but his mother is Tibetan. So he floats back and forth between the two cultures. By day, he works in Mandarin. By night he is Tibetan with his childhood friends.

Relationships must not always be easy for these buddies. His friends never forget that he is a well-connected member of the party. They all laugh together over beers but they also depend on him for getting plugged into the water network or for permits to install their own pumps on creeks near their homes. But an official he remains, and they are not going to tell him everything that is going on. Still, I can imagine that among Tibetans, sharing the complicity of their language that remains out of reach for the Hans, there must be ways to get along beyond the faith jealously demanded by the new regime.

I suddenly have an intuition about a second generation of high-standard immigrants, sons of cadres: no longer Hans, not yet really Tibetans, this semi-privileged class acts as an interface between power and street. Life-loving, they let those mountains perform their magic on them. It is as if Tibet were a mother for all the peoples and all the cultures that pass by, welcoming them and absorbing them, like sand pulled by waves.

The Environmental Bureau: "always less"

15:30 – We return to Lhasa and Sanmu guides us to a banal-looking neighborhood made up of long buildings constructed of cinder blocks. There are little bars painted in many different colors, all of them shabby. This quarter pends gently down towards a marsh. Lhalu is the discreet holder of a handful of world records: national park at the highest altitude (3,650 m) and largest national park inside a city (6.2 km²), among others. At the welcome gate we meet Zhang Dongzi, a barrel-chested man in his forties, whose haircut is brushed to make him look younger. He is responsible for the region's environmental protection. Starting in 1997, Zhang immediately felt his calling, his life's mission. "After being here for three years," he explains to me, "I knew I would spend the rest of my life here."

Taking in the view of Lhalu, we can appreciate how he feels this attachment to the place. It is a wetland ecosystem that Zhang credits himself for saving from destruction. Next to him is Qu Zha, a hulk of a guy with a good-looking head of Tibetan hair gracing a plump, puffy visage. Qu never stops smiling, even for a moment. Qu has been the Lhalu park director since its creation in 2000.

We are on a panoramic terrace made out of wood. It allows the observer to see the countryside and aquatic fauna that inhabits this swamp. All around us are bogs and canals full of limpid water. There is no construction between us and the formidable mountain in the background. At its

foot are a few sparse clumps of trees. In some places there are bunches of greenish-pink plants mixed in with mauve-colored bushes. This plant life serves as a lazy obstacle course for an amazing array of animal life, including 125 species of birds observed in Tibet. Slowly, with long and prudent strides, cranes with black necks and long, graceful, off-white bodies stroll around. They are called "Heiyinghe" in Chinese. They are accompanied by swimming ducks that are grey with red stripes ("Chima"). These ducks are busily dredging the muck, searching for their meal of larvae and worms.

Between now and the end of October there will be the first days of cold weather and the bird population will take wing on its autumn migration to India or Bhutan, 700 km to the south.

Lhalu has come back from the edge. For more than 30 years (1966-1999), it was the backdrop to a disastrous, human-conceived ecological program. Revolutionary ardor was in the air, along with agricultural fervor, and they combined into a Maoist dogma of self-sufficiency. Bands of Red Guards came and took to the task of diverting the streams and creeks in order to dry up the site. It took just a few months of forced labor by the inhabitants to pull it off. Deprived of the Buddhist faith's secular protection, as well as the Dalai Lama's police, all the fauna was massacred and its habitat was replaced by farm barracks full of people's communes. The great expanse was sectioned out with lines drawn to grow revolutionary wheat.

Twenty years later, under the rule of Deng Xiaoping, the people's communes were abandoned, giving the peasants

their liberty. But the fields of Lhalu were full of depleted soil whose nutrients had been exhausted. All that was left was a wasteland where the wind kicked up dust devils of yellow dirt. The most desperate nomads built huts there. All that began to change when in 1999, Zhang Dongzi was mandated by the Ministry of Environmental Protection and the Academy of Sciences (his guardian authorities) to re-establish the wetlands and create a nature reserve. A lot of work had to be carried out. It took a year and thousands of maneuvers, buying and installing ¥90 million worth of pumps using the central government's purse. "We had to move out the 15 families who had built on the land," Zhang remembers, "and once the flow of water was re-established, the flora that had survived further away came back."

Since then, the Lhalu wetlands have been divided into three zones. The area along the mountainside is considered the "heart" of the park. It is the wildest area and now totally off-limits from human contact. In the center of the park is the "buffer zone." It can tolerate occasional incursions. Along the edges of the town is the "periphery." Here, the park is open for the price of an entry ticket for nature lovers or just plain lovers longing for privacy. The park proceeds with small-scale husbandry and agronomic experiments, like new crops and animal rearing in cages. There is still one hideous scar: a line of high-tension pylons that runs across the swamp. "It would cost a fortune to bury those high-voltage lines," sighs Zhang, "but we will get there one day."

Under Zhang's direction, Tibet has converted 34% of its territory into nature reserves, an area equal to the size of Italy. These parks now number 45, including Qiangtang, which is 29 km² of plateau and mountains where wild yaks and Chiru roam. Unfortunately, these antelopes are illegally hunted for their wool, which is made into "Shahtoosh" scarves. These sell for thousands of dollars each on the black market.

Five years back, a team of wardens was assassinated by some poachers they had found in the act of exterminating an antelope herd. "We caught them," says Zhang, being stingy with the details. But we can assume that following their arrest, only one punishment was possible: death, preceded by a hasty trial.

Thanks to this policy on parks, the Top of the World no longer has any species on the verge of disappearing. Those that were on that path, including the Chiru, a golden-colored monkey and the wild ass, are seeing their numbers going back up, defying the death grip of extinction.

Unexpectedly, our director voices the contradictory view that these measures have become excessive. No longer hunted, wolves and brown bears proliferate in their natural high mountain habitats (which in turn are being encroached upon by the pressure of human expansion). Not finding enough to eat, they attack livestock in broad daylight, while antelopes and wild asses graze on the crops, totally unfazed by the scarecrows.

When the reserves were first created and the fauna was placed on protected lists, the villagers protested every perceived deprivation. They would come into town with their bloody livestock that had been killed by wild animals. "We started a campaign of information and explanation," adds Zhang, "and since then, whenever there is a loss of livestock or crop damage, we compensate the farmers according to the regulations and expert estimations."

Of course I have doubts about the perfection of the picture presented to me. Surely in this huge, deserted territory there must be a few hundred poachers who are setting traps or shooting wild animals. Surely there are several thousand peasants killing in large numbers, either with poison or shotguns, the animals of prey that destroy their barley and their sheep. The problem is that for 1.2 million km² and these 45 parks, the state has lined up 400 wardens and 90 agents, which is pitifully not enough.

At the very last moment Zhang springs an unexpected scoop. He tells us about a project whereby they will connect all the nature parks and large farms in Tibet into a "zone of ecological security," a firewall against global warming. Whatever might be carried out exclusively in Tibet, the project will probably influence the future climate of all of Asia. The work is huge and the budget for its success is ¥10.5 billion.

It will reconvert other former wheat farms from the Maoist era into prairie or wetlands. Areas devastated by mining will have to be replanted as forests or tree corridors. This will help slow the wind flows and slow down the plateau's soil erosion. Then there is the problem of the melting of 17,000 Tibetan glaciers, half of China's total, which is predicted within the next 30 years. Any success had by this ambitious project will offer benefits

for the great rivers of Asia: the Yangtze, Yellow River, Brahmaputra and Mekong all have their headwaters here.

The time is urgently now, says Zhang. Already in Tibet the permafrost is shrinking from global warming, which is also causing the snow line in the mountains to rise in altitude, thus reducing snowfall. Dust storms are arriving, threatening agriculture and the health of the people alike. Zhang sees no other solution than his "ecological security territory" where human activity will be limited, especially livestock production, mining and industry. This signifies, by the way, the introduction of immigration and residence quotas to the Top of the World.

But Zhang spares me that last thought. Too political, too risky, too soon with a foreigner! I also note the conflicts between Zhang's vision to protect China by limiting the exploitation of Tibet's land and water resources with that of water director Yi who aspires to multiply the territory's irrigation zones and greenhouses, destroying the permafrost.

In conclusion, our host offers a look at the extent of his powers and their limits. From an environmental standpoint, he is proud to declare that "his" Tibet is often ahead of the rest of the country. He has been able to get a prohibition on any polluting industry and apparently was able to get some cement plants shut down (the only ones in Tibet). He has banned gold panning and the digging up of the riverbeds in search of gold dust. And disposable plastic bags in the supermarkets were banned here long before they were in Beijing.

But he does not hide that he is also in dispute with the water bureau over a series of giant hydroelectric dam projects on the Brahmaputra. Even if "every hydroelectric or industrial project in Tibet must have our stamp of approval, it is a complex problem," admits Zhang, "that goes beyond our borders. It not only concerns Tibet, but the entire country as well."

For the moment, I do not believe that this low-level director or even the national environment bureau has the slightest chance in the face of corporate, industrial and hydroelectric interests. China may not be able to put aside these gigawatts of clean electricity at a time when it desperately needs to free itself from a massive dependence on coal.

As a matter of fact, in November 2010, in Zangmu, China diverted from its natural riverbed the Yarlung Zangpo/Brahmaputra in order to build an impressive dam with a hydroelectric generation capacity of 0.5 megawatts – an investment of $1.18 billion. It was only to avoid exacerbating the delicate relations with neighboring India that Beijing clarified, 12 months later, that the catchwaters of the river basin would not be used for irrigation, that the water would keep flowing towards India. Small consolation…

A cup of coffee with Mrs. Bassan

We are leaving the park. Sanmu just stops, as she often does, to make a phone call. After she finishes, she tells us that Mrs. Bassan, the second-in-charge at the Waiban, wants to receive us. This suits us very well: it has been five

days since we started traveling here and we have not been able to make any contact with this office, nor contribute much to our own itinerary.

That is why from the first day we have been on Sanmu's back about what we want to do: meet the governor, tour a mine, a hospital, a non-governmental organization, that mysterious train terminal crossing at Nagqu, indeed even see a military barracks or prison. Each time we visit a monastery we ask to meet a lama, which up to now has been strictly forbidden.

The fact that the assistant director now wants to meet us seems to augur well. For the occasion, the #2 has invited us to an Italian café at a mall in the business district, right below the Waiban offices.

We are all seated in armchairs ordering cappuccinos when the assistant director arrives, in the bat of an eye, like clockwork. She is a beautiful woman, no more than forty and upright in posture. She sports a youthful, short hairstyle and has an oval, well tanned face. She confidently wears an elegant outfit. She is Tibetan. She is of high intelligence, concise in word and cultivated. She speaks to us in impeccable English. She is well exercised in the use of power. This is not someone who is often challenged. And, I might add, this is a woman who is mad and she is mad at us.

Mrs. Bassan lets us know that that she did not choose to have us come here, but that this visit was "advised." If we have this rare chance to come to Tibet while dozens of our colleagues are growing old in Beijing waiting for a green light that will never come, then we could at least have the

discretion to be satisfied with what we are offered. She does not have an unlimited pool of employees and the work is difficult. We should at once stop that little game of asking little at the beginning but then demanding more and more, once we are safe in the fortress and sure not to be kicked out.

At first, we are a little taken aback by her attack, but we then defend ourselves firmly and diplomatically in hopes of not widening the divide between us. We take turns, Laurent, Li Feng and myself, to say our piece. We really appreciate the favor that has been bestowed upon us. We are writing a book about Tibet, in the hopes of elevating its image in the West. But we are also tilting at windmills in France. There, the going is rough, since the image of Tibet is preconceived and not always in a favorable light, vis-à-vis China. The more Mrs. Bassan helps us gain access to places and meet unknown faces of this society, then the better our chances will be to get heard back home.

We calmly say our goodbyes, with shared solace and I think a mutual respect for the other side's worth. In European culture, it is considered better that your enemy is your friend. But the way the Chinese look at things, a brave man who comes from the other side of the battle line is better than the flatterers and courtiers in your own camp.

I admire the fact that she lives with the double handicap of being a woman and being Tibetan. Mrs. Bassan has climbed so high on the career ladder to get to such a key job, in the most political of offices of Tibetan China! In order to get there, she needed all the qualities we saw in

her when we first met, and the same special conviction that inspires Sanmu: that is to serve one's Tibetan nation while in the process accelerating its Chinese integration. And this evolution has transpired now that she has bought into their styles, thinking and customs, without harboring any fear that she will be disavowed by her own. But what a force she is with her toughness!

An evening in the home of Pu Zhuoba

Night falls on Lhasa. We return to our grand Hotel Brahmaputra long enough to refresh ourselves before going back out, having been invited to dinner. I must now divulge my open secret, one which was cracked on the first day by the secret agents entrusted with the surveillance of us foreign correspondents here in Beijing: months ago, so as to better penetrate the Tibetan universe, I started to initiate myself in the language with the help of a daughter of the people.

Xiaohua, a music professor, introduced me to Zi Zhen, one of her students. Zi Zhen became my Tibetan tutor, my middle woman with the Tibetan soul and the great giver of my initiation into the vocabulary, the alphabet and its grammar. For her safety (more than for mine), I have always held our meetings in a public place and not at my house, so she will not be accused of having intimate relations[19]. Each week, we meet at the Sequoia Bar, which is two steps from my office. It is all I can do to get her to drink something or eat a snack to go with her hourly fee. More than once I have seen Chinese sit down next to us and become all ears for what we are saying. After noting

my paltry linguistic progress, they return to their offices to make their reports.

During the three months before our departure, we worked on repeating phrases and expressions, enunciating the consonants, tones and accents that permit the formation of the vowels.

For my Tibetan professor who may be reading this book, with its coarse descriptions and absence of linguistic expression, my apologies are extended. I have an excuse. As a pedagogical method, Zi Zhen found only one short and simplistic textbook from the 1980s that was used by Chinese students. No re-editions or new publishing initiatives have appeared needed since that time. It would seem that China does not put a lot of emphasis on learning the languages of its minority peoples. But that's OK with me. These several hours of lessons at least gave me the opportunity to detect in this language an impeccable logic, a masculine rigor and a contagious, rebellious humor that pops up at every formulation. Tibetan is a language that is potentially droll and adept, with an enormous capacity for expressiveness. With Zi Zhen, I could sense that she recognized and appreciated that a Westerner held her language in enough esteem to learn it, which is something that the vast majority of Chinese refuse to do.

Right before our departure, Zi Zhen was nice enough to give me several contacts in Lhasa, including her mother, Pu Zhuoba. We called her last night to make contact and, as a result, we are her guests tonight.

Of course, with the constant monitoring of my telephone in Beijing, and even more so here in Lhasa, the

chances that this rendezvous will remain confidential are minimal at best. But the Waiban has absolutely nothing to fear: according to the rules of the game, we are in the best hands possible.

Mrs. Pu's one-story, middle-class villa at the edge of town is emblematic of a rapid accumulation of wealth among the social fringe that has rallied to the regime. It includes a small garden, in a coquettish style and of respectable size, about 300 m² based on a rough estimate. On the main street, where she waits for us, Zhuoba stops our taxi, since she can see it is full of foreigners. Her jest signals a delightful courtesy as well as good common sense, given the difficulty in going up to her place. It is at the end of a narrow alley, flanked by high, tunnel-like walls, with the path alternating between wasteland and new construction sites guarded by Tibetan mastiffs. These monsters are the size of lionesses and capable of tearing to shreds any bad guy or lost traveler.

Zhuoba is alone tonight. Her husband has gone to Ganzi, a big city by Tibetan standards, where he started his career when they first met, before retiring in Lhasa. Rather than follow him on his travels for a religious festival, she stayed "to watch the house… you know," she makes excuses, "how bad the security is here in Lhasa."

We take the obligatory tour of her property. It really gives us an opportunity to discover the real Tibetan style of home decor, heavily influenced by the nomadic life that this society is only now abandoning.

Apart from the kitchen which remains hidden from us, the ground floor has two large, rectangular living rooms, with spartan decoration, or rather a pastoral one. It has the bare-boned feel of a culture that is used to frequently moving around, almost like people who travel from place to place with a fair. The multicolored divans, ochre and red, could at a moment's notice be easily loaded up with all the household effects, strapped on the backs of horses or yaks, to start a season of nomadism. There are also two low tables with their feet sculpted and stained to look like snow leopard paws, the national animal symbol of Tibet.

The upstairs has three bedrooms: the master and the two unoccupied ones of their children, who are off studying in Beijing, including my friend Zi Zhen. Each child's bedroom is bizarrely decked out with a huge double bed and is devoid of any children's accoutrements other than a small portrait photo on the wall and a guitar hanging up in their boy's room. There are no posters, games or books left behind. It almost looks like these two rooms are ready to be rented out and maybe that's the case. Or maybe they leave them like this for the day when their offspring, once married, come back with their spouses to live with them, rejoining the clan.

Pu Zhuoba was not at all bashful in answering my question about how much her place cost to buy. She paid ¥500,000 for it five years ago. This would suggest a really low cost of living, even compared to Beijing.

Pu has us get comfortable in one of the living rooms and serves us mugs of butter tea from an already-prepared thermos. She continues to refill our cups until we are sated. Having already turned on her big flat-screen TV, she disappears for a few minutes, coming back with a

platter full of vegetarian dishes. We savor this simple but very delicious dinner. She serves us buttered rice perfumed with long, red berries which she says are ginseng seeds, as well as pieces of vivid red steamed pumpkin. With no meat or alcohol, our meal conforms to the precepts of tantric Buddhism. All during the meal, while we eat, she manages to not eat a thing.

Like her husband, a former judge, Zhuoba is retired. She proudly shows off her "model worker" medal and her certificate of service to the people, as a nurse for decades and eventually as ward chief at Ganzi's hospital. Embossed with gold stamps, the document is written in both Chinese and Tibetan.

Wife and husband both in public service seem to me a good case for the success of the Chinese policy of Tibetanizing the local administration: somehow things can eventually work out. This is a country without any legal tradition and the husband's post is one of the most compromised there is in China. Yet, it did not stop this Tibetan man from coming to pass judgment on his compatriots on the account of the Mandarin state.

Both the husband and wife are members of the Party, as is Zi Zhen. Her studies in Beijing are a mark of distinction on a clearly defined ladder to success. She already has a BA degree from the University of Tibet and a job for life with a provincial lyric troupe, playing solo "zhen", which is like a bass sitar. In Beijing, Zi Zhen is doing supplementary and obligatory "polishing" training in order to gain an expected promotion.

So here we have a family spoiled by the Party and it is doing just fine. Their house is even financed by the government through a provincial program to help Tibetans buy homes. The loan was given on the best terms. Mr. and Mrs. Pu only had to put down 40%, whereas our farmer Dianba had to put down 50%.

We are bowled over by our frugal and humble contact. It is time to leave. This same evening we make preparations for the other trump card that Zi Zhen has played for us from Beijing. Tomorrow, we will visit her art institute and meet two of her best friends, who are singers in her troupe of 200 professional singers, musicians and dancers, employed by the government of Tibet. We plan on taking advantage of this opportunity to have lunch around the National Museum of Tibet, which has already been put in the program for us by the Waiban. To stay on good terms, we have already informed our young sentry, Sanmu, who gave us a really funny look when she heard the news.

Seventh Day
Friday, 26 September, Lhasa

09:00 - Norbulinka, The Dalai Lama's Summer Palace

Try to make sense of this. Right after the massive desecrations of the Cultural Revolution, Communism restored Norbulinka, the Summer Palace of the Dalai Lama, with the greatest care. They didn't demolish it nor did they squat in it, transforming it into a leisure dacha for some high-level cadre. In fact they are maintaining it for the prelate's return, or more realistically, given the longstanding point of no return with his exile in Dharamsala, for his eventual reincarnation.

Thinking back, China did the same thing with the Potala and the Forbidden City in Beijing. This policy of cultural preservation seems to have been ordered by Zhou Enlai. It is also possible that during the 1980s, Deng Xiaoping's[20] team of lieutenants played a hand. They were the most pragmatic and least ideological the world of Chinese Communism has ever known. At heart, they wanted to sow seeds of reconciliation with Tibet, traumatized since the takeover in 1959. After that, their spiritual leader fled the motherland and then there was the ten years of living hell called the Cultural Revolution. In any case, this refurbishment of Norbulinka was done during a period when the Dalai Lama was being quietly invited to return to China.[21]

Norbulinka is a charming little palace with an intense style, half rococo, half Ming and a little retro, what with its ochre pavilions draped in white, its convex roofs and surrounding moats. It is like a kind of Forbidden City in miniature, in the middle of ponds and foliage. In its oldest sections, it dates back two and a half centuries. However, the "New Palace" was built for the young Dalai Lama in 1956, just three years before the Liberation Army's invasion. The 14th bearer of his title barely had time to appreciate the work.

In the gardens Laurent and Brigitte meet the chief gardener, old and proud, who still remembers his young boss, and who fervently believes that one day he will return alive.

Our relationship with the Waiban is not going well. When we leave the museum, we are ready to honor the invitation extended by Zi Zhen's colleagues and to discover their lyric center. Here comes Sanmu, stiff and impersonal, Sanmu on her worst days, upset at having to tell us the bad news and undoubtedly unsurprised at our reaction. Stepping into the middle of our privately arranged visit, her office bludgeons us with an interdiction to visit the Institute of Thespian Arts under the pretext of a missing permit from another office, the Provincial Bureau of Culture.

So here we are, crossing telephonic swords with Mrs. Bassan, who is perfectly exasperated and the phone is quickly hung up. Then something happens that absolutely floors me. Sanmu reacts in a way that would be unimaginable in a Han Chinese: she bursts into tears and runs off, leaving us to our own devices.

I hate to be a bother, even more so for a member of the fairer sex. But the problem we are confronting goes beyond mere inconvenience or the distress of a young lady. This is about trying to make our visit a successful one, how much of a horizon we can have to view Tibet and those trying to narrow it. And what we are fighting head-on now is less a young girl in bloom than a neo-Stalinist machine that is throwing every wrench possible to keep us from doing our job.

Our first steps after this disastrous implosion are to return to our official program where our young sentry left us, at the Provincial Museum of Tibet, which is two steps away. It is a modern edifice, spacious and with a beautiful look. The government has spared no expense to present the local art that, for the most part, has been preserved for centuries from greedy hands and then from the blind rage of the Cultural Revolution.

As soon as we enter into the grand hall, which is imposing and dark (in this Tibet that is constantly supersaturated with sunlight, this is a real luxury), we read a highly selective rendering of history that goes along with an eclectic selection of works and documents. It presents a Manichean nationalism that shows no concern whatsoever for local sensibilities.

All this immediately reminds me of Mao's old theory that he professed during his 1942 speech in Yan'an: art is nothing more than a tool in the hands of the dictatorship of the proletariat, to be administered to the people as illustrations of propaganda slogans.

Thus the museum is there to demonstrate that Tibet has always been "a part" of China and the Tibetans have always belonged with the Han. The 1959 invasion was nothing more than the formality of putting in place the closing parenthesis, after years of instability. It was the restoration of national legitimacy across an expanse of territory that had been made to lose its way. One of the first objects to be seen in the entry hall is a black and white photo that is sun-faded and in very bad shape. It portrays the Dalai Lama, who was at the time barely adolescent, in Beijing on 31 May, 1951. He is in the process of signing, with the Political Bureau of the day (Zhu De, Zhou Enlai, etc.), the documents that legalize the "pacific liberation" of the territory.

With that "i" dotted, the museum relaxes its tone a little as we look around its two floors. It presents a fairly complete collection of works from the prehistoric to modern and includes statues, pottery and tangkas (the votive paintings on scrolls). Among these latter, some evoke their spiritual domain. Others have medical themes or erotic depictions, where horned gods embrace in their thousand arms a woman in ecstasy. As well, the statues and the tangka imagery of this provincial museum suggest less abstinence than an exaltation of the body and shared carnal fulfillment. These representations want to be seemingly

decorous, respecting some spiritual rules of desire. But sometimes, this veneer betrays itself, like in the portrait of a love goddess in the thousand arms of a monster who is ghoulishly biting her neck. The man maintains a passive pleasure, keeping his passions in check, so to say. She keeps her eyes closed: is it regret, happiness or simply that she is not allowed to communicate her emotions (this is also very Chinese)? Or is it the artist's lie, the untouchable saint who is celebrating his pleasure through his punishment?

For the experts however, these scenes of coupling represent the union of the divinities Yab and Yum. To see anything sexual is to go against the grain. These portrayals have a hidden meaning that invites the meditator to practice intimate union in the example of protectors, in a ritualistic setting. But all of my traveling companions as well as I are brought to the conclusion by these tangkas of what we should not be seeing: that the artists are cleverly displaying titillating pleasures and satiated desires in the guise of theological duty.

A big tangka catches my attention. It represents a nude female demon lying in a lascivious pose. At the same time that she is lustful, she is also geographic: she is depicting a map of the Top of the World. Her clawed hands and feet remind me of the snow leopard, but not her color, which is emerald green. Her body is full of mountains and rivers that double as a map of the country, with its waters, regions and cities. She reminds me of the pre-Buddhist myth about the birth of the Tibetan people, from the union of a monkey (representing wisdom) with an ogress. She is somewhat tamed, being held to the ground with 108 "nails" that represent the 108 great monasteries (and the 108 grains on the "mala" rosary). But this demon is always lively and ready to wake up if the monks relax their efforts. She is the soul of Tibet!

I feed on these masterpieces, of which none can be found in the markets or in the sellers' art stands. Not the variety, the delicacy nor the imaginative power. Clearly the tree's sap has dried up under Chinese rule and through a forced encounter with modernity. Today's Tibetan art is still looking for its new inspiration.

A trendy café

We leave the museum at around 13:00 and stand in the entryway. Li Feng gets a text message from our guide. After having recovered her wits and gained a more conciliatory tone, she assures us that our visit to the lyric center has been rescheduled for tomorrow. Albeit less than ideal (today is a Saturday), the troupe will perform an exceptional rehearsal for us. As for Sanmu, she will join us in 90 minutes, in time for our next rendezvous.

At this moment, things start to happen fast. We run into two young women who are the soprano friends of Zi Zhen, whom I contacted last night. The mystery of our chance meeting solves itself: after waiting for two hours and not seeing us make it to the lyric center, Zhaxi Lazong and Deqing Zhuoga called Li Feng on his mobile and he set their compass in our direction.

Evidently bonded together, they are close friends as often happens with girls in China. These beauties share a hairstyle and clothing in the vein of the local culture, sporting

simple lines and tones (black cotton vests), enhanced by a few items that confirm they are artists. Lazong has a rolled-up neck scarf made of turquoise silk that cascades down the front of a black, V-neck T-shirt; Zhuoga shows off on her front an emerald tangka embroidered into her blouse. She has her hair up with a central braid combed back towards her nape, with the sides combed down in symmetric rays on her temples. They both wear the same pair of large, rectangular sunglasses with a smoky tint. One is wearing them and the other has them resting on the crown of her head.

Without waiting, they "kidnap" us to have a drink in a garden connected to the museum. This low-brow concrete hangout serves tea and "chang," which is fermented barley, as well as Lhasa brand beer. It has become one of the cool places to congregate for Lhasa's intelligentsia. What makes it attractive is its shaded arbor with work tables set between the trees. Here in season you can spend long hours, day and night, and barely be noticed.

This is a chance for these young ladies to share a gab fest. It is as though they are feverishly acting out parts, like a curtain has been raised on a stage for them and they are seriously playing their roles, a fleeting excursion of spontaneous freedom. It is also an opportunity to test us out, turn on their charms and escape with us like a dream, while letting everything be indulgently immortalized by Laurent's sophisticated cameras. They give me the impression of being fascinated with themselves, narcissistic and a little immature, which is normal for Chinese girls of this age. From this point of view, our friends are very much from this country.

Zhaxi Lazong is 26 years old and a lyrical singer. In 2006 she became the glory of her city, Changdo, when she was crowned national champion of Tibet on CCTV in the "folkloric music" category. Her fine traits are belied by a pockmarked complexion, a stigma from her infancy in the village, where hygiene is precarious and children are often not protected from the ultraviolet light.

Deqing Zhuoga is 25 and comes from the city of Tiangnan, in the district of Lingzhi, 500 km away. She did the same wonderful studies and was even honored with a scholarship, earning a conservatory diploma in Shanghai.

They are daughters of local government employees and are both single. The lifestyle they live, in their opinion, is free-wheeling and funky. But in our impression, their lives seem simple and orderly, going from practice to having drinks in clubs and cafés. They are proud of their status as artists and in spite of it all, complain about being severely watched by the authorities, especially since the bloody riots and their widespread fires on March 14th. They dream of dissidence. They have a foot in each camp even while they consider themselves to be trapped. They will never be able to cut loose and commit themselves to an art form where they could really express what they feel. Their art, for better or for worse, must be in the service of the Party and its slogans. Their languorous and vain complaints have a little bit of Madame Bovary about them, as they search for something unattainable and fleeting, a meaning to their lives that cannot be had.

For lyrical singers, their salaries are modest: ¥2,700 per month, which is one half to one third of what they could earn on the coast. Every three years they move up one grade on the salary scale if they pass an advancement exam. As fate would have it, Zhuoga actually has her promotion exam tomorrow. After she passes it, which is a simple formality, she will get a raise to ¥3,000, or 10% more.

But even in a city like Lhasa, where prices are modest, their salaries are far from being sufficient, for these are artists who hang out in small clubs for groupies, in clothes that cost an arm and a leg. They wear leather or fur jackets, all things silk and pashmina, and for accessories they sport motor scooters or cars like they are jewelry. And of course, as is often the case, they are supposed to pay their fair share, as well as rounds of drinks at this restaurant or that bar.

To top up their salaries, Lazong and Zhuoga sing and dance at corporate banquets, marriages and birthdays. Neither of them has an agent negotiating their fees and performances, that being an unknown concept. Both of them occasionally get the chance to perform in a recital around Tibet, neighboring Sichuan, Beijing or Shanghai. Last year, Lazong even got to travel in an international tour, to Singapore.

After three quarters of an hour together, the atmosphere suddenly changes. Following the tentative seduction of the beginning, the somewhat forced laughter and many smiles, we get an unexpected feeling: weariness tinged with grey. Suddenly they want to talk.

It is more than they can bear. It would be hard for them to put on more of a pose. Face to face with we ephemeral extraterrestrials, they suddenly find their existence drab and without a future. It is a question of artistic freedom, of which they are bitterly deprived. The choice of their work, the pieces that they perform are imposed on them by severe censorship. What is on offer is taken from rewritten Tibetan folkloric works, always in both languages and the themes are to validate the generosity of the regime and pride in being Chinese. Creativity is suspect and even bridled. Each of them admits to us that the only thing they dream of doing is leaving Tibet and going to sing elsewhere: America, the UK, Covent Garden, Paris, Bobino…

On the steps of the restaurant, we leave with the willingly whispered promise that after visiting their center tomorrow, we will go and celebrate Zhuoga's promotion. We will be welcomed in their circle of friends, who know we are in town and who are dying to meet us. Under the noses of the authorities, we will take off someplace together in Lhasa, the real, hidden Lhasa. It will be an opportunity for freedom-loving consciences to defy 50 years of authoritarian grip. It's going to be a gas!

Now looking back on the whole affair, I realise the amazing chance we had to give the slip to our young guard dog Sanmu. I also ponder our incredible naivety in hoping that this muscular administration, which excels at controlling souls, would let us shake and bake the night away with a fun-loving band of intellectual artists. We will

have to wait until tomorrow to taste the sour grapes of our candor.

Holy of Holies: The Planning Commission

At exactly 15:00, we find ourselves at the head office of the Provincial Commission of Reform and Development. It is the orchestra conductor for all of the state-owned enterprises as well as influencing private firms through regulations and subsidies. Our visit is a rare occasion. Other than the Communist Party organs, this commission is the place where foreigners are the least tolerated. In 26 years of working in China, I never had the opportunity to visit the national office in Beijing.

The reception lacks imagination, but not courtesy. The director, Ma Jinglin, as well as Mrs. Wang Jingcha and Liao Jiajun greet us. Liao is an employee with a boyish face and it looks like it is his first job. All three of them welcome us with smiles. The room is huge, well lit and freshly repainted in light yellow, which is in harmony with friezes and Tibetan themes in red and green, casting good *feng shui*, as one could say in China. Through the window we see an azure sky contrasting with cumulus clouds of majestic volume. It gives a "more vivid light than in France," Mr. Ma tells us, as a backhanded, welcoming compliment.

In this People's Republic, following a Stalinist administrative heritage, each central organ replicates itself at four lower levels, these being the province, the district, the township and the village. Each ministry clones itself as multiple avatars all across the country. It is the same thing for the National Development and Reform Commission, which is the executive organ of all the five-year plans and driver of the economy. The NDRC reconfigures itself all over the place across these four lower levels, at a scale dependent on the need of each one.

Paradoxically, the lower you go down the totem pole, from the national bureau to the bottom rung, the more these smaller offices reserve their loyalty to the local head chief, and thusly, the less they listen to their superiors. For example, Zhang Dongzi, our (national) protector of the environment depends on his Beijing ministry, but settles his accounts with the provincial governor. As a result, each province and each township pretty much does what it wants and functions like a miniature state unto itself. It has its executive branch, parliament, bank, mine, brewery, not to mention its chemical and steel plants and its own commercial brand to sell washing machines in competition with its provincial neighbors. Between the provinces and the central government there is a huge ambiguity in relations, with a resulting permanent clash between the impulses of autonomy and the Jacobinism in Beijing. Orders cascade from on high towards the bottom and they get distorted like amplifier feedback to the point where they are unrecognizable and inapplicable when they make a hard landing. The Chinese like to use the expression "The mountains are high and the emperor is far away." And from Tibet, very, very far away! So the country is, of course, ungovernable.

At the end of the day, from this exchange, we get a lot of smoke and very little fire. Our hosts parse and parry

our tens of questions with grace, confining themselves to banal reassurances and, whenever we hit on something good, double talk.

How has the violent rebellion in Tibet affected the local wealth? And what is the state doing to reprime the pump?

In five years, Ma says, the state has spent more than ¥100 billion[22] to develop the Top of the World. Revenue for the farmers has increased just as much (by 12%), but has still only reached ¥2,788 per year, this being half the national rural average.

For education, our host notes a literacy rate[23] of 95.2% among Tibet's inhabitants of 20 to 50 years of age – a rate which will be firmly contested later by another source. For television coverage, 88.9% of the people have service, which is a difficult level to achieve given the size of the province and its rugged terrain. We can see the strategic importance of this initiative, since it doubles down on the worried state's objective to snuff out any other voice but its own, the other of course being the clergy. To keep up appearances, some of the programs on radio and TV are more and more in Tibetan and of practical use, such as weather, variety shows and educational programs during the long winter evenings.

The March 2008 riots severely put a brake on growth, Ma admits. The year before, tourism attracted four million Chinese and several tens of thousands of international visitors. This year, those numbers fell by 69% in six months, and hand in hand, so did sales of folkloric objects made by the locals – especially after Beijing ordered the borders closed from the outside and even stopped internal movement among the seven counties that make up the province. All revenue types of course feel it. In 2007, the average Tibetan citizen earned ¥12,000 per year[24], which is only 20% as much as in Beijing. But at least this level doubled in five years, thanks to annual growth rates of 12%. Provincial GDP increased during this same period by 13.8% per year, up to ¥38 billion. But it is going in a totally different direction in this first quarter of 2008, Mr. Ma tells us, barely reaching 7.4%. The actual rate is obviously negative, but never admitted.

"We have gone backwards," Ma declares mysteriously, "but less than we feared. And in a few months, we will have caught back up."[25]

For the authorities, tourism is the future, given its capacity to soak up lots of employment and its low demand on energy needs. It seems like a reasonable choice, especially when juxtaposed with mining that destroys the countryside, factories without easily accessible markets or agriculture and livestock production which pollutes and destroys the prairies and high plateaus in the Land of Snow.

But which kind of tourism? Mass tourism, where hordes of not-so-well educated Chinese citizens stampede the monasteries, listening to their bullhorn-carrying guides and spitting on the grounds of these now commercialized sites of travesty, like so many tourist destinations in this country? Or maybe sporting tourism, where young people, dying for a little adventure, stomp over the hillsides and crawl across the fragile permafrost with oversized tires

on their 4x4s? Sportsman tourism, where millionaires fly around in helicopters to shoot antelope with high-powered rifles? Sex tourism, where 3-4,000 young women are reportedly open for business for the soldiers in Lhasa?

There are a thousand ways to disrespect Mother Nature and humanity in Tibet, a thousand mistakes to make that can be made by the new masters. Based on what we see on this trip, these errors are unavoidable, what with them being at pains to fill up the cash drawers in the hotels and commercial centers, no matter what the cost over the long term.

What will be the optimal population, according to Mr. Ma, for this fragile territory with such limited resources? "We have not done any studies. But there can be no doubt that the current population can be considerably augmented, in conjunction with economic conditions and technical progress." One only has to look in the stores and shops to understand why he says this. Food, clothing and everyday items are all imported. On average, China has not failed to increase its foodstuffs by 50 kg per inhabitant per year for the last 20 years. But to encourage, in these conditions, an increase in population does not seem like a good idea.

In vain, I try to get the director to talk about their big works projects. He does not talk about the new railway line between Chengdu and Lhasa, which will start construction in October 2009. It will reduce the travel time from its current 30 hours to only eight. Nor does he talk about its extension to Shigatse or, according to the press, another line that will go to Katmandu. This last initiative could be a "realpolitik" coup, capable of turning Nepal's affections away from India and towards China. No, Mr. Ma limits his response to mentioning widening of a future road to Sichuan, as well as the primary thoroughfare, 2,000 km long from the border to Kashgar. It is an attempt to pull together and open up from north to south this China that is so oriented from east to west.

He manifestly does not tell us about the 22,000 km of roads and five airports that are being built in the territory. Because Ma has a reason to be discreet, knowing that a big part of these projects are for military purposes. For example, the highway that runs from Kunming to Lhasa will pass close to the boundary with India, through the territory under Indian control called "Arunachal Pradesh" that the Chinese insist on referring to as "South Tibet". Of course this road will allow China to mobilize troops much faster to this region than New Delhi will be able to! [26]

What about the mining that could be the primary source of riches for the territory? Our host insists that as of 2007, copper has still not been exploited. However, a mine and smelting plant are being built in Yulong, where the local group, Western Mining, will produce 20,000 metric tons by the end of 2010. Also active in Tibet is the Canadian group Continental, which announced in 2007 that China started offering them unbeatable rail hauling fees for their ore: ¥0.10 per ton, or ¥250 for the 2,500 km all the way to the smelter. At the same time, instead of being assessed the usual 30% corporate income tax in

China, Continental is being awarded a favorable rate of only 10% from this year's contract signing until 2012.

Nor was a word mentioned by our director about petroleum. A discovery has been identified in Qianqiang, in the north of the territory, with reserves estimated to be in the hundreds of millions of tons of crude oil. Sinopec, China's second largest oil company, has established an exploration and logistical base in Nagqu to drill wells all across Tibet.

As a last point, our interlocutor talks about agriculture. With a serious mien, he unveils two key exports of the future: dried yak meat and walnut oil. Mr. Ma assures me that this last product is already for sale in the top stores across the territory. Later, I amble through the aisles of a supermarket in search of this magic potion and never find it, with good reason: the employees tell me that they had never seen it, were never told about it and had never seen it anywhere in town!

As a lost cause, at the end of the trip, I give Sanmu ¥50 and ask her to please mail a bottle of the stuff to me in Beijing. I am still waiting for it. It is not that our poor guide has broken her promise, nor that walnut trees do not exist in the Land of Snow, but that the production is still way too small-scale and confidential. Thus it is unfindable, except in Mr. Ma's poetic discourse!

How to lay bare the bureaucrats

Around 17:00, leaving this office, we again find the ultraviolet sun and the bluish mountains of Lhasa, tasting a perplexed nothingness. This interview marks the last of a series of meetings organized by the local departments to roll out the regime's success. Starting tomorrow, our agenda will turn towards more visual and touristic scenery. But with all these precise numbers floating in our heads alongside the silence of the apparatchiks who gave them to us, in all fairness, what balance sheet do we report?

In the "liabilities" column, I note the biased and deceptive instinct of the system, where every government employee is a henchman in an army on the march, and where the truth is in service to the Party. A foreign journalist is not the ideal person to whom these bureaucrats would like to spill the beans.

As a professional who has been confronted for ages with this type of misinformation, I must admit that this trip tops the charts and the manipulation ranks right up there with my first years in China. Unlike the normal practices in the lowlands of China, no one ever gives me any documents as reference, not even in Chinese. Not one orator in Tibet will take the risk of confirming their declarations in print!

Also, with the exception of maybe the ecologist Zhang, no one shows me the big picture and long-term priorities. All of them are evasive with my questions, which does not shock me in any way. But this dearth of information speaks volumes of the tension that rules here. Be it on the streets or in the office, it is like a war is taking place.

In the "assets" column, however, Tibet scores a few points. Even though they are inexperienced in greeting and meeting western journalists, these men and women at least are showing up. They are all courteous and polite and

even interested in getting to know us within the limits of their authorization, pushing the envelope a little in order to learn something about us, who came from so far away.

The majority of these public servants are locals, which reflects 50 years of the Chinese Tibetanization policy. To win this wager, the regime started out by mining what were probably the very few intellectual circles of Tibetans who did not flee the invasion: socialists, secularists, Sinophiles and modernists. Or simply those under the old regime who had nothing to lose in the dismantling of the Dalai Lamas' aristocracy and governing system.

These people thus vote for China and play by the rules. But never for an instant do they give the impression that they are betraying their people. They are one of the two irons in the fire that supports Tibetans in the story of Tibet. They are one of the hopes of the future for this region, fighting to catch up in terms of modernity, education, health and technology. They resemble the Catholic clergy of the French revolution, torn apart from one end of the country to the other. Its members opted for substance over form and each one served God, the people and even the republic.

Some of these locals secretly take their children for religious catechism in the monasteries, or send them to India to study in schools in exile at Dharamsala. It has gotten to such a point that several weeks before our visit, the local government felt obliged to release an edict banning this practice. Never mind that this directive stands a good chance of being a dead letter: their loyalty to the regime is a nuanced one in the spiritual sphere and its verification that much more difficult.

On our own from 17:00, we take the tour around the Potala using the circular road under the cliffs. The copper prayer drums softly squeak while being spun by the odd pilgrim, who is rare at this hour. I still admire these brass drums that are machine-stamped with the elegant, raised letters of "Om mani padme oum." They are mysteriously constructed to rest on a lower hub of forged iron spinning on the head of a tibia bone, from either a man or woman. It spins slowly, according to the gyrations applied by the passing faithful. I am curious as to what this spinning represents. Is each turn like a prayer, an indulgence, a day earned in paradise (a petition to the hereafter for a more rapid arrival to reincarnation)? Or conversely, could it be a torture, a merited punishment for past sins, an act of purification through torment, ecstatic pain, an exquisite cadaver? The ground around the drum is black with dri butter and scattered with grains of wheat and barley: like nourishing life with death or vice versa.

We terminate our promenade in the adjacent park, which is small but splendid and welcoming. Its vegetation is rich and well maintained. Expanses of lawn alternate with shimmering flower gardens around interspersed ponds, under a vivid yellow canopy of ginkgo biloba trees. Tibet may be poor and its administration authoritarian, but at least everyone can agree on preserving the beauty of their public gardens as treasures. Very few cities in China can make the same claim.

Madelon, Madelon, Madelon

20:00 – How do Tibetans live, how do they enjoy themselves in this city where jarheads patrol all night along empty streets that house a number of faintly lit tavern signs hanging behind little, lugubrious window panes?

The hotel's young manager promises to initiate us. In the end, it is one of his floor workers who takes us. He is an acne-faced adolescent. No matter that he is Sichuanese and can barely put two words of Tibetan together. Chen does not seem visibly bothered to spend the evening with us and "those across the table."

We aimlessly roam the streets. We are looking for places that are popular with the trendy youth of Lhasa, the golden boys and girls. We stumble upon a watering hole where it is old age that rules the day, and not just a little. Imagine a room four meters wide and ten meters long with walls covered in insipid wainscot, coated with the vapors of cooking oil and badly lit by a floor lamp spattered with insect poop. Only two of the four light bulbs in the place are working. One is a low-watt incandescent light and the other a pallid neon one, giving our faces a ghastly appearance. Along the wall in the back, four other hidden neon lights pretend to glow without much conviction. On the right, a primitive staircase goes to the second floor. On the left, a short hall goes directly to a windowless cubicle. This turns out to be the disgusting kitchen where several bowls of nauseating noodles are being prepared for us. The whole scene is such a promising vision!

Along the lateral walls are wooden boxes that serve as benches and low tables with the now familiar cat's feet.

The tables are multicolored in old, dated and loud hues that are miserably faded. Aged between 30 and 70, about ten commensal, windblown and wrinkled compadres who look like characters from a Brueghel painting, are drinking and laughing.

What has happened is that we have walked in on a private party: hurry, hurry, we have to leave now and not bother these fine gentlemen. But it is already too late. Seeing us trying to make a quick getaway, all of them get up as one, pounce on us, take us by the arms and escort us back to a corner with some still-empty tables. They sport smiles as broad as Cheshire cats and once seated, a tepid Lhasa beer is handed to each of us. And we're off!

They speak to us in a rusty Mandarin and make introductions. Some are retired and others are professors at the nearby middle school. They are all friends and neighbors. What they are celebrating is this Friday evening: it is not only the night before the weekend, but a weekend that is doubly imminent, since it is the start of the National Day holiday which will mean six days of vacation!

For we newcomers, they all demonstrate an uncontrollable curiosity and boundless friendship. There is an old woman dressed in local attire: a very long dress with faded colors and layered petticoats with an apron and embroidered blouse. She does not stop addressing me with grimaces and a tongue fully extended (a sign of welcome, according to *Tintin in Tibet*), while she makes equivocal gestures with both hands. I pass on trying to translate her meaning!

We are under the watchful eye of the assembly. A woman in a form-fitting black blouse over braless and proud breasts initiates us in the ceremonies of the insipid beer. It is drunk in shot glasses, according to local custom. The beer shot is gulped down in one go, at an ever-accelerating pace.

As we arrive, there is already a tipsy bald man who is singing a ditty. He is encouraged by hand clapping and knows all the words and music by heart. Now, while we are keeping the conversation going between the tables, they continue their recital. Each drinker takes their turn belting out a traditional love song. Soft and flowing, their singing is as robust as it is powerful. The way they are singing and their jests give us a clue about what the songs mean: unrequited love, an abandoned woman, saying goodbye to the village… Two women keep coming back to the singing "stage" next to the bartender. One is the busty owner and the other is a skinny girl in a turquoise sweater. We quickly figure out they both tend to the cash register. For them, singing is a way to increase the frequency of the drink orders. Each man in front of whom they sing must down their shot glass, and they are fully assisted in completing the operation. As luck would have it, the tables never seem to empty of these 600ml bottles of local brew. The refrain continues. The whole ritual is a slick commercial money maker. There is of course the pleasure of being together, sharing folklore and, in our case, cross-culture. This is a potlatch that sacrifices everything for the pleasure of the group, without worrying about individual expenses. This is how it is done, Top-of-the-World style.

After a while, I sense something else about this drinking frenzy that is part chemical, and that is the amplification of the effects from the mountain-high altitude of Lhasa. The goal is to get as drunk as possible as fast as possible, and be transported together in this troubled world to where we can unload our miseries in a state of euphoria. As if time is really being kept track of, release the pressure dressed in khaki, uncertain about tomorrow.

These people are down to earth and really nice. Never once during this lyrical bacchanal do we see an untoward gesture, a bitter remark against China, the neighbors, no admonitions or fighting. There is no revolt against their fate in life. Only hospitality and humility, the full expression of this group's identity.

A math professor describes his job to me. His work conditions are satisfactory. He puts in his 30 hours per week and takes home his ¥3,000 per month, along with medical coverage and a retirement pension. As we already saw at the experimental college, he is treated exactly like his Chinese counterparts. A small teacher with glasses keeps asking about what happened to Zi-Da-Né (Zinedine Zidane), and as quickly he forgets my unofficial and not very important response. What really matters to him is to be able to come back and talk to me, bludgeoning me with his verdict of what really happened during that infamous World Cup match where the French midfielder was given a red card for headbutting an Italian competitor, who apparently was impugning his mother's virtues. On autopilot, every five minutes this teacher comes and tells me that under no circumstances can a headbutt ever be

considered acceptable in the world of soccer. There are rules to respect after all, hiccup!

And then the women are standing in front of us! They spared us during several tours around the tables, saying that as guests we were exonerated from singing and that we maybe do not know how to do it. But now suddenly here they are. We have a challenge to stand up to! And when you need to go someplace, you gotta go. After a few seconds mulling it over, we push ourselves to come up with a good ritornello, "She Likes to Laugh, She Likes to Drink," followed with "The Prison of Nantes" which is taken from a little sailor's ditty straight out of Quebec.

But we are the highlight of the evening with "Madelon," which is so successful that when we give them an encore, the whole café chants along with us, "Madelon, Madelon." The guy sitting next to me asks what it all means. I evoke the beautiful, innocent girl, in the middle of a tavern full of grunts. So joy wins out, everybody repeats the theme, the words… Wow! Here is an evening that will be marked in the annals of this humble establishment. This ship full of drunks stammers it out through the lens of their own language: "ma-de-la, ma-de-la," etc.

At about 22:30, entertained, a little cloudy and exhausted, we get it in our heads to return to our beds, when things start to get interesting. We take this turn of events in stride. Showing us the bill, the boss tries to bilk us like we are some vulgar Beijingers, asking ¥140 for her ten bottles of beer and four bowls of nasty noodles. Even in Beijing, this amount would be the limit and here in Lhasa, just outrageous. The speed with which she calculates the total, with her chest pumped up more than ever with its jet-black bodice, is suspicious to say the least. A quick calculation in our heads and we come up with about half that amount, which is still paying rich. We settle on ¥100 max, which she accepts like a grand lady or a shameless brigand, take your pick.

As we pull out our billfolds, Mr. Zi-Da-Né forcefully intervenes in the name of expected hospitality, trying to take the bill and pay it himself. We could accept and "give him face." But knowing his likely modest lifestyle, we decide otherwise. A little bit of hocus-pocus, a pat on the back and we slip the pink ¥100 bill to the ogress, who has now become our ally. Mr. Zi gets there too late, but still manages to follow us out onto the street trying to pay us back the bill. Li Feng and Laurent come to the rescue and manage to get him back into the bar with a conciliatory word. The sky is graced with a crescent moon and a dome of brilliant, ebony-backed stars, the likes of which we will never see in any other place again…

EIGHTH DAY
SATURDAY, 27 SEPTEMBER
THE DREPUNG MONASTERY

It is a short night of rest, and not a good one either, as we are still far from being acclimated to the high altitude. At 9:30 we courageously swallow bowls of "zhou"[28], the commonly served warm and watery rice soup. It always seems lukewarm, since it is invariably served from a communal pot where it remains unheated for hours. We strike out for the mountains of Gambo Utse, in Drepung, which houses the biggest monastery on the Top of the World. It was founded in 1416 by Namyang Choley, a disciple of Tsong-Khapa, who was the first of the Dalai Lamas (1357-1419) and whose name signifies "the man from onion valley." It is for this reason that their hats are yellow. It is the ultra-dominant sect in the Land of Snow and self-proclaimed as "virtuous" (gelugpa).

The trip only takes 20 minutes, the time it takes to drive the seven kilometers and an added 100 meters to get us up to 3,733 meters.

All along this road, the sides of the mountains are black and uncultivated. But once we get to the slope of Mount Gephel, the base of the monastery, the surroundings brighten up with orchards, gardens and tree groves, all carefully maintained thanks to a system of irrigation which distributes water in little streams.

A Mount Athos on the Roof of the World

Drepung is a redoubtable fortress hung on the side of its mountain, designed over the centuries to resist every form of attack. These have included Mandarin troops passing through as well as bands of brigands who combed this territory in the 30s and 40s. These latter were former peasants who were uprooted from their frozen culture and plunged into banditry.

Drepung has carefully manicured walls covered in ocher-washed crowns, fortifications 20-30 meters tall and bouquets of foliage in vivid green tones – some kind of cedars or olive bushes. It stands out as an altogether different kind of sacred sanctuary, a veritable Tibetan Mount Athos.

The crescent-shaped valley must have been fertile from time immemorial, as its translated name would suggest: "mountain of rice." The sanctuary is called the "Nalanda" (an Indian word) of Tibet: a theological university whose first historical mission was to translate sacred texts from the Sanskrit. In better times, Drepung sheltered seven colleges; and during peak periods of grand synods or festivals, when all of the Top of the World descends upon it, up to 10,000 brethren at a time come on foot from thousands of kilometers away.

Today, under Beijing's rule, Drepung only has the right to house 400 lamas: its superiors have to carefully choose their monks from the flock of candidates to fill the quota.

From the national Tibetan drama that just concluded, with its stopgap epilogue, nothing seems to have filtered through here. We climb the steps that go to the building and are stopped by hundreds of fat sheep with large ears and black heads. They are gaily driving, jumping from atop the small walls, a shortcut to the pastures in the valley, under the watchful eye of a shepherd who is a teenager in black clothing and a baseball cap.

Further up the street, we pass by several hermitages and miniature gardens (peonies, chrysanthemums, climbing beans). A well fed monk greets us, seemingly happy with his two sheep and a tangle-haired Angora cat which is taking a nap on the ground. In the corner of the enclosure is an oblong solar oven made out of polyester resin and decked out with mirrors, making its teapot shimmer. In the back, the holy man's cave room juts into the cliff face. There are some other cave havens that are occupied by retired families, parents of monks perhaps, including mothers with their baby infants: a micro-society on the ephemeral margins…

Among these Lamaist monasteries reigns a grand unity of style. Their crestlines hide their wind cemeteries, which are hinted at by the multicolored wreaths hanging from a dead tree. These are the "lung ta," or "wind horses." These offer their mantras and benedictions by clacking together. Even the order of the colors has a special meaning, which is so different to the rational and technical world of the Mandarins.

Visitors can also see the naïve rock paintings of Tsong-Khapa. There is a demon with yak horns and the beak and claws of a vulture. Drepung also boasts, with its inclined slope, a support for the giant tangka, 25 meters wide and 35 meters high, which the brothers only deploy and reveal for one half hour each year, in front of throngs of pilgrims: during the Shoton ("sour milk") Festival, which happens during the 30th day of the sixth Tibetan month, towards the end of August.

This "goddess of milk" festival is a celebration of grace towards nature, at a time of year when there is plenty and the fruit is abundant and sweet; this is a time of mild temperatures that favors the transformation of fermented milk to be even more digestible and invigorating.

During Shoton, the monks adopt a surprisingly fearful and conservative attitude. They forbid themselves from going outside, to not risk squishing under their sandals the myriad numbers of worms and insects. Why do they then harden their rule of contrition, and consciously oppose the call of Mother Nature? Did the fathers of this church invent an innocent contrivance to protect the souls they have in their charge from the sins of gluttony, the exaltation of the senses? A penance for all of the temptations the earth has to offer? I can see so many possible gateways here between Buddhism and Roman Catholicism, both old, hereditary religions of their millennia, of meditations and stratified traditions.

The population is not stupid. Each of these religious festivals, when the weather is good, is a chance to have a picnic on the lawn with parents and friends, to exchange snacks and polite words or crack jokes with the neighboring group. These get-togethers are spiced with bowls of "chang", the local "cider" made from fermented barley flour that gets you as nicely drunk as beer does elsewhere in the world.

Another instrument for prayer in Drepung: the crossed street climbs up in staircase fashion, and swirls and drills its way through the body of buildings or around walls. These axes of contrition and theological gymnastics inevitably have their accessories: spinning prayer mills, with their drums covered in stamped print. Here, we can see they are conveniently being spun by the flow of water, playing the role of relay runner when the force of human hands is lacking. Likewise, in the big nave of the sanctuary, the blades of another mill take their turns, animated by the heat from a butter candle.

The theological implication of this natural propulsion carries a certain interest. We know that each turn of the mill is worth the announcement of one lotus mantra or compassion mantra. Each 360°, turning in the bone or socket of a deceased, is worth to them the shortening of their time in "purgatory," the time before they materially change into their new reincarnation. Drepung teaches us that this mantra's propitiatory action can not only be obtained by human effort, but the exploitation of terrestrial energy is also admissible. It is like Prometheus, who stole fire from the gods – or Charlie Chaplin, who escapes from danger through a slapstick pirouette, fooling bad luck.

In fact lamaism, behind its prim and proper facade, also maintains a form of admirable and dignified buffoonery, a unique knack to add to its meditation on life and death, an extra five percent of grimaces and laughs.

Old-fashioned chores

Throughout the monastery, the chore keepers carry on under our view with old-fashioned determination, an obsolete effort to refuse this century's technology.

In the kitchen there are 20 brothers who prepare the "momo" for lunch and they use no electrical appliances. The steam they are generating to cook in their stoves is from burning wood, which is romantic, but horrible for the neighboring forests from which it came. Also, the two brothers who are washing the tablecloths and robes do it by hand, standing apart from each other and twisting the wash in opposite directions, to squeeze out all the water. This is unconditional manual labor, which we can suspect is imposed by theological norms against progress. There is neither a washing machine nor a mixing bowl for making the dough. While a piece of washing is straining under its twisted tension, one of the two brothers lets go and it falls into the dust on the pavement. This uncoordinated team picks up the sullied wash, both sniggering like boys. It is all so unimportant when looking at an eternity.

But when it comes to one's private life, these anachronistic concepts go out the window. From their pay (their shares of the donations), the young monks are

decked out with MP3 players and GSM phones. They play with them during their downtime, to call friends of both sexes and family members; these gadgets are a way to reduce the distance from the lay world.

Could this refusal to use technology for the religious part of their life also possibly be equal to a big raspberry against China? The least demobilization, the least concession towards an easier way of life could be translated into a creeping dependence on the invader and a dissipation of the traditional culture.

It is a legitimate tactic on an uneven playing field, a battle already lost. Or at least it needs to be redefined, what with all the baggage it comes with, what they want to keep and what they are willing to give up. To be even more severe, we could say it is the same error that was made by the masters of the kingdom a century ago, when they banned the entry of all foreigners. Fortunately we can see these same Tibetans, once away from their religious hierarchy, striving to catch up from their technical backwardness, wearing blue jeans, building greenhouses, borrowing from the bank and using computers... Under our eyes, a new Roof of the World is being built.

Sanmu and us – a war of attrition

In this theological city full of half-ghosts, across the levels and buildings we pass, Sanmu does not miss one step of our journey. It is for this reason we fantasize about some form of resistance: to ditch her. So, Brigitte's mission is to distract her. She plays it perfectly. From the first time I met her, my partner has always looked for the human aspect when meeting someone, and finds it, sincerely feeling her truthful interest. Later, under this effect, Sanmu will reveal another facet more delicate, a secret aspect of her personality. But for now, she finds herself reduced to playing the role of the "guarded guard"; a local version of the water sprinkler.

In one of the chapels, two brothers, with whom I exchange pleasantries for five minutes, ask me about any news of the Dalai Lama. They declare that they are still waiting for his return. With the look of a conspirator, one of them shows me photos of the Dalai Lama which, if discovered, would cause this man some serious worries. One them was a page torn from a weekly American magazine, apparently a gift from a tourist.

By staying on the move through different rooms, my new friends and I get a chance to exchange our own original testimonies. They allow us to conclude that the disorder of March resulted in eight arrests at Drepung and 50 banishments. This does not include the five months they spent in their villages, or worse. They are under heavy surveillance, by armed guards on their own roofs and even in their cells. The rescued Lamas do not hide their fear.[29]

At 12:30 we watch a prayer service limited to about 20 brothers which is presided over by a prior and doyen. He is 88 years old, wrinkled, bald and with many missing teeth. I finally locate a prelate to talk to. I already have my dictaphone out when, stiff like a female pope, Sanmu takes control and tells me it is forbidden to record, to even talk. After some cajoling, she tolerates a couple of questions, on the condition that she is the one who chooses them,

and to translate the responses under the same ignominious conditions.

"How was life here?" I start out, a question that was acceptable on the face of it for its banality. Laconically, the response was up to the task: "Very good." I ask if this doyen is waiting for the arrival of the Panchen Lama (the second prelate of his clergy). This one went down the trapdoor. My third question had better luck. From all your studies and research, is your monastery worried about the climate and global warming? Yes.

And that was the end of that. A brother is in a rush, on order from a higher power, to start the first psalms of the ritual.

Sanmu did not understand the meaning of the question that she censored. Is Gyancain Norbu, the official (China-appointed) 11th Panchen Lama considered legitimate in his homeland, or does the local clergy maintain its faith in Gedun Choekyi Nyima, the original Panchen Lama forbidden by the Party? What we have here is a fact known by few people, outside of specialists, that there are two simultaneous, competing 11th Panchen Lamas.

In May 1995, President Jiang Zemin did not accept that Gedun, then six years old, was presented to the world as the reincarnation of Choekyi Gyaltsen (the 10th Panchen Lama, who died in 1989). To be more precise, what he could not stand was the fact that the Dalai Lama made the announcement himself and from abroad.[30] For Jiang, as for all appendages of the Communist state, the monopoly on power in China is indivisible. In making his announcement, the pope of tantric Buddhism had carried out a smashing psychological victory over the Chinese Communist Party. But it came at the cost of irreparable political damage. The Dalai Lama caused the regime to lose face and so, in the eyes of the Communist administration, reinforced their perception of him as an implacable adversary. Before invalidating this reincarnation, regardless of the cost, China's top gun demanded a vote among the Political Bureau to have the Panchen Lama deposed and arrested, and just to be safe, his parents as well. In these political spheres, paranoia is absolutely manifest, and ensuring in all certainty the loyalty of the next Panchen Lama was a top priority, indispensable given his position in the clergy. In the absence of the fled Dalai Lama, the Panchen remains the depository of the wealth of the Lamaist temples and the negotiator-manager of their destiny.

Gedun is therefore locked up in some Alcatraz, and to this day it is a secret as to his whereabouts. Among the exiled Tibetans, he is called "the youngest political prisoner" of the regime. Unofficial sources locate him somewhere near Beijing and being carefully watched. He would have his rights to "the usual studies," as we were told one day by an official of the Ministry of Foreign Affairs.

In November following his arrest, Gedun was replaced by Gyancain, following another round of selection by the same committee of monks. This time it was minus their head man Chadrel Rimpoche, who was incarcerated for suspicion of sharing intelligence with the enemy.

One unexpected, rather hilarious consequence of these coexisting rival prelates is that our monks, caught between the dangers of State treason and betrayal of the mother

church, have simply opted to ban from their monasteries any pictures of either boy: since then, they revere the photograph of the 10th, deceased, Panchen.

Stroke of treachery at the Lyric Center

This afternoon, we go to the Lyric Center for our "informal" rendezvous with Zhuoga Deqing and her buddy Zhaxi Lazong. The day before, in order to give the girls the chance to whisper to us at the first occasion, the place of our evening meeting, all of us had agreed to avoid any sign of conniving together.

But once on the spot, an unexpected and sorry scenario unfolds. The deck has been stacked. Awaiting us is an honor guard composed of the director and the director of the political commission, along with an assortment of other officials. In the middle of them is Zhuoga, with a troubled smile. Refusing my attempts to ignore her, she gives me a big sign, something like the kiss of Judas, to let us know that our little plan and cover has been blown.

Throughout the visit, she sheepishly stands by the officials, through the rehearsal of *The Eagle of the Mountain*, a ballet with eight magnificent dancers. They are equally supple with their bodies as they are with their graceful footwork. Then she has me interview Dexi Meitou, the beautiful assistant director, who sings with a remarkable soprano voice. She and our friend join in a duet. They belt out, with unbearable treble stridence, lyrics evoking their primordial loyalty to the Party, their prince who feeds them. Between the lines was the loss of freedom that Zhuoga explained to us so languorously the night before. We had been betrayed.

The interview and duet take place on a stage in front of an empty auditorium for 1,000. It is equipped to international standards. We see lighting and stage set systems that we could never imagine in a region that is so isolated and threadbare.

The whole center cost 50 million yuan. "We made the choice to exhaust all our budgetary allocation for 10 years," explains Dawa Xizhen, the athletic, fortyish administrator. Dexi adds that their company is the best in Western China and has collected many medals, including the 2006 national prize for minorities. Tibet has something like one-thirtieth the population and is two or three times less rich per person than neighboring Sichuan. Yet from the perspective of performing arts, Tibet soundly defeats this economic lung of China's West. This confession comes across as a little parochial. But competition between provinces is allowed and is even considered in good taste in China. Dexi, the soprano-singing director, hits the nail on the head by citing a Tibetan adage that is kindly jingoistic: "Tibet is the mother of song and dance. As soon as we learn to talk, we know how to sing and as soon as we learn how to walk, we can dance!" [31]

We must finish this day of being played for dupes. This end is preceded by a text message from the Waiban telling us that the visit to a Muslim family's home, unsolicited but put on the schedule anyway last night, is cancelled, due to it being Ramadan. As compensation, we are offered a visit to the mosque and an interview with the imam.

Looking back, I maintain the view that we gained rather than lost from this change. But in spite of it all, we end our day with a clear realisation of what we are here: just grains of dust between the wheels of this state machine, which is extraordinarily powerful but insensitive to the aspirations of any human beings.

Just when we are about to say our goodbyes on the steps of the center, the administrator Dawa Xizhen tells me, with a natural and affable air, that 80% of the Tibetans "carry the Communist Party in their hearts."

OK. But then why shut the place down so hard? This splendid tool of artistic creation means that the Chinese government takes very seriously its responsibilities in matters of culture. And it has no doubt in its ability to control everybody else, to get them to sing its song in the key requested. It is like the old people in the park here, lugging around their nightingales, magpies and finches. They sing blindly in covered cages while their owners delight in their songs.

What dissidence?

This mishap at least helps me to think about the manner in which dissidence, or its tendencies, lives and dies.

During that hour on the terrace at the café, these two young ladies flirted with the devil, who was not us, but the illusion of their own audacity and the chasm before their eyes of the little advantages they had to lose. They went beyond the line in spending an hour with us sulfurous foreign visitors. For sure, they did not risk anything by normal Communist rules, because they still had not received instructions about us. But our paths had barely separated and they denounced us without so much as a thought.

If they had not done it, we would probably have ended this evening in some apartment or empty bar with several friends from their circle. And there, a spy, an informer would be hiding, who would denounce the whole group, with even more grave consequences to consider. The secret services would have pinned these imprudent crickets, these presumptuous grasshoppers in their bug collections. It would be a rich and morbid harvest, with a super jackpot of punishment, blame and obligatory self-criticism. There would be other sanctions for those who confided in us their most venomous resentments. At the worst, for our two new connections, it would be "Farewell to the good life and easy street" – guaranteed jobs, nice apartments and circles of friends.

Zhuoga and Lazong simply caved in from a lack of mutual confidence. Or another possibility, they did it together in a joint decision. This would seem the surest way to avoid a major goof-up on their part. Therefore, they did not have any choice and it would be pointless for us to hold it against them.

For the price of her "correct attitude", Deqing Zhuoga received her promotion the very same day. This is according to what Li Feng later learned.

During this same day, by pure chance, we run into several other forms of dissidence. In three different places, three men approach us and answer in somewhat simple, but heroic and efficient English. They let us know that

they refuse under any circumstances to speak Mandarin. It is their humble but useful form of resistance. One works at the Jokhang terrace café. The second one is a waiter in the "English" garden of a big city hotel. And the last one is a tour guide whenever he finds the time. He proudly declares to Laurent that he has learned more English during one year of practicing it on the streets than Chinese after three years of obligatory classes.

One of the sources of this Tibetan dissidence naturally derives from a conflict between the generations. Some of these 20-year-olds scream at their parents, "What have you done to my culture, Dad?" The French Huguenots of the 18th century and France's Arabs of today are no different, complaining to their elders for sacrificing too much for creature comforts, to the detriment of the soul. And as Tibet is on track to becoming a tourist mecca, the rule of the turf from a Tibetan perspective is to speak with the travelers in English, all the while ignoring as much as possible the occupiers and their Mandarin tongue.

Another obvious branch of resistance is the clergy. So, the state takes no risk and keeps them muzzled. Everywhere in these holy places hangs the photo of the deceased Panchen Lama. No photos are seen of his official, contested successor. But the monks are not willing to simply indulge in this kind of childish, half-endorsed kind of foggy rebellion and innocent acts of resistance without damage nor consequence. No, they are the ones who were in the thick of the riots, falling in hails of bullets and riot clubs, in 1987 as well as 2008.[32] The nuns are not sitting on the sidelines either. They also committed acts at least as courageous as their brethren. However, when taking action, all of them trembled with fear, and tell us so: a mental state which, in my view, could make quite a good description of heroism.

These monks love life, but have so little, so they feel they have nothing to lose. These battles are patriotic. They look upon themselves, and rightly so, as the soul of their people and the repository of their past. It is also theological, this fight against China: it is a struggle against materialism, earthly passions, pleasure and worldly values.

In the end, another source of this dissidence is Tibet's economic checkmate. It is taking a full body blow from the border closings and every person stuck on the inside is a potential recruit for a revolt. Unemployed people circle the Potala, kneeling and begging. They can only look up jealously at the high class of mainly Hans who cavort around town in their Porsche Cayennes. The incendiary insurgents of March 14th included among them these enraged poor. Contrary to what was written in the Chinese press, they not only turned their wrath on the symbols of the Party and the state, but also destroyed the belongings of the rich property owners, office buildings, fashion stores and chic restaurants.

The charcoaled remains say a lot about the violence of the shock, like the anti-UV glass bay windows that were knocked out with paving stones all the way up to the fourth floor. Some of these places were abandoned. Others were reopened but not restored. Their merchandise is simply stacked up on trestle tables, between walls and under ceilings that are still blackened from the soot. It is almost

like the owners do not have the confidence to reinvest. This fear to reinvest five months after the insurrection, in spite of a police force armed to the teeth, suggests a victory for the insurgents, who have infused in their occupiers an indelible doubt in the future and even their legitimacy on the plateau. It is the same sort of doubt that would be felt less than a year later in Urumqi. There, the Hans of Xinjiang cried for their 192 deaths during the insurrection of 5 July, 2009!

Hans and Tibetans, an unexpected solidarity

Surprise: Dissidence in Tibet extends to the Han Chinese, this dominant ethnic group that has come from down below. On the streets, we meet three young people from the lowlands and they do not mince words, bemoaning how the Tibetan crisis is being handled.

Pan is a tour guide from Shandong who came here in 2007 to start his life anew. Mei is a university graduate and is with her boyfriend, who is a driver in the military. They all expressed their dissatisfaction with how Lhasa is in such lockdown mode. "We don't treat a city in our country like this," says Mei. Confidence in the state is at low tide. This official authoritarianism and nationalism pushes each group against the other. The powers that be have rhinoceros hide for skin and the alarm bells, shrill and ever-present, are never heard in Beijing.

These three friends adore this land, with its 350 days of sunshine each year, the purity of the countryside and air. They also love Tibet's local products and the lordly privilege of being able to escape the promiscuity of the rest of China.

But at the same time, this solidarity of dissidence has its limits. The two male friends particularly have a political fiber that is vaguer and less argumentative. They still retain from their childhood culture an atavistic contempt for the local population. They think there is no need to learn Tibetan, since it is "too difficult" and not interesting. And it has to be said that the locals are, in spite of everything, simpler in spirit, not as educated and less concerned about hygiene. Above all, what really gets their goat is their inability, almost genetic, to save money or know how to run a business.

"When they have three cents, they spend it among themselves, drinking and feasting, almost like if they have money it dirties their hands," says the driver, while the tour guide gives the refrain that "the men let the women do all the work; they are the only ones who do anything here." Bolstered by the certitude of their cultural superiority, our newfound friends spout, without malice, all the standard racist clichés, justifying – and justified by – China's military conquest.

Mei has been here for seven years. She gave up her university career and friends to follow her man. Her companion exhibits no coyness when confronting his role with the occupying power. He is very proud to have crisscrossed all the roads and mountains of Tibet and he knows them by heart. But he is worn out from this arduous work. In terms of health, he is paying a heavy price, his body starting to suffer. His teeth are getting

brittle and falling out due to the lack of fluoride in the water and food. He dreams of going back to the lowlands. Conquering Tibet is not worth his life, and now that it has been a few years, the sense of adventure is over.

NINTH DAY
SUNDAY, 28 SEPTEMBER
THE CHOTA NASJIB MOSQUE

So, here we are at the Chota Nasjib, or "Little Mosque," one of five Muslim places of worship in Lhasa. This one is two steps from the Jokhang. This ancient Mohammedan chapel is of Persian origin, via neighboring Kashmir, and co-exists on good terms with the Tibetans and their language. This is in contrast to the Muslim Hui population, which is Chinese-speaking, a recent import, and hated.

The Chota Nasjib edifice is reconstructed, modern and impersonal, which is too bad since it hides its glorious past. Starting on the outside, on the little square in front of the foyer, we can see that this place of another religion is subject to a tension that is just as palpable as in the Buddhist temples. Armed with a machine gun, an elite marksman dressed completely in black is hunched over on the roof behind the pediment, focused on lessening his exposure to being shot by a sniper.

Winter worms, summer plants

The steel gate is lacquered in green paint. Outside, there are about 50 "Ka Che"[33] faithful moseying around. The men are bearded, in tunics and skullcaps. Plump women are in multicolored tunics with veils over their noses. They chat with each other in small groups, standing or sitting on the ground, but not perched on their flat feet, crouched down like the Chinese do. We approach and see that business is being done. It's a little market, devoid of clients but full of riches.

Buckets are sitting on newspapers spread out on the ground. On display are several kilograms of a top-selling commodity: they are curled up and dehydrated, about three to four centimeters long and bronze in color. These are cordyceps, also known as caterpillar fungus (Yartsa Gunbu in Tibetan). They have been worms and they have been plants: now they are heading for their third lives. This mushroom grows inside insect larvae, whose eggs are laid and hatched underground in the prairie in the autumn, where they spend the winter in dark lethargy. When the weather warms up in the spring and especially in the summer, these larvae come out and they are engulfed and colonized by the spores of this mountain fungus – this is the second part of the cycle which is the genesis of its Chinese name, "dongchong-xiacao" (winter worms, summer plants). Thus in its last life cycle, it is freeze-dried and used in Chinese and Tibetan pharmacopoeia, where it has a reputation as one of the best and most efficient products to reinforce the immune system. In this little souk, before our very eyes, the price is 70,000 yuan per kilogram, according to one of the sellers.

Like every minority religion that is semi-segregated, these Ka Che are very well organized and lead a lifestyle in the milieu of making money. Their diaspora has thus monopolized, from times immemorial, the market for dongchong-xiacao. The gatherers or harvesters are Tibetans. They are accused of causing damage to the fragile prairie with their spades and rakes as they turn the topsoil in search of this fungal gold; hectares upon hectares and entire valleys are canvassed for a handful of worms. The harvest is getting sparser and sparser, given the explosion in demand that is far outstripping the environment's natural capacity to reproduce.

So, what are the relationships like between the Tibetans and the pockets of Muslim residents? Pretty unfriendly, in fact. Labrang ("Xiahe" in Chinese) is in Gansu and is one of the holy cities of Greater Tibet, sheltering 6,000 monks and lamas. In 2006, we were taken by some Tibetan teenagers to a celestial cemetery. These rascals proudly bragged about their favorite pastime: when the sun sets, they throw pigs' ears, tails and, of course, testicles over the wall of a Hui mosque. I could only presume that such a grotesque profanity as this must be coming from the parents themselves. The next day I did a little investigating among the Muslim community. I was able to verify that they return the hate towards the Tantric Buddhists: the imam and his faithful, who are some of the richest businessmen in the city, amplify their prejudice for the

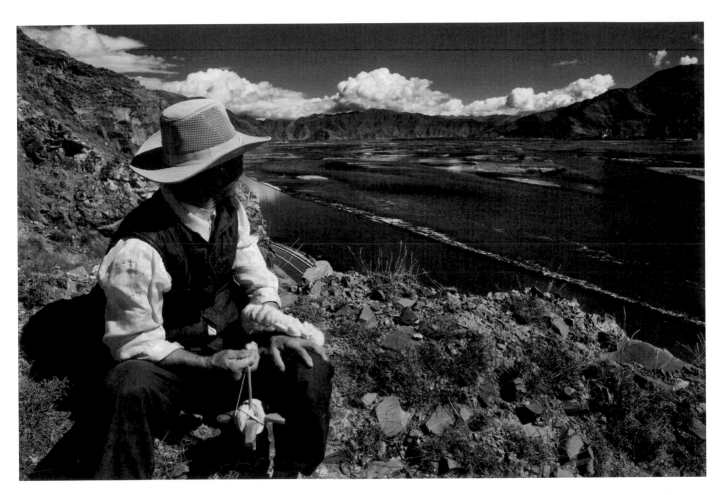

A farmer spins his wool close to an irrigation canal near Kapa.

Buddhist monastery of the Gelugpa order. Drepung.

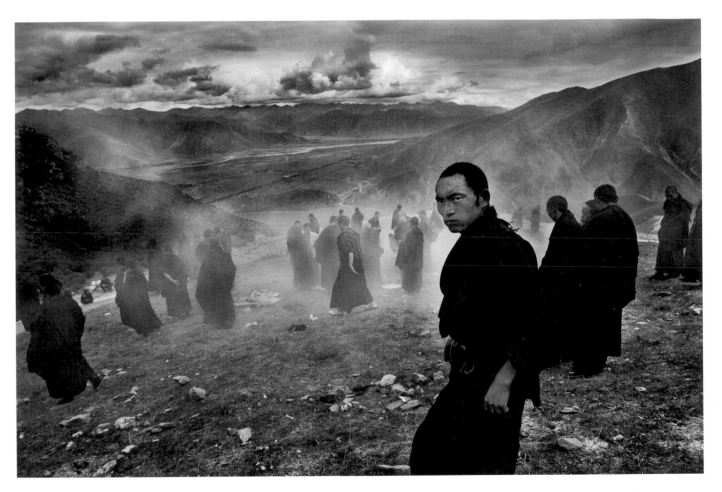

Monks have just completed a ceremony marking the end of their quarantine. Buddhist monastery of the Gelugpa order, Ganden.

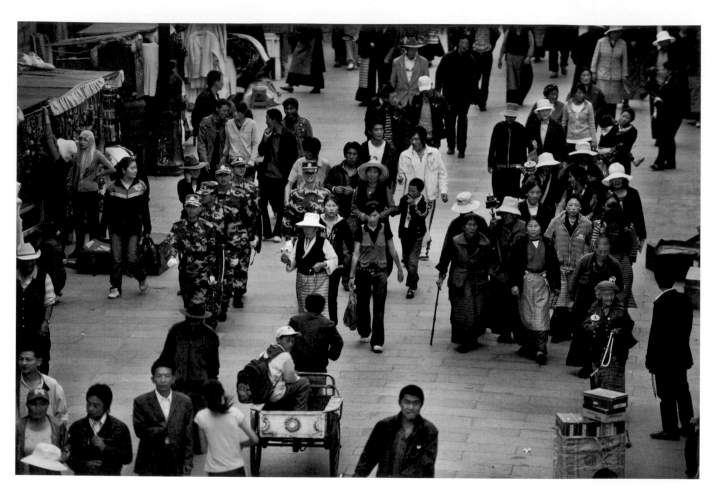

The military patrol the streets around the Jokhang in Lhasa.

Wire fences prevent nomads and their herds from crossing into newly irrigated land.

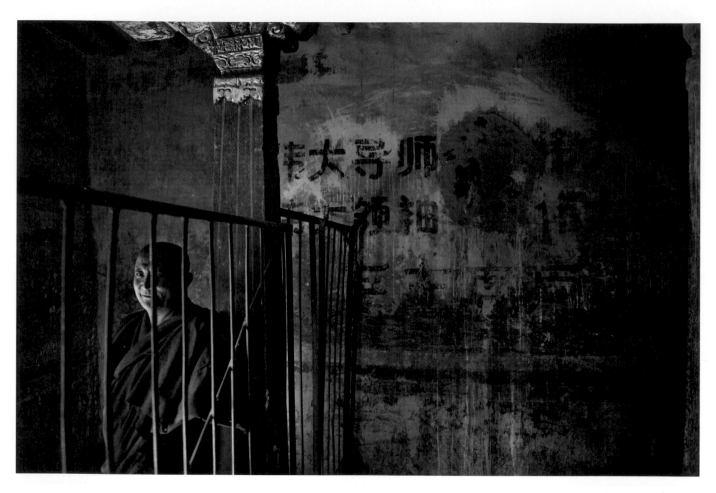

At Drepung Monastery near Lhasa, a monk stands near a slogan proclaiming the glory of Mao Zedong.

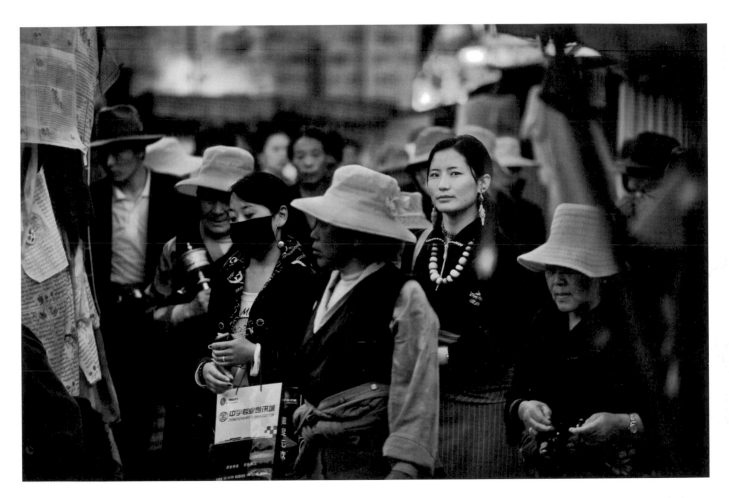

Pilgrims circumambulating the Jokhang in the Tibetan part of Lhasa.

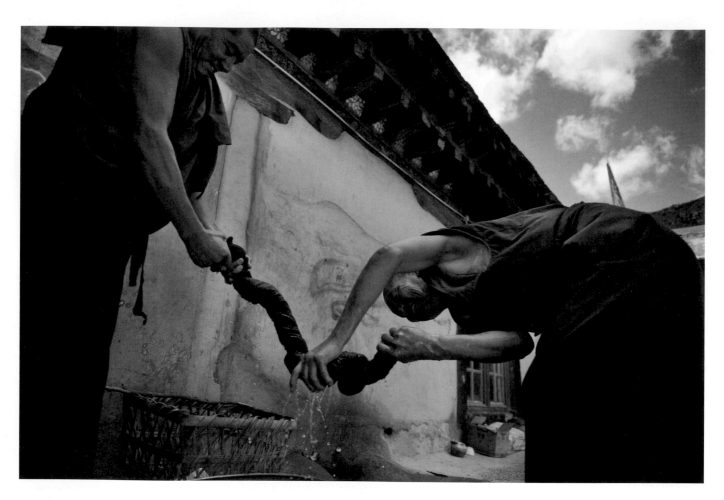

Monks living in the Drepung Monastery take care of daily chores.

neighbors and blame them, along with the Hans, for all the world's miseries.

Yakub

10.00. We go inside the Chota Masjid mosque. It is deserted during the day, because now is the time of Ramadan, the holy month of fasting. The nave is clean, full of light, and shows an order that borders on the impersonal. Rugs are spread out here and there; a straight staircase leads up to a wooden pulpit. Yakub, the *Ahron*[34] (Imam) who welcomes us has fiery eyes (not slanted, but looking Caucasian), and an angular nose, his face flecked with little veins. He is neatly dressed but without style, in a white shirt, grey vest and jacket. Even in the vestry where he receives us, behind baskets of fruit and bottles of mineral water, he sports a curious tweed hat with washed-out grey and white chevrons. Underneath this headgear, chestnut-colored rebellious locks stick out like the unruly hair of Rasputin, notorious Russian monk and confidant of royalty a century ago.

Yakub comes across as cultivated and courteous. He seems quietly fanatical and a little sad, knowing that this group of visitors is beyond his faith's salvation. Nevertheless, that does not deter him from giving us precious information about his ancient community, which plays an active and unexpected role in the history of the region.

According to Yakub, there are not many Muslims in the city: only about 5,000 out of the 600,000 inhabitants of greater Lhasa. José Cabezon,[35] a respected expert on Tibetan Islam, estimates that the number is closer to 3,000. Yakub says the parish was born in 730 AD in the early years of the Tibetan kingdom and grew from 812 onwards, the year a lord of Kabul, vassal of the Tibetan king, converted to Islam after losing a war against the Abbassid caliph al-Ma'mum. Then in 982, another great Afghan scholar by the name of Udud Al Alaam[36] confirmed in his writings the existence of a mosque in Lhasa.

Originally from Ladakh to the west, from the Sikh Indian territories, and especially from Kashmir, the "Ka Che" trace their genealogy back to the 12th century. They form Yakub's congregation in the Chota Nasjib mosque and, most important, they are Tibetan-speaking. On the other hand the Muslims whose forbears originally came from Ningxia in the north via the Silk Road and now form the 2,000-strong Gya Ka Che community of Lhasa, are *Hui*, children of the Celestial Empire and so share the language and even the cuisine of the People's Republic.

A legend illustrates the cordial and mutually tolerant relationship between the Ka Che and the Lamaist theocracy. Around 1650, the fifth Dalai Lama is said to have heard about a devout religious person who practiced his daily devotions alone on a hill. Called to the Potala palace, the man explained that he prayed out in the open because he did not have a sanctuary. Touched by his piety, the ruler sent one of the best archers of his personal guard to that hill. From the top, the archer shot an arrow in the direction of each of the four cardinal points. The four arrows set the boundaries of the domain that the ruler granted as a concession in perpetuity to this imam and his handful of followers. It is this piece of land, called "The

House of the Long Arrows," that we passed through two days ago on the road from the celestial Lamaist place of the dead. To this day, it accommodates the imam's house, his mosque and small Muslim cemetery.

Islam has thus had an ancient and more peaceful presence here than Catholicism, which was introduced towards the end of the 19th century and suffered consderable pain and intermittent martyrdom of its French, Swiss and Italian missionaries.

Why such a difference in the way the two religions were treated when they came to Tibet? Ahron Yakub gives this unsurprising reply: "Because Islam is a peaceful religion which respects other cultures." In reality it doubtless has more to do with historical chance in line with the ups and downs of tolerance in any given region. Thus, 1,000 kilometers to the north, in Xinjiang, Christians enjoyed better fortunes. Arriving 1,600 years earlier in Kashgar, not far from the Roof of the World, they established a Nestorian kingdom under the rule of a mythical sovereign with a flowery beard and the vaguely French mediaeval name "Prester John." It was an enclave lasting only a few generations, but a brilliant though short-lived mixed-race civilization.

Another surprise: Yakub considers his community to be Tibetan and challenges the official term "national minority." However, the Ka Che rely on China and its police to live in peace – the elite sharpshooter on the roof is a sure sign of this.

Yakub and his brothers are prudent men. They define themselves as Tibetans, they claim the historical protection of the Dalai Lamas, but for all that they accept the support of China and its laws. Did the Ka Che suffer from the anger on the streets last year? At first Yakub denies it. But then he quickly admits that along with their Hui fellow-Muslims, they suffered the sacking of 50 stores, or 15% of the total destruction. "The bunch of bandits who set fire to Lhasa and drew blood that day had nothing against the Hans specifically nor against Muslims, but were against all humanity," he said. Perhaps that was not untrue. We have no testimony from the rioters of 14 March last year. They were clearly young, desperate, probably blind with fury, and ready to kill outsiders regardless of their ethnic origin.

The imam is therefore aligning himself with the Chinese position in analyzing the disaster. This may be due as much as anything else to the presence of Sanmu, as ever assiduously writing down everything that is said. Not to mention that also in attendance is someone who is introduced to us as the president of the "Democratic Mosque Board of Directors," the Party man, who is an obligatory functionary of every "patriotic" religious association in China.

To train his 10 preachers of the Lhasa Ka Che community, the Ahron informs us that his congregation is simply not big enough for spiritual self-sufficiency. Training is taken care of in China, at seminaries in Ningxia and Beijing (in Yakub's own case), or overseas – in centers including Pakistan (the International Islamic University of Islamabad), India (Lucknow), Dhaka in Bangladesh, and not least Riyadh in Saudi Arabia, which contributed

20%, or ¥700,000, towards the reconstruction costs of this mosque in 2001.

At the end of the interview, the imam surprises us with a question of his own: about the law in France against the veil being worn in public schools, at that time a highly topical question across the whole Islamic world. I explain to him the principles of the French republic and the need for an appearance of equality in the dress code of French schools, without any distinction of religion or ethnicity. Yakub thanks me. I do not hold out much hope that my answer will convince him. Nor do I suppose that his question was motivated by innocent curiosity about a simple matter. But we know very well that the ways of the Lord are inscrutable to us humans!

Drepung revisited

In the afternoon, we return to our Drepung monastery. It has as much to do with slaking the photographic thirst of our friend Laurent as anything else, as we are going to attend the Cuo Qian ("Big Meeting" in Tibetan). It includes all 400 of the temple's lamas and takes place four times per month. The dates are set by the abbot, using geomantic criteria, aided by books and traditions.

In the great nave, two celebrants intone religious responses. Quite portly and probably in their forties, they cut splendid figures. One reads his liturgy incredibly fast from strips of paper, which are turned over as required by an assistant. Meanwhile, a baritone chants texts in amazingly deep tones and an indescribable range, so rich that it sounds as if it was echoing within the walls of a cave. This is a unique art form, perfected by the lamas from the time they are small boys.

Under tastelessly decorated square columns painted in vermilion and ocher, the nave is lit by thousands of little vases with bases made of brass and in which a cotton wick burns in yak butter. The monks squat on rows of low benches covered in carpet. They only take up half the space and do not number more than 300. Fifty others are outside taking care of temple services or preparing food in the kitchens. If they are supposed to number 400, where are the missing 50?

"In prison," a solitary monk whispers to me after the ceremony. We run into each other in a deserted room and his eyes look like those of an animal that is being hunted. Those taken away were rounded up for their role in the March riots, after having been identified by video cameras.

The service lasts about two hours and is accompanied by a fraternal meal. After 20 minutes of liturgical chants and psalm readings by part of the members (the others constantly fidget to adjust their robes against the cold or chat in a low voice with their neighbors), a group of the younger ones jump up and take off as if they are running the 100-meter dash. A minute later they come back, each carrying a 10-liter bucket of butter tea, and use ladles to pour some for the lamas into wooden bowls that they have kept in their pockets. The more I watch, the more I imagine these Lamaist robes to be like the caves of Ali Baba: they store all kinds of unusual things, such as mobile phones, books and even kittens.

The tea is the aperitif. Next, without interrupting the chanting duos and collective litanies, it is time to be paid. In all, ¥535 is distributed to each monk. It is a nice haul which does not arrive every day. The minimum weekly donation is only ¥30, a bare-boned amount to say the least. As at the Jokhang, these young clerics show complete indifference upon receiving their alms, almost scornful of the money, but then discreetly put it in their pockets. Next, a woman layperson comes to hand over her *Obole,* a little offering, of three yuan. Her friend follows her and films the scene. Perhaps she hopes to take the photos with her to the portals of the afterlife to prove her good works and be judged favorably.

Then the young brothers again sprint away like jackrabbits towards the kitchen, and each one returns laden with food. Some carry buckets of "mantou" (steamed rice-flour buns), others a feast of vegetable noodle soup, which they diligently pour into the same tea bowls, going down row after row, place by place. To receive the burning-hot soup with its big chunks of cabbage, each monk has his preferred method, magically pulling out from his miracle robe spoons and chopsticks as needed. The unprepared among them, or at least the ones lacking in polite manners, eat the soup using their hands or suck it down in big gulps.

After second helpings of soup and steamed bread, now is the time for them to clutch their bright yellow (or in some cases faded) Phrygian bonnets, either kept on a shoulder or by their sides. Each of them takes his and quickly adjusts it on his head: this is the celebrated "yellow hat" that was imposed in the Buddhist school of Gelug by its founder Tsong-Khapa in 1409, shaped like a mane.

According to Sanmu, to wear it is an act of purity and grace in the face of passions. But after hardly a minute of this illumination, the devotees put their bonnets back down on their seats, get up without further ado, and scatter like sparrows flying across the mountainside. One of them speaks to us in English. Hailing from Shigatse, aged 29, Tsering has been living under the tutelage of Drepung since he was 14 years old. His only wish is that he never has to leave, since he has found serenity in his existence within the temple.

With the little goldmine that he has just received, Tsering plans to go visit his parents, as soon as permission is given (one day per week is normally allowed) or buy books, for example to help with his English.

When you think about it, his testimony is ambiguous. Several months ago, dozens of his brothers were arrested and interrogated. All of them are regularly forced to submit to incessant classes on patriotism or attend meetings where the Dalai Lama is insulted. None of this is broached by Tsering. He is right to hold back, as he is well aware that the path we are walking along is full of spies in monks' robes, not to speak of our guide who is within earshot. Yet Tsering is so at ease and spontaneous that he does not appear to be manipulated. His simple joy and confidence in the future runs against what we had been told before about a monastery that was completely closed from late March until mid-August. Whom or what can one believe?

The treatment of these monks is emblematic of the designs that the regime has for the region. The monasteries that were torn down 35 years ago were rebuilt by the brothers using materials paid for by the public treasury. But at the same time, their community is bullied and re-educated in the hope of breaking any resistance. That is probably futile; these brothers are undeniably strongly unified and supported by their families, even secretly by parents who are members of the Communist Party. The monks' hearts beat as one. In their monastic way of life, they share everything except beds. They pray together and preserve their powerful spiritual ambience and the right to live according to their own rules.

The regime's religious policy arouses within me very strange and ambivalent feelings. Weighing the facts, the scales can easily tilt towards the positive, with the administration respecting the domain of the soul, or just as easily towards the negative, an atheistic and narrow-minded policy doomed to weigh on a terrain of bitterness, rancor, and collective revolt.

The financial aspects of the Party's efforts are not in question. It pays for the restoration of religious sites and even partially covers the day-to-day expenses of the monasteries. Then there is the cost of 300,000 soldiers who are stationed on the Roof of the World, amounting to billions of euros per year. No, the issue here is the intolerance shown by both sides. The occupiers are convinced of their technical and moral superiority while the Tibetan emigrants neither forget nor forgive anything. It is a civil war, a cold war, between these two camps; they force one to make a choice: either for Beijing or for the Dalai Lama. But maybe, as Solzhenitsyn would say, we are talking here less about the regime than its henchmen, or more generally about the wide range of individuals responsible to it for managing the monasteries, from the local political leader to the guards atop the walls. All these people have their own, differing, visions of how things stand, with attitudes sometimes benevolent and sometimes narrow-minded. But for all their actions collectively, it is the state that has the final word, that holds the cards. What troubles me is that the state of peace here seemed better 20 years ago than today.

The Lhasa Diner

This evening, on one of Lhasa's grand avenues, we find the Dunya, a trendy restaurant these days and one of the rare ones that dares to stay open after 9:00pm. It is not deterred by the constant police patrols after this hour, or by a lack of customers. Fred, the Dutch owner, says his business was ruined for this year by the three days of riots and the clamp-down in the city afterwards. The result is that he has 28 waiters and waitresses in fantasy uniforms who still expect to be paid but are just twirling their thumbs. Except for a table of Dutch tourists and us, the Dunya is empty.

Fred sees a demoralized administration, in a fetal position, without the slightest inclination to reopen Tibet to the world for the time being. "I am simply very surprised that you managed to come here now…"

Fred is 51 years old, a hulk of a man marked by a truly entrepreneurial spirit. Two years ago, he risked buying a place on one of the most beautiful streets in the city to open his diner, counting on serving the hordes of Chinese and international tourists various dishes from around the world, based on "beef". The source of his meat is in reality invariably yak – served in Tibetan, Indian, French, Italian or Mexican dishes, pizza, paella or Khumb Dopiazza (Kashmiri mushroom curry). Fred will close in November as planned for the winter, and will reopen next year. The year 2007 saw four million tourists pound the capital's sidewalks, which gave Fred the opportunity to build up a sizeable war chest. And it is this reserve that will allow him to hold out until next year and then resume his venture.

A small health briefing

Your health matters here more than in other places. This high plateau reminds you very quickly and free of charge of a truth that is often forgotten elsewhere: you may take your wellbeing for granted but here you ignore it at your peril, as your body will take revenge.

Compared to sea level, the oxygen in Tibet's air is reduced by an average of 40% and the ultra-violet rays are twice as powerful, except when the sun is blocked by clouds. The obvious risk is altitude sickness, as well as pulmonary, cervical or cardiac edema. The only cure is to immediately immerse oneself in a pure oxygen tent and if this does not work, the patient has to be taken to lower elevations with more concentrated air. Push it too far and

one can experience in succession intoxication, numbness in the extremities, paralysis, unconsciousness and death.

Before leaving the lowlands, we subjected ourselves to a workout regime lasting several weeks (walking, biking and swimming). We also got medical checkups, including chest X-rays, while consulting several high-altitude veterans, Chinese and Western, for advice. We deduced from all this two competing and widely differing strategies.

The Western version is recommended by Benoit Raeckelboom, the physician at the French Embassy. The method consists of taking the diuretic Diamox for three days and drinking as much water as possible to purge the body of uric acid and all the other toxins. This lessens the work the kidneys have to do when they are confronted with having one-third to one-half of their normal fuel, oxygen, needed to function properly. This strategy is functional and mechanical, and like the recommendations of the Surgeon General is based on a multitude of studies.

On the more mysterious side, the Chinese method asks you to take handfuls of Hongjingtian (红景天) capsules, the rhizome of the red-flowered Tibetan Rhodiola rosea, as well as gel capsules of shark extract.

This second approach is less easy to understand for those who follow the precepts of Western medicine. The Chinese explain it by the theory of meridian lines along the axis of the body and by "*qi*", which is considered to be the body's vital energy. The gel capsules are supposed to make the immune system fight back naturally and the "naturopathic" capsules are to refresh, detoxify and stimulate the blood[37]. In any case, this remedy is quite

popular. Its advertising can be seen on walls everywhere and the treatment seems to work, according to all the locals I asked.

The first week our ills were numerous: stomach aches and headaches, insomnia, eye aches (even when wearing sunglasses) and joint pains. Three days after our arrival in Lhasa, we all got diarrhea, which was well taken care of by the clinic across the street from our hotel where the staff were friendly and competent. Hospitals and clinics seem liberally dotted over Lhasa's landscape and the fee is affordable for most: to treat our diarrhea, the cost was ¥28 for each of us, including stool analysis.

As the French predicted, our bodies are able to "take in" the altitude at a rate of 500 meters per day, which would mean about a week for Lhasa. One problem persists even now, the dehydration of the nasal passages and the sinuses, since the mucus membranes dilate and get infected. We have ended up not being able to breathe through our noses once we lie down flat. Last night I woke up again out of breath, in the dark, exhausted from the physical effort of consciously having to work on the breathing action of my lungs and rib cage. In the morning, Laurent and I exchanged "war stories" about our night-time travails and he said the exact same words that I was thinking: "I had a feeling like I was fighting for my life." Luckily, this sensation, warped by dreams and the rhythms of the dark, dissipates once we are fully awake . The burning aquamarine sky, with pinks and yellows at its edges, and the purity of the alpine peaks drive away the nightmares and easily overcome them in the morning. Our miasmas and petty pains are amply compensated for by the dreamlike spectacles and pristine perceptions that we experience in the light of day.

Another handicap from the altitude is that after we take a few steps, even on level ground, we get out of breath and pant like puppies. The hypo-oxygenation also acts on our "*Gemüt*", our mood or disposition. We are permanently affected by feelings of hilarity, even fulfillment and good luck. Due to this psychotropic effect, we can detect in our consciousness a change in the powers we have over our emotions and even our thought processes, perched as we are 3,000 to 5,000 meters above where we were born and where we are accustomed to living. For the body and for the soul, everything takes on new qualities. This is the heritage of a living kingdom, something free that no amount of money can buy.

TENTH DAY
MONDAY, 29 SEPTEMBER, GANDEN — FAITH AT HIGH ALTITUDE

Situated along an arc-shaped ridge top, the monastery of Ganden makes you work to reach it; the 40 kilometers of mediocre-quality road are punctuated by military checkpoints, where guards meticulously examine the paper laying down our designated route, all of which extends the driving time from Lhasa to our destination to a full two hours.

Ganden's surpassing magnificence first comes into view at the foot of the mountain, once you leave the banks of the Lhasa River. Surrounded by grassland and patches of scree, red houses are set off against the whites and ochres of the palace. Blue and white drapes flap in the high, asymmetric windows encased in black, under gold roofs that glitter like glowing stars. At the summit, surrounded by its two votive deer, the Buddhist swastika turns gently in its Orb of Laws.

The temple has retained its supreme status and beauty, thanks to the stature of its founder, Tsong-Khapa. In 1409, he faced a Buddhism that was in total crisis, having exchanged the essence of its faith for personal squabbles, sectarian conflicts and hollow slogans. His mission was to raise the faith from its ashes and bring it back to its original sources. This leader created the Gelugpa order (the yellow hats), which was quickly promoted to become the official school of the Dalai Lama. The geographical choice of location of its headquarters, Ganden, was not accidental. It is full of symbolic meaning. The monastery sits high in its mountains, far from the intrigues and luxurious life of the capital. Ganden is in a class of its own in another way too: its altitude at more than 4,000 meters above sea level. It is the sanctuary "closest to heaven," isolated from worldly concerns and material distractions.

Unlike the monasteries of Sera and Drepung, which along with the Potala were protected during the Cultural Revolution, reportedly by Prime Minister Zhou Enlai himself, Ganden suffered serious destruction before its main buildings were restored in the 1990s.

When we arrive at the main nave, the religious service is well under way, with 400 monks all in the lotus position chanting their psalms. Their voices are stronger than in the valley and are less prone to fade into vague mumbling. The verses sound more forceful and virile. Here too surges forth an incredible weighty voice, which sounds as if it comes from deep in the stomach and reaches the very extremes of the bass range.

After the service and several stories higher at the end of a maze of ancient stairs and passageways, we find a cell where two monks are seated performing their own separate

ritual, with cymbals, bells, rattles and an imposing drum at their feet.

Elsewhere, alone in a big room, an old lama chants his prayers.

On one of the highest terraces, we can make out several hundred meters away about 50 monks on a sloping lawn, seated in a formation resembling a swallow in mid-flight. They are chanting behind a fire giving off a huge plume of incense smoke: it is the festival of Gai-ye, the Celebration of Joy. It is the time when the brothers can "return to earth" after 40 days of fasting and purification. Once their ceremony is concluded, they return to the monastery, arm in arm and having a great time!

An innocent question: do these youthful young brothers in their prime have a sex life? According to the information we were given, abstinence as it is practiced in the Tibetan orders is not the same thing as that practiced in the Catholic church – perhaps it is a more modern version. Chastity is imposed on full-fledged monks and nuns, while the laity is expected to practice "correct sex," that is relationships that do not cause hurt or suffering. In reality, they are often quite free. In other words, it is hinted to us that if a woman is desired, provided that the tryst happens outside the monastery and not during hours of service, what harm is there in that? These remarks certainly do not mention the possibility of homosexual practices, but for all that do not exclude them either.

Sanmu surprises us today. We are certainly at loggerheads and will remain so: she issuing her official instructions and making us comply, we desperately wishing she would just leave us alone and let us enjoy some freedom. And now suddenly she allows herself to say things that are off-limits, outside her zone of control, with a touch of humor and apparently with sincere feeling. Is it because we are communicating with her in Chinese, her second native language? Or that she can see for herself at every moment our respect for her two peoples? Her contact with Brigitte, the complicity of humanity and compassion between two women, seems to be having an effect on our relations.

We park the minibus two hairpin bends below on the road going back to Lhasa and make a lunch out of several tomatoes, some eggs and some "mantou" rolls saved from breakfast, washed down with bottles of beer bought at the souvenir store.

There is a charnel-house cemetery behind the crest next to us, marked by a pole festooned with many wreaths and a profusion of birds of prey circling slowly overhead. Sanmu informs us that this form of open-air burial and passage to the afterlife is preferred by 80% of the people. In order to liberate the souls from their dead bodies and allow them to take flight, Sanmu's grandparents chose to let their bodies be devoured by vultures.

Sanmu does not comment further. But this practice must surely be contrary to her sense of confidence in modern-day progress, science and education. She has made a choice to break away from the obscurantist past. She supports China and the Party, believes in her region's integration in the nation, in which she sees less a chance of disaster and more an opportunity to put to an end, in two generations, to what has been millennia of backwardness. But her

family and her culture have also deeply instilled in her a blind respect for the wishes of parents. This young woman cannot but feel torn between the diametrically opposite values of the church and the state. Li Feng has learned that Sanmu comes from a prominent family in the old regime. They might have been former landholding aristocrats who were dispossessed by Mao in 1959. Would Sanmu follow the credo of "revolutionary parents"[38], breaking away from grandparents loyal to the old traditions? The Lamaist faith has major elements that are still alive in Sanmu and in conflict with her Communist beliefs. The reticence which generally prevails here restrains me from questioning her more.

Like all the reformed Tibetans that I meet, Sanmu has absolutely no doubt as to the capability of Chinese Tibet to preserve its culture and its language. Better yet, to reinvent them, with a contemporary style adapted to the needs of the 21st century. Perhaps these assurances are nothing more than a fig-leaf or an indispensable excuse for her allegiance to the nation, to avoid her being cast as a traitor to her own people here.

Sanmu then lifts another veil concealing the rifts between her community and her wider world. Laurent joked with her about all the good-looking guys cooped up in the monasteries and taken out of social circulation for all the beautiful local girls. She responds by citing a Tibetan proverb: "Cultured and educated, the good boys are at the monastery and when they come home, their mothers proudly serve them food." Then she adds as an aside, in a half droll, half bittersweet tone, "For us girls, 90% of the good boys today are in India," meaning those who left on foot in the darkness of night to trek across the Himalayas, to regain their freedom, and to be with the Dalai Lama.

Among these "good boys" is Ogyen Trinley Dorje, the 17th Karmapa Lama, who fled to India in 1999. He is head of the Kagyupa school of the faith and is considered a possible successor of the Dalai Lama as head of the Tibetan church. Even after ten years, he is still very much in the line of sight of both Lhasa and Beijing. This is a reminder of one of the complex and unfamiliar aspects of the religion: Tibetan Buddhism has not one, but four religious orders[39] , each of which have played their part in the country's religious and social development, with all sharing spiritual and worldly powers.

While Sanmu would never say anything so politically sensitive, it is known that a large number of masters of these orders, their liberty threatened, chose to take the road of exile. Many of those who remained here to teach the dogmas, doctrines and rites are of lower standing and caliber, providing training that is sometimes a little fanciful. This is of course exactly what Beijing wants, but it would be a mistake for Chinese leaders to rejoice about it. On its own ground below, across China, Beijing can look back over the last ten years and see for itself the price of persecution in all religions: too closely watched and suffocating, they react by going underground and worshipping clandestinely, entailing the risk of splitting into sectarianism. False prophets emerge with no-one to block their paths. It is like a form of AIDS infecting the

faith. Everybody is a loser, the bona fide churches as well as the secular state. The Falun Gong movement is not the only fruit of this perversion, even though it is the most famous and the most stubborn, and is now ineradicable.

What Sanmu is suggesting with her "good guys in exile" comment is that these are brothers and potential lovers who are now lost. Obedient to their parents, they have taken the path in which deeply traditional Tibetans see their country's salvation, the gesture of ultimate resistance. They have chosen exile in the land of freedom to the south, India, for lifelong asylum.

Curiously, across the aisle, the fairer sex seems to me to be taking another path. Looking at Sanmu, Mrs Bassan, Zi Zhen or Pu Zhuoba, her mother, and others we have met on this trip, the "girls" seem to have a more realistic, more pragmatic and conciliatory vision of their world. They opt for real secular power, for Communism and the state, with its laws, investments and modernisation. In the name of such a promise, many Tibetan women are ready to overlook ethnic discrimination and authoritarianism, and all the errors committed by China's post-Stalinist regime. They seem to be betting that these concerns will somehow be resolved in the long run.

Naga, a simple French restaurant

At the start of the evening, we go out and discover something very rare in Lhasa, the only French restaurant in the capital of the Land of Snow. It is situated just a few steps from the official theological publishing house, in a neighborhood that is fiercely guarded by army patrols on foot and in trucks. Helmeted, armed with billy clubs and guns, these soldiers are dressed for combat. They are frequently ensconced in plastic armor protecting their entire bodies. This armor is khaki over the body and transparent around the head: it is the ultimate urban anti-guerilla gear.

This example of French gastronomy answers to the improbable name of Naga, which in Indian and Tibetan signifies simultaneously the cobra, illumination of the mountain spirit, spirit of the ocean, and the dragon people led by Varuna, the master of climates.

This symbolic name would make you think that we are entering some incredible palace built by a lord. But alas, the Naga does not even come close and offers little in the way of Gallic style. Its small bay window covered half-way up by a curtain fronts a cramped square room that is poorly decorated with garish wallpaper and very cheap-looking lamps.

The Naga has its reasons; the waitress explained that they just had to move under catastrophic conditions, following a fire.

However, a look at the menu amazes us. They offer a whole series of regional dishes from France, including *fricassée* (yak meat), *pot au feu* (yak), spinach crepes and *gratin dauphinois* potatoes. Other dishes go even farther in the fusion of the two cuisines, such as a ratatouille with "paneer", a roasted Indian cheese. With all this choice, we are able to order without any worries, especially given the Naga's extremely reasonable prices. After several minutes the dishes arrive and the food is of excellent quality.

While we eat, we learn that this little restaurant is 100% privately owned and does not have any French person in the kitchen, nor any outside French help. No one in the restaurant even knows a word of French! So who, we ask, has given this place its authentic French feel, with such touches as its little zinc-covered bar (made of plywood), and its square tables for two with red and white check placemats? Not to mention the perfectly written menu, the service and the taste of the dishes?

Once again, it is our precious Li Feng who supplies the key to the puzzle. Two years ago, two expatriates helped to launch the restaurant. A woman tour guide known as "M" and Philippe, a doctor sent here by the International Committee of the Red Cross, got together to assist the entrepreneur. They chose the recipes and translated them, trained the chefs, and detailed the use of spices, cooking methods and proper presentation. They defined what the interior should look like, and typed up and printed the menus in four languages: Chinese, Tibetan, French and English; since then not even a comma has been changed!

This is another of the many developmental micro-projects that have benefited Tibet and from that point of view makes it one of the most pampered provinces in China. At the very least, the Tibetans are quick learners. Since the doctor left the region 18 months ago, this modest establishment has survived winds and storms, riots and fires!

The red light district of yellow Lhasa

Having savored our last mouthfuls, Brigitte and Li Feng opt to go back to the hotel to get some sleep while Laurent and I leave to discover the enchanting flowers in the garden of vice, Lhasa's temple of sex. We seek to verify an allegation that we keep hearing: under the new regime, Lhasa has become a hotspot where big money is being made by offering the bodies of thousands of women.

Today, in the kingdom of profit, Shigatse (the second largest city in the region) counts "thousands" of female prostitutes, mainly Hans from Sichuan province.

On this subject, the internet is not silent, but its information should be treated with caution. As of 1998, Lhasa is said to have had 658 brothels plus another 238 massage parlours and karaoke bars. Most are quite small, with half a dozen girls aged 15 to 35, often Sichuanese Hans but also some impoverished Tibetans arriving in the city from the countryside. Flourishing near the military barracks by the river Kyichu, in the Shol district below the Potala, and in Jamalinka Island, the number of such establishments is reputed to have risen to 1,600 in 2004, prompted by the custom of thousands of railway construction manual workers and 300,000 soldiers. Other clients come from the contingent of 200,000 Chinese civilians, especially Han and Hui officials separated from their families. They are often sent "To Tibet," after being in disgrace or committing a serious mistake, like Russians exiled "To Siberia." Also, with the region opening up for tourism especially from within China, women also work

in the hotels, seeking customers among the four million tourists who visited the Tibetan plateau in 2007.

The problem with these data is that they cannot be verified, and are ideologically tainted (taken from sites that are violently anti-Chinese and/or anti-communist such as www.phayul.com). In contrast a French traveler, Jean Dif, who was here four years before us, reported that he had heard of swarms of Lhasa prostitutes but had not been able to find them. In all my research on the internet and among my fellow correspondents, I was not able to find any reliable statistics. It is symptomatic of the state: prostitution is a taboo subject of discussion. Any independent information, or numbers, is quickly censored. The prudish government will never admit to the existence of such a running sore.

For an urban area dedicated to sex, the English-speaking world talks about a "red light district." The Chinese prefer the color yellow, which pornography shares – who knows why? – with the emperor.[40] In Lhasa, the biggest zone for vice and the obscene is located on the island of Jamalinka, renamed in Mandarin Taiyangdao or Sun Island (hence yellow!). It is a newly developed quarter, inhabited by Hans. Thirty years ago, it served as pasture for migrating herds of goats and sheep, as well as for fields of barley and rye.

The owner of our taxi agency told us that in March, during the three days of fire and blood, he escaped and took refuge in Taiyangdao with tens of thousands of other Hans. The site offers a natural defense that is almost impenetrable, surrounded by the blue-green, freezing waters of the Lhasa River. There is only one narrow bridge connecting the island to the city. During the troubles, all it took was 50 soldiers armed to the teeth to maintain the security of the island. Today, in times of peace, it is a very discreet place, isolated and enclosed.

Once we have driven across the raging torrent of water below, we go along lanes that are gloomy and bumpy. The lack of lighting gives the whole place a Dickensian feel, a place where you feel much better observing from a taxi than on foot, as we skirt the façades of buildings and their sinister shadows.

However, the island is spacious. We drive past many restaurants that are lit but deserted. In spite of our clear instructions to the driver, from the taxi we cannot spot any of the seedy places we want to see.

The taxi finally stops in front of a tower that is graced by a large, garish electronic sign (eight meters tall and three meters wide). On it is a clip that plays, over and over, images of a disheveled female in a miniskirt and T-shirt, doing various dances. The images are in black and white giving the effect of a comic book, quite unexpected against the jet-black sky pierced with glittering stars.

We mount the flight of Freudian red-carpeted stairs. Once inside, we are welcomed by an army of idle minions who seem surprised to see clients arrive. This is undoubtedly due to the extreme rarity of receiving any "long noses[41]" in the region. It could also be due to the hour. "It's a little too early," the boss says, excusing them (it is only 9:00pm). But at the end of the day, business is business, so they escort us along a hallway where there is a

row of little salons, all decorated in the same design. They each have an alcove with a sofa, coffee table, flat screen TV and door with frosted glass. They tell us to relax and wait until they bring in the parade of girls. In less than five minutes, we will have our choice of pleasure. Alcohol will be coming. And the rest.

No thank you.

Upstairs, via an elevator and several corridors, we end up on a small balcony, among many others, made of wrought iron, overlooking a little Rococo opera hall. Several light men perched on ladders are setting up projectors, the final preparations for the next strip-tease act. Down below, there are rows of chairs waiting for businessmen and their girls in tutus and behind them a dozen tables with empty ice buckets, in place for the champagne…

Discouraged by the 50 minutes we would have to wait for the show to start, as well as the smell of old tobacco smoke, we go back outside, continuing our game of walking through the ecstatic dreamland of the Chinese in the Land of Snow.

Another taxi driver picks us up. In the front passenger seat sits – yes! Eureka! – a paunchy and wrinkled prostitute who keeps turning around to give us the eye and a limited amount of conversation. Her face looks tired with greased eyelids and large bags beneath. She is still young, probably in her mid-thirties. But hundreds of nights without sleep and hundreds of days under the cold sun have aged her prematurely.

It does not take long for her to realize that her clumsy invitations are going nowhere. Being a realist, she backs off. In fact, she probably never really believed anything would come of it. But why not try, just in case? There's nothing to lose. She admits to being from Sichuan; heck, everybody here is from Sichuan, it seems. In her case, it is her accent that gives her away.

After several seconds of silence, the woman suddenly begins a bizarre dialogue with her companion.

"They are foreigners… "

"Yes".

"They want girls…"

"…"

"They've got money. Maybe we could…"

After a long silence, the time the driver needed to concoct a plan, he declares that there is really nothing on this island, but he knows a great place, a short half hour's drive outside Lhasa with lovely girls, which we certainly would not regret visiting. Laurent and I look at each other, both feeling a chill going up our spines.

OK, OK, it is time to take control of the situation. I demand that he immediately stop the car, unless he could give a good address that was close by. Unwillingly, the two ne'er-do-wells end up dropping us off in front of a half shut-down hotel. We go upstairs, treading carefully on broken fake marble steps weakly lit by flickering lights, to the inevitable series of rooms where the bathrooms are separated by a simple pane of glass. Curiously, other than the person on duty, the place is deserted: no barman, no hostesses. "They have been notified," the man says, "They are making themselves beautiful."

But we are hardly convinced and hit the road. This place feels neither light-hearted nor fun, and here again we fail to find the answer to the puzzle: why is a brothel, at what should be the peak time of its business day, devoid of clients and ladies?

Back in the city, we make our way to the Babyla Club. It is one of the "must-visits" in Lhasa and it is at least not nearly as gloomy. We can almost say that it is welcoming. We get past the array of strobe lights, walking across a space that is choc-full of tables and chairs. There are adolescents and young adults wearing factory-torn blue jeans, skintight black jackets – a uniform which is universal but lacking in originality. Our ears adapt to the din and our eyes to the sticky atmosphere of smoke. It is a disco like any other, universally interchangeable, the clone of hundreds of thousands of others across the planet, from Vigo to Atlanta, Bombay, Omsk or Tel Aviv… the semi-curfew on the city has not discouraged 200 young people from meeting at the Babyla with its rhythms and songs from America and Taiwan. The songs are nearly up to date. They are the ones that were all the rage in Beijing for my daughter and her friends – last year.

These Tibetan youngsters are rich and/or close to the regime, not unlike our opera-singing friends from the day before. The club is very long in shape. Facing the bar and dancing space, one side is furnished with sofas arranged in arcs, each of which seat about 10 youngsters, close to the standing crowd who are dancing or drinking or just shouting to their friends. In the center of the horse-shoe of sofas sits a little cart full of bottles of beer and hard liquor that is paid for on the spot. While not onerous for our wallets, the prices are steep for those on a local salary. Beer is ¥20 a bottle and local liquor ¥100 per liter. In each group, Tibetan is spoken if everyone present is of local ethnicity – but if just one person happens to be from the lowlands, they speak Mandarin. At least this disco puts into practice one objective of the regime: the two communities are sharing a place where they can relax.

At around 10:30, we make our last stop at a 24-hour massage parlor that entices us with brightly lit pseudo-Egyptian bas-reliefs at the entrance. They depict an armada of women dressed in flowing veils and shown in profile offering muscular men with almond-shaped eyes and wearing triangular loincloths a warrior's relaxation (spot the mistake!).

We opt for a foot massage. While the water steams up and softens our feet in wooden buckets, we talk. The masseuses are petite (1.5 meters or shorter) and chatter freely among themselves. Like all the 70 personnel and the boss, they come from Chengdu. No Tibetans here. They belong to that group of eternal underdogs, the naïve and uneducated. Their stories are all similar. Xiao An (Little Peace) is 27 years old and Xiao Mei (Little Rose – I suspect both are probably pseudonyms) is 30. But their histories sound alike, as if they were twins. Both are married and have kids (five and eight years old). They left their homes for a new job more than 3,000 km away, in very difficult conditions. Using postal money orders, they send home three quarters of the ¥1,000-2,000 they each make on average per month. They phone their husbands

and children every Saturday for half an hour and do not go home to see them except once a year, for the Chinese New Year holidays.

In addition to their mediocre pay, the owner gives them a space in a dormitory room with eight bunks, and three bowls of rice with vegetables every day. Their existence is precarious. After the insurrection, "anybody who had ¥300 in their pockets for a train ticket," says Xiao An, "jumped on the train for Chengdu" – the safe home area reached after a 30-hour rail trip. Little Peace and Little Rose were not among them; too poor, they were stuck in the middle of the riots. Even today, says my masseuse, if she had the means, she would immediately go home and never come back.

The other characteristic of these women that strikes me is their racism that bursts out as if it is almost innate. For these women, who are dominated and mistreated, this ethnic rejection of others seems to me to be a way to compensate for their own situation. For once, they can feel superior to the human beings of another group who are even more scorned and unlucky than they are.

In her seven years living here, Little Peace is proud to say she does not have even one Tibetan friend. Because of their vulgarity and banality, I will refrain from quoting here the terms full of predictable prejudice that she uses to describe the local people.

Neither of them have the slightest desire to learn a word of Tibetan: "It's too difficult," affirms Xiao Mei, though she had never tried.

Without any fake bashfulness, these two masseuses lay out their misery and their hatred of the other, especially if that other is poor. This simplicity in admitting their bad luck is different from what is often the case in our cultures. In China, deprivation is considered not so much a loss or shame as a normal state of affairs, because it is both expected and mutually shared. What the Chinese poor look for is an ear to listen with some compassion to their tales of woe. Having the other person hearing your story is the beginning of therapy. To talk about it and get understanding from another is to restore one's dignity, whereas the Westerner who has lost all seeks refuge in bragging and fabrications.

The final tally of our rounds as grand dukes: Laurent and I have this evening broken a record for heroic failure, worthy of inclusion in the Guinness Book, taking the prize for the most hours spent looking for legions of whores and ending up finding only one – and an ugly one at that!

Do these 30,000 alleged prostitutes in Lhasa exist only in the imaginations of macho anti-Chinese? Anyway, that is what we think. Even at the Babyla we mingled with a crowd of well-heeled young people, but saw no prostitutes looking for clients. That is not typical of nightclubs in China.

We search for the most plausible explanation and conclude that this year without tourists has discouraged the ladies of easy virtue so that they took the train back to the lowlands to practice their profession there, or else reconvert themselves seasonally into workers with jobs earning less money but a more steady income. The sex

market here has collapsed for lack of customers in a time of ferment, with police everywhere. Apart from patrolling the streets and manning guard posts, the soldiers are kept cooped up in their barracks for fear of being attacked. Non-resident business travelers are forbidden from entering the territory. The climate does not help, either. Starting tonight, the temperature drops to zero (C), and in two weeks it will be cold enough to crack rocks. But another explanation cannot be excluded, namely that the rumor of armies of prostitutes especially for the soldiers is false, spread by malevolent prejudice.

ELEVENTH DAY
TUESDAY, 30 SEPTEMBER, LHASA

The Potala revealed

The big day has finally arrived. Holding no grudge for the worries we cause her, Mrs Bassan lets us know that at a cost of a thousand inconveniences, she has obtained for us the unheard-of privilege of four paid tickets to see the King's Palace, among the 3,000 fortunate visitors each day. For the Potala, as for so many other world sites, there is a *numerus clausus*, a daily limit set on the number of entrants to respect the place's venerable age. Last year a forged ticket racket hit the market. It allowed lucky would-be sightseers to slip in among the rightful ticket-holders who had paid the fee of ¥1,600. This year, following the closing of the provincial frontiers and the strangling of the flow of incoming tourists, the pressure has dropped. Currently the entry price is only ¥100. But not for long, Sanmu assures us.

A rush of adrenaline courses through our veins as we realize we are on the on the point of ascending to a place that is so emblematic. Gasping for breath in the rarified air, we finally finish climbing the bare paved slope towards

this masterpiece. From where I am standing now, the Potala seems like an eagle, or an eagle's eye overseeing its city-nest, from its mountain orbit. The nine o'clock sun streaks the sky and the clouds look as if they have been artistically sketched into the scene.

In every century, the Potala has breathed power, terror and the sacred. Only the last of these remains today, with thousands from the city and countryside making it the object of their own humble pilgrimages around its perimeter since they are unable to enter its heart or reach its summit. Since starting up the winding road, our eyes and ears register two clashing scenes:

Today is the day before China's National Day, which falls on October 1st. An army band marches, goose-stepping with boots banging down on the asphalt as an accompaniment to their military tunes. Reaching the flagpole with its scarlet national flag and without stopping playing, the 60 soldiers make a right turn and come to a halt on the plaza in front of the palace, a smaller version of Beijing's Tiananmen Square. This scene seems to me to be gratuitously provocative, a transparent symbol from a China that has decided to demonstrate at all times who is the boss here. Trumpets and horns add enough flats and sharps and other false notes to make up a whole second concert.

Several meters from these ear-punishing notes played by men in smart khaki uniforms, dozens of Tibetans in torn rags ruined by all their genuflections and black with dust and grease – yak butter perhaps – follow their path of Calvary, throwing themselves to the ground on their hands every three steps, enthusiastically and single-mindedly pursuing their sacred mission.

Military in the middle and pilgrims along the edge, each with their own discipline. Noise for one and silence for the other. Two societies next to each other, two concepts of the world, spiritual and temporal power. One dominates and the other is dominated. Heralds of their respective ethnicities, the two groups ignore each other; they have nothing to say to each other or to share, except this space.

Having observed it for eight days, from every angle but without going inside, we find that the Potala has had time to evolve in our minds, forming a double impression that is confirmed as we walk upwards.

Soldiery is everywhere, triumphant and indiscreet. The People's Liberation Army could not have done more to impress upon the population their need to bow to its conquest. Even in front of us, just a few dozen meters away on a hill called "Mount Medicine King," the army has wrapped electrified barbed wire around its base with big "Do Not Enter" signs. They have also disfigured it with a military telecommunications tower, as if to proclaim this sacred site's new function. Before 1959, it was an inviolable domain, with the penalty of death for anyone setting foot in the realm of this little "god of medicine."

Yet in contrast there before our eyes is the view of a Potala that was protected in all its splendor by the army and by Zhou Enlai, unlike the thousands of other religious sites across the realm which were desecrated during the Cultural Revolution. And more recently the Potala was

restored as one of the highest priorities of the state, regardless of cost.

Violation or respect? The administration and management of the Potala (and of all Tibet), the feelings of the Chinese and of the Tibetans, all are tangled up and mysterious…

Behind its surrounding wall at the base of its hill, the Potala begins at the former administrative village that once housed offices and royal ministries; today it is deserted. After ten strenuous minutes, we reach a large courtyard at the foot of the residence of the Dalai Lamas. From here on, military rules apply: absolutely no photography is allowed.

Colorful groups, Chinese, Tibetan, European and American follow along through forty halls that are open to the public. They are jointly guarded by Tibetan lamas and army recruits, in a coexistence that is both strange and silent. Forced to co-exist, here the members of the two communities of different ethnicities and generations seem as incapable of ignoring each other as hating each other.

Absurdities leap to the eye: the clash of incompatible rules, one set being of the carmine order and the other of the khaki. Within the minds of these young soldiers and old lamas, we can sense the vortex of contradictory, multiple sentiments, ranging from stoical or disillusioned resignation to haughty superiority, or conversely tantric meditation to naivety, crowned by an unexpected feeling of affiliation or parenthood. One could even say that such a situation could be a form of Buddhist ordeal imposed by masters on novices to teach them to control their passions.

And who knows if some of the army recruits, deep in their hearts and without admitting anything of the sort at their weekly political sessions, could be loyal followers of Buddha? At the same time (for the best of them), as being obedient members of the Party?

In front of me, one of the enlisted men picks up a fallen kitten and places it back in its sheepskin-lined basket, which is fastened on a pillar one meter off the ground. In another room, as serious as a pope, another soldier makes his way to the cracks between the ill-fitting boards of the wooden walls between the doors and windows and pries out the offerings of coin and paper money that are stuck in them by visitors. Then he walks over to place them in the offerings baskets.

And as a supreme finishing touch to the whole bizarre scene: a conscript enters the hall, swinging on his arm a huge incense burner hanging on three chains, to waft around its white smoke – a choir boy in khaki green! It's a new alliance, completely Dadaist, between saber and holy smoke!

None of these players chose their role. The ineffable and comic ambience we witnessed in the Potala seems to have its incoherent elements drawn together by a blind authority that turns out to be imaginative in spite of itself. For the palace, as for Tibet as a whole, this sort of heterogeneous melting pot is what will forge its destiny, its unique personality. And who knows, maybe its hope for its future.

From hall to hall, with my miniature camera, I break the rules. Sanmu sees me doing so, but does not stop me

– thus becoming a bit of a secret accomplice. Within the bounds of loyalty to Communist power, there are grades of priority. And suppleness too. The essential is forbidden to allow the rest to be tolerated. For their part, the monks likewise allow photos, even giving me a discreet signal of warning at the approach of a guard. This military regulation could have been theirs too. For in Shigatse, as we shall see, the monks frown heavily on tourist photos and this disapproval amounts to a sort of ban. But here, several smile at me, shaking my hand and when I furtively pose a question about their lord the Dalai Lama, they answer in whispers, in monosyllables, timid but determined at the same time.

From an artistic point of view, the Potala seen from the inside does not always have the most convincing aesthetic appeal, with thousands of repetitive, coarse gold statues that differ only in size. These Buddhas are of the Tzong-Khapas school, with long earlobes and pointed noses and the ubiquitous yellow bonnet in Tyrolean- or Parisian-style felt – the same model as that sported by Yakub, the Imam-Ahron. Without concern about too much of the same thing, each room repeats ad infinitum the same windows and lighting, and on the walls *tangkas* and dyed cloths with their rancid odors. From library rooms to mausoleums in chapels, the flocks of visitors move through a maze of corridors, some wide and others cramped, and wooden or stone stairways, some dangerously uneven.

The architects responsible for restoring the palace confirmed that they never had available any plans for this edifice erected in the 7th century. And in between, it has been repaired or partially rebuilt a hundred times. Even some materials cannot any longer be found, such as the 3,586 kilos of pure gold on the sarcophagus of one of the 13 sovereigns. Or the imperishable reed that, according to Sanmu, can only be harvested at very high altitudes and which can be seen on the outside walls of each floor of the palace, serving as an insulating material as well as decoration lacquered in purple.

The room of one of the pontiffs includes a private chapel on the mezzanine, which today is his tomb. The saintly man entered by five steps which are now blocked by a red rope. In that overhead space above the visitors, a lama keeps watch. A devotee in her Sunday best hands him a white *hada* (sash) and a thermos. The monk takes them and places the sash on the neck of a gold statue. He pours the liquid yellow-white butter into the 16 cups of a chandelier, all in a long row. He then gives the young woman back the empty thermos. Overcome by her good fortune, the country girl makes her way out, after several prostrations. She has probably just realized the dream of her 20-year life.

Leaving the palace, we pause before heading back down to take in the unique view, thanks to the sparkling pure light enabling us to see more than 10 km into the distance: the lake, the grasslands, the train station, the historic town center all in stone, the new neighborhoods with high-rise apartments and office buildings, and the 928-meter-long, shining-white viaduct on the Lhasa River. The breathlessness which stays with us during the promenade

adds color to our canvas of exaltation. Our intoxication is permanent.

What hold does the clergy have on Tibetan society?

After having seen so many monasteries, monks and lamas, so many intellectuals and government employees who profess to be non-believers, and so many soldiers deployed in the streets to impose peace at the barrel of a gun, the time has come to try to draw up some sort of balance sheet of the silent war for and against faith, to examine the contest between faith and materialism for an indication of which side is winning.

Until 2005, during the annual Monlam festival, hundreds of thousands of the faithful, men and women alike, competed with considerable vanity in displaying fashion statements such as Texas-style cowboy boots of fancy leather, "chubas" (robes) made of silk rather than cotton or coarse wool and for embellishment necklaces of silver and coral (or even gold), with scarves and hats made from white fox skins, marten and snow leopard. The Dalai Lama became concerned and from Dharamsala released a directive prohibiting the faithful from wearing such accessories as they violated the fundamentals of Buddhism, modesty and respect for life.

The result was dramatic: all across the territory, even in Kham or Outer Tibet (parts of Sichuan and Qinghai provinces), many Tibetans abandoned their fur items, even throwing them into garbage cans and burning them with gasoline, such as in Rebgong (Qinghai, 6 February, 2006), or in Dzoge, with chants of "Lha Gyalo" ("Victory to the Gods!").

Very conscious of this visible display of the influence wielded by the ruling pontiff, the local authorities tried to ban such destruction of property. They put up warning posters urging people to "respect the orders of the Party" without realizing that by pressing them to keep wearing their otter skins, they were violating their own laws for the protection of endangered species. Some of the "pyromaniacs" were arrested, accused of trying to stir up the flames of separatism with their burning. This affair of the "pyres" kept Tibetan and Chinese intellectuals busy for months on end. It demonstrated to Beijing just how much moral authority the Preacher-King in exile has over his flock and his people. A logical result of all this might be for Beijing to compromise and acknowledge the Dalai Lama's competence in the fields of Tibetan culture and religion, granting him limited powers of decision in those specific areas. But the socialist state is not ready to make such a painful concession: in its very isolated way, it exercises iron discipline to keep the Party united and suppress the effects of its mistakes.

Tibetan medicine according to Tse Wang Tan Pa

We return to the city at 11:30, cramming ourselves into another taxi, continuing our Stakhanovite program, with the Traditional Tibetan Medicine Hospital our next destination. A product of 1960s architecture, the low building in forgettable concrete looks like a place that has never been blessed by its budgets and seems to be giving

thanks to the gods for its mere existence. We pass through the foyer and are royally disillusioned. How would you feel if you entered a hospital and it was absolutely deserted, from the main entry area to the waiting halls, consultation rooms, pharmacies and the cashiers' windows? With only the ghosts of patients bustling along the corridors? The only people we see are two or three patients in their rooms, wearing striped open-backed pajamas and with drip infusions stuck into their arms. Each one is surrounded by half a dozen family members who watch us impassively. This hospital of traditional Tibetan medicine, the biggest in China in its field, closes during the national day holidays.

But this "bad luck", possibly a deliberate gesture of ill-will on the part of our organizers, in reality brings us a double benefit. Apart from our guide, this empty echo chamber does not conceal any watcher reporting on us. Also, Tse Wang Tan Pa, our host this morning, has plenty of time for us. A strapping man, bronze-skinned, mustached and strong as an ox, Doctor Tse Wang is keen to describe his universe frankly and in his own words, which he proceeds to do – protected by his impregnable position as the hospital's Party Secretary and Deputy Director.[42]

Tse Wang Tan Pa is cultivated and friendly. With a mischievous look, he is of all the government officials we have met on this trip the most boldly outspoken. He begins by saying that his medical practice stems from Buddhism, which "95% of the Tibetans practise," that it is inconceivable without it, and that the link between the faith and medical care has not been severed. Our interview takes place in a ceremonial room cum chapel and museum, complete with statues of lamas illuminated by candles, and with *tangkas*. The whole décor is votive and would be unimaginable in an atheist socialist hospital in the lowlands. But here it is *de rigueur*.

The hospital is 92 years old. Its original name was Men Tsee Khang, which means "Institute of Medicine and Astrology", testifying to the desire for modernization of the then Dalai Lama and to what were seen as the deep links between health and other domains of the mind: science, morals, theology and meteorology. Pushed by its call for compassion, tantric Buddhism claims through its practices to interpret and improve life. Across the millennia in its service to mankind's physical and moral needs, Buddhism has studied illnesses and discovered therapies based on plants and other techniques.

"Based on our current knowledge," the political commissar explains, "our medicine has 5,000 years of history, of which 2,400 are documented." It has experienced three golden ages:

— In the 8th century, Yutok Yonten Gonpo was King Chide Songzan's personal physician. He spent 25 years climbing mountains in search of herbs and other medically useful plants whose benefits for therapy were explained to him by shamans and bonesetters. From this, he took his "Four Medical Tantras," which became the foundation of the Tibetan science of life. His academy developed medicine centuries ahead of the rest of Asia, and within its walls Yutok trained hundreds of practitioners.

— In the 17th century, the fifth Dalai Lama assembled a body of reputable doctors from the four corners of the kingdom, and beyond. He asked them to write an atlas of the human body showing its various functions in 80 *tangkas*, These documents remain today the bible of Tibetan medical practice – several originals are displayed on the walls around us as we talk.

— And the third golden age is taking place… before our very eyes. The lasting impact of Chinese and Euro-American medicine now finally permits them to compare various practices and move forward in developing for our time the empirical methods of earlier centuries. The hospital has 700 caregivers of whom 80% are doctors or nurses, as well as several dozen students and researchers. In 1999, our host inspired the creation of a medical school for 400 students in a doctorate curriculum of five years of theoretical and applied studies. There are 2,000-3,000 Tibetan doctors on the plateau, compared to the 4,000-5,000 who practice Chinese or Western medicine.

Tibetan practices include therapeutic baths (cold or hot, using natural springs found all over Tibet), diets, massage, moxibustion, acupuncture and of course, pills, little tablets and concoctions of plants and insects.

Tibetan science is sister to and shares many techniques with Chinese medicine, but distinguishes itself in its foundations. The Chinese stress the opposition between the *Yin* and *Yang*. The Tibetan view of health rests on three pillars of energy, the nerves (*"long"*), heat (*"cheba"*) and cold (*"beye"*).

Another fundamental of life, illness, and death is water quality, which Tibetan tradition defines in seven states. Rainwater is the most beneficial and forest water the most harmful. Between these two aqueous extremes cascade the waters of snow, glaciers, rocks, wells and ponds. Tibetan medicine mainly treats infections and internal problems, as well as bone, cardiovascular, ophthalmic and obstetric conditions. "Our local pathologies are very special and somewhat extreme, as a result of the altitude, intense sunlight and humidity," our host explains. The biggest worry is digestive disorders. Also of concern are goiter (due to the lack of iodine, or to thyroid disorders), joint pains and tooth loss.

However most health services in Tibet, 80% of the total, are provided by the Western medicine of Thomas Vésale and Ambroise Paré.

This does not prevent the hospital from experiencing a constant expansion, thanks to its ties to the religion – primordial here – and its low cost. Using threefold diagnosis (the pulse, dialogue and observation), the Tibetan doctor charges ¥4-10 per consultation, whereas a night in Lhasa's western hospital costs ¥2,000, a year's pay for local peasant farmers. Tibetan care is also interesting because it can prevent illnesses as well as provide low-cost remedies when they strike, Dr Tan Pa said. Also, because of the very high altitude, its pharmacopoeia is blessed with a unique characteristic: the leaves, flowers, mushrooms and insects and other nature remedies grow between 3,500 and 6,000 meters above sea level, under the bombardment of the sun's rays and fluctuations of hot

and cold that are not found below. For these reasons and at the instigation of the Chinese, the medicines of Tibet are beginning to interest European social security systems and health insurers, who have been sending researchers as scouts. Once the big laboratories on the Chinese coast, and in France, Switzerland and the USA have tested and developed these treatments[43], the Party Secretary believes exports will take off..

That is the background to the hospital's expansion since 1959, when it had several dozen beds, to 326 this year and a planned 500 by the year 2011, with an investment of ¥120 million. Last year, the outpatient department handled 260,000 patients from the capital and the entire province. Some spend days in buses and travel more than a thousand kilometers for treatment here.

And here is a small secret that Doctor Tan Pa lets slip quite innocently: contrary to Director Ma of the Reform and Development Commission, who was tight-lipped about the drop in economic growth, Tan Pa is not afraid to reveal that consultations will drop by eight to 16% this year for the local population; and for clients from other provinces currently hit by travel restrictions, the reduction will range from 50 to 80%.

An almanac reflecting sky and spirit

In contrast to all other hospitals in the world, this one in Lhasa is distinguished by two trump assets. The first is its almanac, edited by the hospital's doctor-editors from texts compiled by the astronomer-lamas of the monasteries.

Following a technique inherited from history, very much in parallel with the Chinese *Yiqing* (the "Book of Changes") and in line with its hexagram images of points and traits or trends, the Tibetan almanac describes in advance the rains, the snows and other natural events expected for the 365 days of the year to come. "Last year, we predicted the great earthquake in Sichuan," boasts Tan Pa, while frankly admitting that its announcement was vague as to the exact place and date. The almanac also gives for each (Tibetan) astral sign and for each individual physique within it, the chances and risks in prospect day after day.

The almanac's greatest asset is, however, something completely different: a Tibetan language full of verbal riches that only insiders can understand, allusions and linguistic winks of the eye comprehensible only to locals, and many pungent and untranslatable expressions. The Tibetan tongue is a refuge for the soul on this plateau. The hospital did once attempt to translate the book into Mandarin, but unsuccessfully. There is a lack of shared understanding, of connectivity, between Tibetans and Chinese. To each their own secret garden.

The breviary is a consistent success in Tibet's rural bookstores and with street hawkers who between them, regardless of good and bad times, sell 200,000 copies a year including in the other Tibetan-speaking regions of Kham and Amdo (portions of Qinghai, Sichuan and Gansu provinces). It is followed more closely than the weather forecast on TV or any government announcement. Its popularity is based squarely on its status as the last rampart

of the local culture, in the face of the haughty stares of the new masters.

A "fatty meat" pharmacy

The second great "milk cow" of the hospital, so to speak, is its pharmacy which supplies its patients and the world with traditional ointments, concoctions, and elixirs, or more modern ones invented by the hospital. Our hospital administrator says its passionate devotion to this work underpins the third "golden age" of Tibetan medicine. Before 1959, a handful of monks and assistants in the hospital produced 2.5 tons of medicine a year. Today, his 256 chemists and laboratory technicians extract from their stills and presses 60 tons annually, made up of 400 individual remedies each with its own formula. They earn the hospital ¥70 million each year. One third of the production is consumed on the plateau, 60% is exported to the interior of China and the rest is destined for Mongolia, the sister nation of Tibet in history and religion.

This detail affords us a glimpse of a degree of real integration between China and Tibet, including culturally. Europe and America may think they know the Land of Snow, but are ignorant about its medical remedies. Not so the Middle Kingdom, which demonstrates a whole range of moral positions towards its autonomous region, from racist contempt to unabashed adoration. But regardless of any other matters, China knows all about its medicine and takes it seriously.[44]

"We are fatty meat," our political commissar smiles with an ambiguous look, commenting on the pharmacy's success. Because worries are on the way. Too much success can do harm. Although the hospital took pains to pay on the nail its ¥6 million tax bill last year (or maybe more precisely because of this), the bureaucrats of the central government are getting hungry and seeking to annex this goose that lays the golden egg.

"In fact," says our host, "they are all at our door and want to swallow us whole: the tax bureau, the planning commission, the health authorities."

"But you are a public institution. How can the state nationalize you a second time?" I ask with feigned naivety.

"You know very well," he retorts with a wink.

What this means is that in China, the publicly-owned economy, still by most measures much the larger part of the whole, spends much of its time cannibalizing itself. Harmony exists only in the flowery language of the president of the republic — it has been one of his main slogans. The fact that you may be a "*danwei*" or public "work unit" under the Communist sky — owned and controlled by central, provincial, or local government — does not immunize you in the slightest from depredations. Depending on the support you have or do not have from the higher-ups, you can find your company moved on an organization chart from one guardianship to another, without even one yuan being paid to compensate those who created the unit's prosperity.

Be that as it may, our astute administrator has already organized his counter-attack, inspired by the 27th trick in the ancient Chinese military manual called the "36

Stratagems." Number 27 says, "The golden cicada sheds its skin." So Tan Pa reveals that the hospital is on the point of inaugurating its new factory, which this time will be private in status and law and thus beyond the reach of state bodies. To this new factory will be transferred the exclusive rights over molecules and active ingredients, trademarks, as well as the bulk of the team of pharmacists and researchers, leaving only an empty shell. "Let them do what they can with the rest" deadpans the party secretary with a smile!

A long term investment – social security

Tse Wang Tan Pa goes on to describe progress in the field of social security in the territory. This is a crucial question for the whole country, where most people still have no protection against illness, unemployment and old age. To deal with this situation, the traditional Chinese method, especially in the countryside, is to have children to provide for one's old age, and to save instead of consuming. The result: the country finds itself with 23% of the world's population and strong demographic pressures. China has the deepest money bags on the planet, with (in January 2012) more than US$3,200,000,000,000 in foreign currency reserves. To consolidate its economy and make its growth more durable, the Chinese state has over the past ten years built at an accelerating pace, a minimum social security system, providing a measure of support for retirement, unemployment cover and medical expenses. In addition to imposing payroll taxes on companies and

employees, the state is also dipping heavily into the cash pie of pension funds.

Thanks to these efforts, Tse Wang tells us, Tibet is at the cutting edge in China for social security. Like in all the cities in the country, Tibetan city-dwellers pay ¥100-300 per month, or 11% of their salary, which Beijing then doubles with its subsidy. A very poor or insolvent rural peasant pays only ¥100 *per year* for his individual account. The state tops it up with ¥1,200. In 2007, the state paid ¥6,500,000,000 for Tibet's social security needs. In Lhasa, all salaried employees are reimbursed 100% for their hospital costs, and in the six other counties, at least 50%.[46] But there is a major restriction nonetheless: such hospital patients must hold a residence permit, which is rarely the case among the rural people who migrate to the city and obtain jobs illegally. They form the vast majority of the urban workforce and are shut out of the system, like the nomads of old wandering into new villages. In their new lives, they are still subject to the rules of their herdsman's rural residence permits, that is, "independent" and without salary. The state owes nothing to these people who are the most deprived of all and who must pay for all medical expenses in cash before any services are rendered.

But that does not discount the fact that documented Tibetan city-dwellers still have the best social coverage in the country, our director tells us. The state makes this effort to take responsibility for helping Tibet make up for its backwardness and overcome its legitimate frustrations – to buy peace. And it is conceivable that the state will soon spread the scope of its medical and pension safety

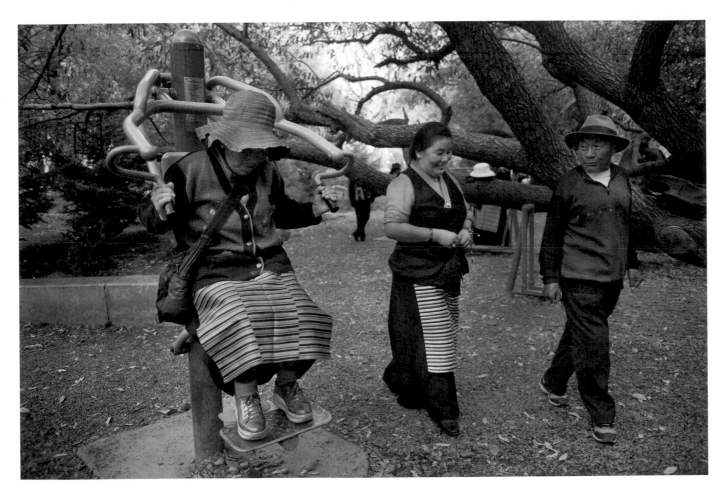

Pilgrims get some exercise in a park below the Potala Palace in Lhasa.

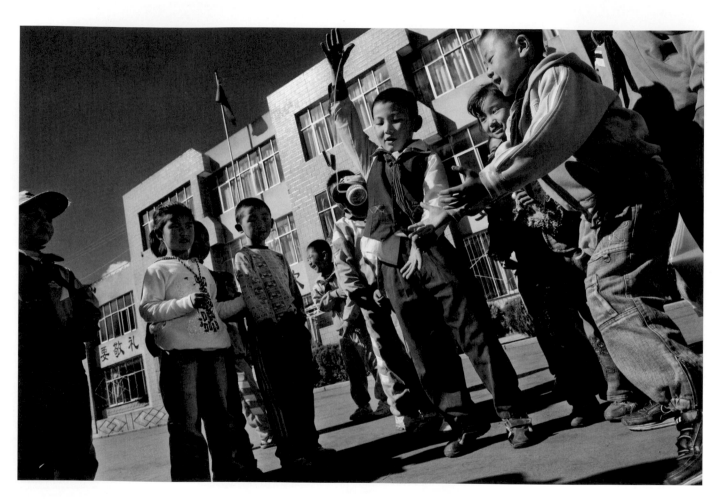

Children at Lhasa Experimental Middle School.

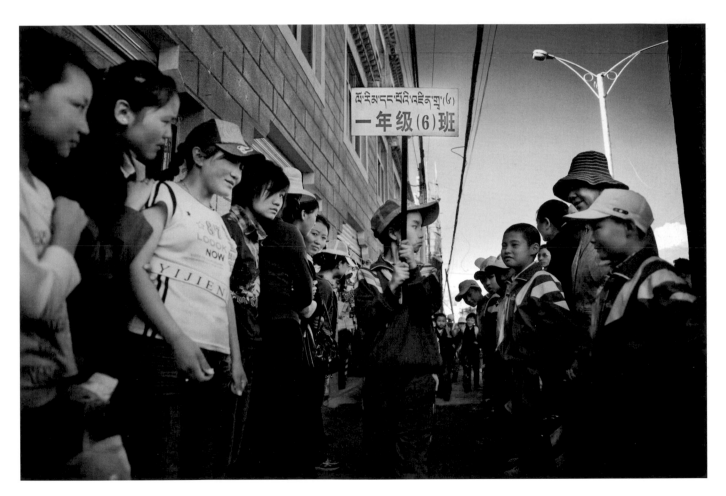

Children at Lhasa Experimental Middle School.

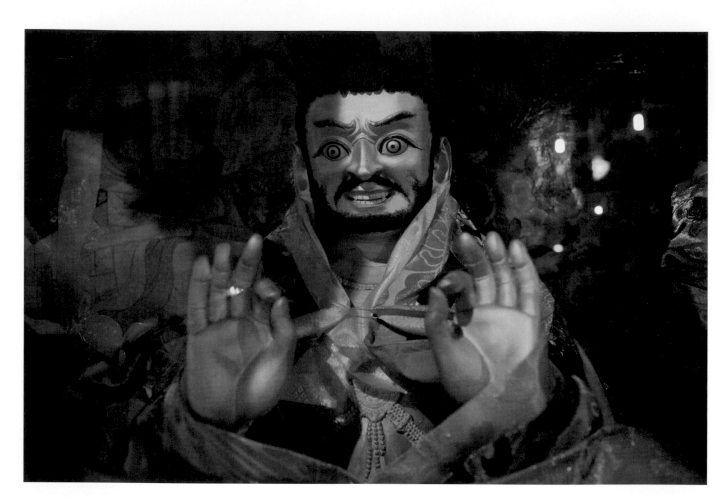

Statue in the Jokhang temple. Lhasa.

Customers watch TV in a Han Chinese restaurant and herbalist shop in Lhasa.

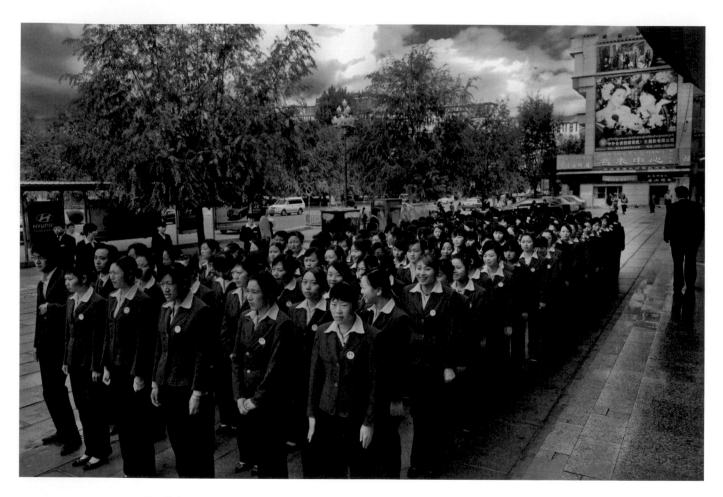

Staff do exercises before the opening of the state-run Lhasa department store Bayi. (The name Bayi refers to the August 1st founding date of the People's Liberation Army).

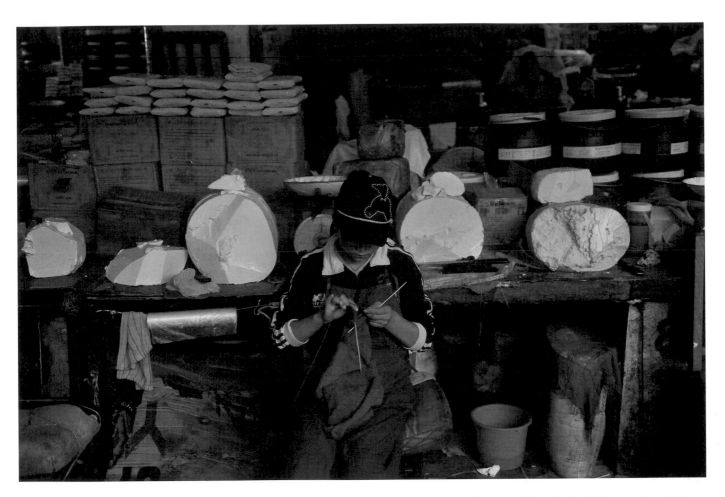

Dri cheese stall at the Barkhor market, Lhasa.

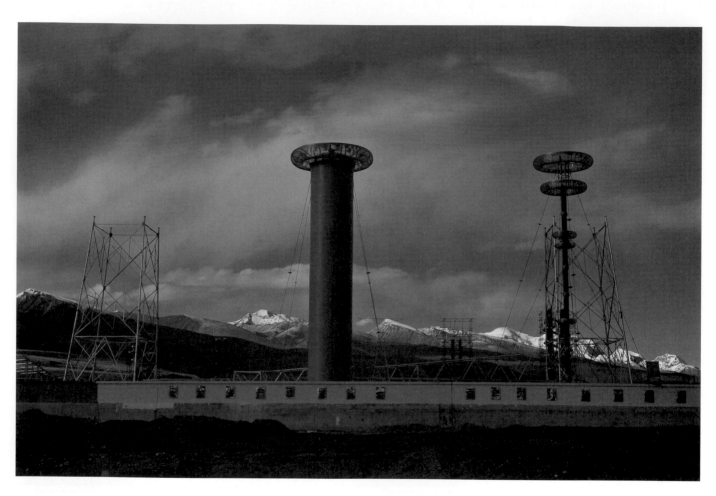

Experimental high-altitude electric power station, Yangbajing.

net to the whole working population. The price to pay for several hundred thousand employees would be negligible, relative to the numbers involved, and to the means at China's disposal plus the potential benefit of a bet for social peace.

I put to the Party Secretary one last loaded question: Since you are now receiving from the central government such large sums of money to insure the population, won't the local officials be tempted to embezzle the funds? Yes indeed, Tan Pa admits. Several years ago, many rural people refused to pay even ¥100 per year for fear of wasting their meager savings on filling the stomachs of pen-pushers at unearned banquets to which they had no legal right. But since then, Lhasa had cleaned house, he declared. In 2007, a vice-mayor of Konga and a deputy county commissioner were fired for diverting funds to a construction project. That gave the rural folks confidence. Well, if Tan Pa says so…

Meeting "M."

12.30. As we leave the hospital, saying au revoir to Sanmu until the rest of our day's program resumes in the early afternoon we meet a young European woman in her thirties. She is slender and sporty-looking, her hair cut short in the style of Barbra Streisand. "M.", whom we have been expecting, joins us for a short time and provides an intense and vivid briefing.

Her humility and good nature are not deceptive. M. is a person brimming with energy, determination, and moral rigor. Still young, she is devoting her life to the Tibetan plateau and its population far and wide. She has dozens of projects going on at once, from ecology, sustainable economies, and fair trade to modern communication techniques. Here, via the internet, she asks surfers to send French books for a small lending library. There, she launches a project of small garden cooperatives. In the county of Ngari (an area with a very large number of migrant herdsmen), she is opening dispensaries, allocating doctors for whom she co-financed their studies with the occasional support of the local Red Cross and foreign countries[47]. She has lived here for about ten years, but her attachment to these people and their language came well before that, following a path that is not at all typical but which I have been asked to keep confidential.[48]

To earn her daily bread and maintain her residence permit, compulsory in Tibet and very difficult to obtain, M. works as a tour guide and spends a good part of her time trudging the trails, accompanying Chinese or foreigners across the slopes of the Himalayas, the plateau, or peaks of more than 6,000, even 8,000 meters.

She spends the rest of her time working on her own development projects, like "Hope Corner." Its goal is to teach the Hans and Tibetans to live together.[49] Hope Corner is co-sponsored by the Ministry of Social Affairs and the Youth League (a mass organization of the Chinese Communist Party), both of which come and inspect her work every year. This initiative, dating from 2005, is one of the rare ones to fulfill the hopes of the government, getting up to 100 Hans and Tibetans to meet each week. M. has brought together six full-timers and a network of

volunteers across China to organize free classes in yoga, training in theater workshops (in English or Tibetan) and language exchanges. Every Saturday evening in Lhasa, a writer, agronomist, doctor or other invited speaker to "The Corner" introduces a subject in simple English. Then, the young Chinese and Tibetans debate in this language, "the best possible," remarks M., "because it is neutral."

On Sunday, employees and volunteers of Hope Corner work overtime in boarding schools and colleges across the territory, helping students do their homework, joining them to play football or on the theater stage, anything that will yank them out of their cultural isolation, to be together, Tibetan and Han, under the aegis of the language of Shakespeare.

Among the other activities started by this 100,000-volt lady is the "Highland Trekking Initiative," which today runs itself. It makes dozens of local travel agencies aware of the need to respect the environment and village communities, and grants the best among them its seal of approval for sustainable tourism.

She also manages a fair trade label that encourages and guides the eco-artisan – making little ornaments or woven goods, or traditional foodstuffs on the farm. All her activities of course mean the training of hundreds of intermediaries, partnerships with distribution chains and advertising in China and Europe on the internet.

M. handles all this with an easy manner, starting up and running non-profit ventures just like that, between two treks.

Opinions

M. embodies a classic contradiction in China,[50] one affecting everyone who knows the country well and truly loves it, but does not in any way accept all of its practices. For the sake of honesty as much as pragmatism, she refuses to condemn the regime for its authoritarian behavior. She rejects the prejudice against China in the West, which looks down on it as an entity "without democracy." She knows her stance is fair and also that such reticence is the price to be paid for the right to live and do good works here.

But at the same time, she affirms her values and denounces the blunders and mistaken policies of the local administration's officials. To us, she corrects or modifies a large number of half-truths about the success of the regime that we have been plied with in large doses for the last eight days.

Turning to education and the modern, well-lit schools that we were shown, she said many children of ex-nomads who come to the city are refused access for the lack of a residence permit. A free public education, the principle introduced by President Hu Jintao, still does not apply to them.

As for the Men Tsee Khang Hospital that we just left: "It's true," she says, "that it is not expensive and open to all... but the people who go there only have trifling medical problems. If they are stricken with a serious illness, they know that to get well, Men Tsee Khang is not the place to go."

It is in the countryside where M. sees the greatest damage; without ever having planned or even wanted it, China now sees that the end-result of the totality of its actions over the years has been the rapid disappearance of the nomadic way of life, but without the ability to replace it with a suitable settled alternative.

To the north of Lake Namso, in Changtang County, dozens of mines are in the process of being prospected (of which the Planning Commission did not breathe a word to me) and are destroying pastureland, she said. Other value-enhancing practices are equally dangerous: changing to intensive farming is accompanied by over-use of fertilizers, which leaches the soil. The greatest damage comes from the tendency of the counties and districts to sell land to satisfy their budgetary needs. The new property owners enclose their new plots with fences, blocking the routes of traditional migration. The herdsmen and their families are therefore forced to make detours that sometimes take them hundreds of kilometers out of their way. Inevitably, they eventually have to sell their under- fattened animals without receiving training for a new urban job.

Ecologically, the process is irreversible. Hitherto, sheep, yaks or goats have instinctively selected the best-tasting grasses when they graze, the seeds of which they then spread further through their droppings. On these immense and virgin plateaus, from time immemorial, the flocks create "routes" of pasture, in symbiosis with their roaming. "From now on," M points out, "the grasslands where the animals no longer graze are seeing a proliferation of other species of plants, some harmful. The bad grasses crowd out the good and the equilibrium of thousands of years is destroyed."

Of course, as part-compensation, there are modern subsidized greenhouses that guarantee miraculous harvests of golden fruits and vegetables under the region's 355 days of clear skies per year. But for now, they remain in the hands of immigrant Hans and beyond the reach of Tibetans.

The state also tries to tempt the pastoral communities to put down roots by providing villages with houses heated during the winter months. They drill deep water wells around which the nomads begin to settle. But these anchor points, embryonic cities of the future, still do not provide them with jobs, or trade, or credit with which to dream of or start another way of life. These villages do in fact prepare them for assimilation and erode their desire to move on – but at the risk of having young people yield to the temptations of lost hope: violence, delinquency and prostitution.

"The result," M. estimates "is a Tibetan society that in 1959 was 80% nomad and today is barely more than 5% so."

M. is still shocked by this policy of settlement, synonymous with pauperization and the loss of a proud and free lifestyle. But, being intellectually honest, she feels bound to admit that "this evolution was unavoidable", China or no China, Communism or not. China is not trying to destroy Tibet, she said, but seeking to wrench it from its ancient ancestral ways. The problem is it wants to develop the region too quickly and without asking the

Tibetans for their advice. "Quite simply, the region is not ready for this social upheaval, a transformation that took us 200 years and to which the Tibetans must adapt in two generations."

It is not so much the decisions themselves that trouble her, but the authoritarianism with which they are applied that raises her hackles. "All the Tibetans invariably end up feeling like they are being treated worse than dogs." The imposed meetings for civic and Communist education that the city people, farmers and monks must attend every week are the worst of errors. Frustration is just as overwhelming as despair. "So then, what can you say?" "What can you do?" Many Tibetans repeat these cries when they know they can talk freely, without risk of being overheard.

For M., the Dalai Lama plays no direct part in dealing with the problems of the region, which anyway has long resigned itself to living with his absence. "Tibetans continue to emigrate clandestinely to India. This is proof enough that something is not working. Unemployment and the discrimination in favor of the Hans, the vanishing rural countryside, the Chinese obsession to control everything, trying to roll back the local customs. Without being able to express their differences, the Tibetans are losing their soul…"

16:00 – Save the Children – an NGO with aims aligned with those of the authorities

The quirks of our schedule are such that this afternoon we are invited to visit to another non-governmental organization (NGO), Save the Children (STC). This private international agency with headquarters in London has been present in Tibet since 1991. Thanks to substantial funding from London and Copenhagen, STC exerts strong influence in the region. Jigme, a British Tibetan and its program director here, welcomes us warmly in its modern offices, empty today as, just like the doctors at Men Tsee Khang, his team has taken off for the obligatory National Day holiday. STC cooperates loyally with the regime, helping to make the latter's education program function better. It steps aside completely from all course curriculum planning and in a self-effacing way plays no part in deciding what is taught. Instead it limits itself to improving the pedagogy, the teaching methods, devoting its efforts entirely to the task of helping teachers take children more quickly and efficiently through the courses whose content is laid down by Beijing.

That is why STC does not itself train the teachers directly, but only trains the trainers, who are supplied by China. Jigme explains this very logically. "Formerly we did everything ourselves. But as soon as we left a country, we noticed that after several months the results of our work petered out. The teachers we trained were never autonomous. They knew how to do their own job and teach the children better, but they could not reproduce the same results with colleagues independently. By training the trainers, we create continuity."

At the price of working with the regime, STC states that it is improving the education of 18,000 children in the Lhasa Valley and is now ready to expand the program to

Gopka and Nagqu counties. Fine, but our little group has trouble accepting this collaboration by an NGO, which leads it to renounce its democratic values while facilitating an authoritarian regime's grip on the children. This seems to us a moral abdication. Now we can well understand why the Waiban chose to send us to this organization rather than another.

Fortunately, STC's programs extend to other less contentious areas such as access to drinking water and the installation of toilets. It says it has already brought running water to 58,000 school children, eliminating endemic contagious intestinal and eye diseases, thanks to better hygiene among the children.

On a third, and perhaps most pleasing front, STC has protected 3,000 children from abuse by teachers, parents and bullies. Tibet is ideal terrain for such violence, with the dual effects of a post-Stalinist system that imposes directives without anyone being able to object or question them in any form of debate whatsoever, alongside what can only be described as a typically colonial situation. In the schools, the children of the two ethnic groups can easily be tempted to replicate the racist patterns of the dominant and the dominated, as practiced or experienced by their parents. "This latent violence," says Jigme, "is our most insidious problem. In the home too, especially in the countryside, many children are beaten. Some even suffer at the hands of other children performing scenes of war. They create gangs to protect themselves and if they have the upper hand, they run wild and torture others in turn." Abused children lose self-confidence and concentration

and invest all their precious energies in organizing gangs to defend themselves. They waste their study time so every year they are the ones who fail their university entrance exams and miss out on the resulting engineering, medical and other diplomas.

It is a remarkable fact that this very Anglo-Saxon NGO withholds all moral judgment – its strength in discussions with officialdom is to limit itself to an accounting approach: the abuse costs the children their ability to become competent for future employment, and this loss of competence imposes costs on the province economically, which in turn costs everyone money because of the need for bigger subsidies just to keep Tibet afloat.

But Save the Children knows what it is doing. It elects parent delegates and teachers, organizes conferences and training programs on child abuse prevention, and the detection and warning signs of bullying. It presents medals to parents who star in this struggle (with titles like "Qualified Daddy"). The kids too, Hans and Tibetans in the schools at the most risk, take lessons in "social talents" and are offered decorations, parties and other incentives. And thanks to these imported techniques from English-speaking countries, bullying among the children is on the decline.

I leave Jigme feeling there is a fundamental difference of approach for development aid between on the one hand pragmatic and opportunistic England and on the other France with its sweeping philosophical principles – two sources of worldwide influence based on very different foundations. For French NGOs, to carry out development

projects without adding the salt and pepper of democracy is inconceivable. But at Save the Children, it is deemed acceptable to cooperate with an anti-democratic system as long as doing so achieves tangible results in improving the lives and conditions of Tibetan children. These two approaches to altruism, French and English, are complementary and both are legitimate.

TWELFTH DAY
WEDNESDAY, 1 OCTOBER
THE BRAHMAPUTRA ROAD

Leaving Lhasa, we follow the Yarlung Zangpo Valley (of the Brahmaputra River). The route starts out narrow and boxed in. Occasionally we see small plots of barley or wheat, where the harsh and sun-bedazzled slopes allow, among groves of trees and sand bars. Then, after 50 kilometers, the vice-like grip of the mountains is relaxed and the valley widens, though without ever flattening into a plateau. We pass through four checkpoints of surly police who would never give travelers without the sacrosanct "Open Sesame" red ink stamp the faintest hope of going any farther. I harbor the strong suspicion that locals do not mind avoiding these roadblocks by going through the mountains, along mule trails. Not necessarily to militate for separatism, but simply to sell a yak in the neighboring market, move a smuggled goat or visit a cousin for a party without being subject to the hassles of police registration. Nature along the mountain slopes thus serves a purpose, to re-establish contacts between the valleys and enhance the flow of life, shackled on the road below by the police.

Along the river banks are long rows of young birch, ginkgos and sickly looking poplar trees, part of a reforested regional park designed to stabilize the river banks and protect them from the furiously turbulent blue-green waters, capped by white foam, of the torrents. A sign states that the size of the park is 10,000 "*mu*" (the standard measurement of land area in China; in this case a total of 700 hectares), evidence of the recent realization by the regime of the urgent need for soil conservation. Soon there are further signs of its awareness. Along the road we see an increasing number of bilingual placards with comic-strip drawings for the illiterate nomads, to make them aware of the need to protect flora and combat forest fires. In some places the river has been channeled into a concrete bed, with spikes fixed at an oblique angle on both banks to break up the surge of water.

Then we arrive at Xue Qiong, one of our unplanned stops. Xue Qiong is a hamlet of traditional Tibetan farms, built at the beginning of the 20th century like little forts for protection from bands of robbers and soldiers of fortune. The walls of crude brick have only very few, and narrow, doors and windows; at each corner a basket of branches claws the sky, maybe intended to scratch demons and keep them at bay. The inside walls are covered with neat rows of cow and yak droppings in circular shape looking like lines of pancakes, hung there to dry. Symmetrically arranged like a Vasarely painting, these brown discs serve as insulation in the winter, reducing the loss of what little heat there is in the houses. Later they are pulled off and burned in a central stove, with the hot smoke circulated via a system of tubes to warm up the brick bed the family sits on by day and sleeps on by night.

At part of a field of rye being harvested we meet a big family of seven – men, women and children. The men cut the grain stalks with sickles and the women gather them into bunches and tie them with a switch of straw: the noble and age-old rhythms of harvest.

As luck would have it, they stop for their noon break just as we arrive and sit in a circle on the stubble. From deep baskets, the women take out the food and invite us to join them, which we do after several token refusals. Then big mugs are filled with hot tea for the women and for the men, *chang* (freshly made beer lightly fermented) drawn from a huge teapot. With an air of authority, one of the women gives us a bowl of flour each, for us to knead into the butter tea. We start by churning the mixture with a chopstick in the bowl and then roll it in the palms of our hands to make balls of *tsampa*. It is a test for us, a rite of passage, and when we have passed it with flying colors she gives us other simple and delicious things such as thick rye crepes flavored with a chopped mountain herb, little new potatoes with fine skin which everyone takes from a big wooden salad bowl and religiously peels. With awkward little gestures of kindness, the women invite us to try everything.

In gruff tones and hesitant Mandarin, the father, sporting the inevitable hat, offers us several rounds of his beer. We carry away with us the warm memory of a family's gracious hospitality.

A tense stop at Bianhui

In that rural and idyllic scene with its ancient and unchanging harvest movement, we feel at ease and deeply relaxed. One hour later though, well before our arrival in Shigatse, our guide begins to display signs of extreme nervousness after we informed her of our innocent intention to pay a visit to our friend Michael, manager of "Braille without Borders"[51] (BWB), at his boarding school for young blind children in Bianhui, a suburb of the city.

For the twentieth time, Sanmu repeats her solemn decree forbidding us from interviewing anyone or photographing anything once we get there. Her irritating attitude and infectious tension does not prevent me feeling a tinge of compassion for her. For her instruction manuals and years of training on how to control foreign journalists within the borders of the People's Republic do not lay down rules specifically applicable to this visit, so the scenario that we are imposing on her is a total unknown. To her it smells dangerously of gunpowder and entails a real risk of her failing in her duties. So Sanmu rows with all her limited might against our currents, looking for some chink, some good reason to cancel our stop there. If by chance the boarding school had been far from our route, with what great pleasure could she have forbidden it, invoking our tight schedule! But we are taking no risks and this time luck is on our side. With his mobile phone, our precious Li Feng calls the NGO and he gets the answer that BWB is ideally situated at the roadside on our very route! There's no way we could miss it... If we were going there for news reporting purposes, Sanmu would have an acceptable regulatory basis to scrap the visit. But this home for blind children makes and sells western-style cheese and we have every intention of stocking up, yes, yes! After several long exchanges with her head office, Sanmu throws in the towel with a long sigh and relents.

But it is a costly victory: notebooks and cameras must stay in the minibus and we are shaking with exasperation as we go inside. We are welcomed by a swarm of cheerful adolescents with grim-looking eyes or hollow sockets, their faces turning haphazardly in every direction. With them, a giant westerner of some 65 years, one hand pushing back a lock of grey hair from his forehead while the other is extended with a "How do you do? Welcome to this home."

During our visit, we are immersed in an atmosphere of simple brotherhood, joy, ineffable goodness and an absence of heavy earnestness. This place is infused with the humble certainty of doing the right thing.

The atmosphere was created by Ms. Sabriye Tenberken, the founder and patron of this NGO. A wealthy German, blind herself, she established a Braille transcription of the Tibetan alphabet in 2002. Four years before, she had opened her first Tibetan school for the blind in Lhasa. In the following year, 1999, she oversaw the printing of the world's first book in a form of Tibetan Braille, and finally in 2004 opened the school here in Bianhui just outside Shigatse.

As Michael explains to me, one resolutely modern aspect of BWB's approach is its drive to dissipate the stigma of blindness, looked down on here as a defect.

Buddhist or not, Tibetan society is not kind towards handicapped people. No more than the Hans. On the street, nomads insult blind children because of the belief that their sight was taken away from them by the gods, as deserved punishment for a crime committed in a previous life. But according to Sabriye, blindness forces the affected person to compensate by honing the other senses and it can become a strength, maybe even a blessing. After two years at this school, in a loving atmosphere, these young blind children discover their abilities and gain motivation, a sense of purpose, and self-confidence. They respond tit for tat to anybody who denigrates them. They say that even without sight, they have know-how, a job. They are worth more than good-for-nothing herdsmen, sighted but living a backward life of wandering with their flocks, grimy and penniless. Thanks to Braille without Borders, these children convert their handicap into feelings of self-worth, validation, and victory over fate.

"How the hell did you manage to come all the way to us here?" Michael asks cheerfully, astonished and full of good cheer as he leads us to the big dining hall cum living room. In ten months (since December), we are only the second group of whites to cross their threshold. Moreover, the first was not exactly the kind that the authorities could block, as it was a consular mission from his embassy in Beijing coming to visit its national. For Michael is Canadian, an English-speaker from Montreal. He announces proudly that this year he is celebrating his 45th anniversary in Asia, having started out in the northern Indian tea-growing district of Darjeeling in 1963, fresh from his studies. He

still goes back regularly to Darjeeling, 150 km by bicycle from Bhutan. Now totally immersed in Tibet, he leads a life of unalloyed happiness, among the children and his simple staff who all offer him unlimited devotion, which he fully reciprocates. He even has, luxuries of luxuries here, a computer with internet connection, his two racing bikes oiled and dusted off in a corner in his room, and a small refrigerator; he is a hermit with his little flock, in a miniature Eden forgotten by men but not by the gods.

A shroud of obscurity hangs over the origins of this orphanage, a shadow which I will now boldly lift, in the conviction that for everything done with goodwill, light ought to triumph – as long as that causes no harm. So I can state that when it founded its second Tibet school in Shigatse, Braille Without Borders was blessed at its baptismal font here by several good fairies, some of them unexpected. The first was Sabryie, who by dint of dedication and an intense desire to change the world, pushed her way through the doors of the local government in Lhasa and in just ten minutes of negotiation obtained from the governor and his staff the necessary permit for the school.

Her NGO on the other hand happens to include a Jesuit priest among its permanent staff. In one of history's oddities, it so happened that Choekyi Gyaltsen, the 10th and next-to-last Panchen Lama (see earlier chapter, *Day Eight*) was a personal friend of Pope John Paul II. When the Panchen Lama died in 1989, the Catholic pontiff ordered prayers for him across the length and breadth of Christianity. From that time, ties continued to be nurtured between the

Vatican and this seat of Tibetan Lamaism. In honour of the links between Rome and Shigatse, Gyaincain Norbu, the 11ᵗʰ Panchen Lama (the one officially recognized by the government), granted BWB a 15-year lease on this piece of land in Bianhui. It comprises 17 hectares, which after 35 years of being occupied by the army, had just been returned to the Panchen's control. Part of it is now used to grow food for the whole community and the rest for living areas, dormitories, and classrooms, in the former military barracks now converted for school use.

Other godparents of the center are the National Federation of the Handicapped, presided over by Deng Pufang, the son of Deng Xiaoping, as well as the regional government, which issued the boarding school its business license.

It is hard to believe that such good fairies could hover over the founding of this school. But they really did. It cannot be denied that nothing predisposed them to cooperate in this undertaking, given their contradictory ideologies and moral values. Yet they joined hands, and in French we would call that goodwill. Those fairies confirm the truth of the adage that in absolute terms there are no totally bad people.

To enable Sanmu, who is watching us anxiously, to cope with her own interrogation by her superiors this evening at the hotel, we promptly visit the cheese factory and go quickly to the shop, our pretext for stopping at the school. The cheese plant is meticulously clean. Displayed on the shelves of the air-conditioned and dust-free store are numerous cheeses rather like French Tomme. They are of varying sizes and colors, according to the number of months each cheese has been aged to mature and which added flavors have been used – pimento, black pepper, garlic or dried tomatoes. Too dry and crumbly to be a genuine Tomme and lacking its smoothness, their product is in fact more like something half-way between Italy's famous Parmesan and Pecorino cheeses. So when he had to find a name to market it, Michael came up with the creative and charming registered trademark, Tibetino. Produced in limited quantities, the school's cheeses were in great demand last year at the restaurant tables of Lhasa. Production was suspended at the time we visited, but started up again in 2009 with the resumption of tourism. It is a point of honor for Michael to use only cow's milk, from 20 head of a fine breed imported from the West, rather than using the milk of the *dri*, the humble female yak.

Self-sufficient thanks to muscle and sweat, the 30 staff and up to 60 children produce almost all their daily needs: rye, wheat, barley, potatoes, green vegetables, forage for the cows, and meat. In another strategic choice, the school's director ensures it can lay claim to the "organic" label. Everything is grown without fertilizers, contrary to the local practice of using high levels of phosphates which run off and pollute rivers and lakes with the first rains. The center also turns the wool of its sheep and goats into products for sale. The children wash, spin, weave and dye it to make scarves and rugs. This is of course a trade they can use later, after they leave the school. After 24 months of training here, the adolescents emerge literate in

their own language, and also with beginner-level Chinese and English, and above all with a diploma and a trade: cheese maker, weaver or masseur/masseuse. Several former students have already opened their own salons or shops and are making a living, some recruiting employees from the school. The horizon is beginning to clear for these children.

The school has very few salaried workers. There is Michael, Owamba "the Father Innkeeper" (a small man with tanned skin and a felt cap which looks as if it has been screwed on to his skull), his wife the cheese maker, a chef and a gatekeeper. Helping the instructors and experts are Tenzin, Norbu and Yudon, all three blind former pupils and less than 20 years old.

At the time of our visit there were 36 boarders. The school has the capacity to take in more, were it not for the restraint of its permanent need to keep a low profile in the face of authorities easily prone to paranoia, to pay attention to their views, and never under any circumstances cease to struggle for acceptance by them. So as not to shock anyone, the school limits its publicity to a very discreet level, merely informing people of its existence.

Another limitation is the love of parents for their children and their reluctance to entrust them to "an institution," with the resulting sense of failure. This prejudice is all the more pervasive when the center concerned is run by foreigners, who under communism never get a good press.

Lastly, the school's ability to accept more pupils is held back by monetary constraints. It must cover its own living costs and fund the education of its students, as it is banned from accepting donations or subsidies from China or from abroad – a rule which in fact applies to all NGOs in China – with the only exception being its mother house in Germany with which it is authorized to maintain a slender financial umbilical cord.

But the Bianhui school is strong enough to overcome these handicaps, thanks to two aces: its good reputation, and the considerable gratitude it earns in the region for giving opportunities to children previously condemned to an existence bordering on the inhuman.

It is now the time for recess. Friendly and playful, some girls chat with us while a bit further away two boys play poker. Laurent notices that their playing cards are normal and not engraved with Braille. But this does not prevent these inveterate gamesters – one completely blind and the other with only two out of ten vision in just his right eye – slapping the cards down on the table without missing a beat or making a mistake. And the blind one wins. Watching how with each hand dealt, they stroke the cards with their index, middle and ring fingers, Laurent can see that they identify their cards by the thickness of the ink printed on each one. Now there's a talent unforeseen by Sabriye to convert their handicap into an advantage!

All told, our visit to the school lasts three hours. We prolong it by accepting from our hosts a delicious meal – goat meat stew with potatoes, washed down by some tart-tasting *chang* beer, certainly home-made.

I am amazed by Sanmu's metamorphosis. Imperceptibly, our guide shakes off her terror of seeing us transgress

against Communist regulations. As if she had shrugged a heavy rock off her tired shoulders, I see her becoming more relaxed and even lighting up with some timid smiles while chatting with the teachers, the children and Brigitte. It is almost as if her view of our little group was swinging from a past image of us as suspect individuals and subversives towards one of honorable people now. Our long break of journey here has enabled our guard to feel for these adolescents, who had such an unlucky start in life but can now mock their previous condition as pariahs and regain their dignity, with a helping hand from adult fellow humans. As a Tibetan she can only be proud, for her people and for China, of the hope that is being generated here. It is entirely to her credit that Sanmu has allowed herself to be caught in a trap of hospitality.

16:00 - Tashilumpo, last monastery and last trick

We arrive after a few minutes at the gates of Shigatse, the second largest city in Tibet and make our way to Tashilumpo, a white and ocher monastery designed along the same lines as the great Gelupga sanctuaries in Lhasa. Historically, Tashilumpo is in fact older, having been built in 1447 by the first Dalai Lama. In the era of its glory before the occupation, it was a sacred place for conclaves and religious festivals to which tens of thousands of monks and lamas converged from all over the kingdom. Today, under the regime's straitjacket, only 200 to 300 remain.

Behind its high walls, the phantom citadel allows us only to guess how this human universe functioned, what great refinement and magnificence marked its days, how an atmosphere of piety mingled here with careerism, like a Vatican bustling at all hours with the rustling of robes on paths of marble finely worked down to the last millimeter, along its covered passageways, past fountains and wooden galleries, and in its thousands of cells for resident monks, courtiers, visitors and missionaries. Today, all is falling into decay and ruin for lack of upkeep.

Shigatse is only 300 km from Lhasa but its people speak a different form of Tibetan which is incomprehensible to the citizens of the capital. Until China took control, this fief of the Panchen Lama was notorious for its proud opposition to the Dalai Lamas and Lhasa. It was closer to China, in mentality and in kilometers. The wealth of the temple of Tashilumpo irresistibly evokes its desire to lord it over the rest of Tibet. The most common image seen on their mural frescoes is that of the heraldic snow lion, claws fully extended, as if to illustrate an imaginary motto, something like "touch, and you get scratched."

Under this same need to affirm its glory, Tashilumpo possesses the world's largest *tangka* screen, an elegant tower in the form of a truncated pyramid that I estimate to be 120 meters wide and 60 meters tall. One truly unique aspect of Tibetan culture is its theology of the spectacular, such as this giant *tangka*, the very suggestive frescoes in monasteries, and the many festivals like those of "Curdled Milk," "Joy," and the New Year. The latter are doubtless a chance for people to demonstrate their devotion, but also to sit with family and friends on the grass, munch cookies

or fruit, sip tea or *chang* beer, all against background music of horns, pipes and drums.

On our arrival, Tashilumpo presents something altogether different, an example of a tourism policy gone awry. The monastery is under heavy assault from teeming throngs of tourists from the lowlands. Having just poured out of their planes and buses and showing off their latest-model photo and camera gear, they delight in a jungle safari where lamas are treated as the hunted animals. They have to shout to talk to each other or to get people in place for photos – and they frequently spit for mouth or throat hygiene. Their noisy chattering does not even die down in the naves used for worship and in prayer rooms – they find it necessary to continue even above the loud phrases booming out of the tour guide's loudspeaker.

The lamas defend themselves with sign boards, threatening photographers and movie cameramen with prodigious fees: ¥100-200 to take a picture and ¥1,500 to film "the biggest sitting Buddha in the world" (sic), in bronze and gold alloy. Hidden in the shadows are lama police on the prowl, ready to pounce on any offender to make him pay.

We are quickly put off by this vulgar display, so we go outside and stroll through some deserted alleys. There we pick up the unexpected refrain of a traditional ritual orchestra. Coming closer to the sound, we stretch our necks to peer over a gate to where the nasal notes are coming from and push our way past some 15 curious onlookers.

And so by blind luck, we stumble upon a very big party going full steam. Thousands of pilgrims are seated, stretched out or wandering on the grass, watching masked dancers performing their routines to the drum-beats and plaintive airs of about 60 musicians in robes and boots of golden yellow.

We stay for a good half hour, enjoying the best show of our trip. We are overcome by the power of the scene, but also irritated. Sanmu swears in the name of all the gods that she was unaware of the festival, but we do not believe her for a minute. It is the famous and unique *Ximoquenpo* or *Shmo Shenmo* (she suddenly remembers its names, "Oh but of course, yes, you are right."), a six-day cultural and religious gathering for the exorcism of the dead, one of the most important events of the year in Tibetan society and tradition – and one that she and her *Waiban* tried to hide from us! Without further discussion, we order our guide to rearrange our travel schedule for tomorrow, so we can come back here first thing in the morning. We go back to our hotel, at the end of a day full of kilometers, happenings and a wide range of emotions.

THIRTEENTH-FIFTEENTH DAYS
2-4 OCTOBER, 2008
THE END OF THE JOURNEY

Shigatse, the Shmo Shenmo Festival

09.00. Returning to the festival, we watch the spectacle of the religiously-inspired actors and dancers on stage beneath a white awning to protect them from the glare of the sun.

Dressed in purple with a rectangle of golden silk hanging from his belt, and clogs sharpened at the toe, a monk draws arabesque shapes around his frame with a golden yellow veil as he dances solo. After him come other actors in allegorical costumes. Wearing red, yellow and bottle-green brocade with epaulettes of royal blue, they sport enormous boiled leather masks. One represents a prince with a fine moustache, another a black demon with a hydrocephalic-looking swollen head, then a female demon as a doe with wooden fangs. Other monsters, half yak half tiger, perform a strange dance with bells on their feet, arms horizontal and palms flat facing upwards.

Within this demonic bestiary, two characters stand out as the exception. They are the only humans in the drama and as if to make up for this distinction, their role is to present in ridiculous fashion all the desires and suffering of the human race, from which Buddhism aims to free us. They do not wear masks but instead bushy wigs and fake beards and for clothing, rags and animal skins.

In contrast to the others who always dance with rhythm and movements of slow and symbolic grace and precision, these two clowns run around in absurd disorder, contorting their bodies into extreme positions, turning a thousand somersaults, all with many childlike and unpredictable gestures. They play with a whip and a stick to make people laugh, not to scare anybody. They throw pieces of candy towards the audience and race (but in jest and not too fast) with children who dare to run forward to pick them up. They serve as the antithesis to, and light relief from, the earnest scenes of exorcising this or that human passion and the fight against creatures from hell.

Later, skeletons come on stage with white bones depicted on their vermilion costumes. The designers obviously have a very good grasp of human anatomy, except for the solar plexus which is greatly exaggerated in size. Their backs are covered by yellow scarves and their hands and feet are clawed and webbed. The four of them spin around slowly to mournful notes from the Tibetan horns, three meters long, made of copper fringed with silver and capable of producing deep rich tones. In the stands, elderly spectators protect themselves from the heat of the sun with Tibetan-style felt caps or cowboy hats. Some wear huge sunglasses carved out of rock crystal or local amber. They look alternatively thoughtful and thrilled as they comment

about this actor or that interpretation with a good-natured laugh. Nearby, dignitaries wearing carmine robes sit in armchairs, some of them still quite young. These are the "sons of the archbishops," coming from upper-crust families. Everyone, ecclesiastic and lay alike, chews all day long on roasted pumpkin seeds, spitting the shells out at their feet just like the Chinese.

Debonair but vigilant, a Hercules-sized lama policeman does his rounds. Bald and robed in carmine, he unwinds his rosary through his fingers as he walks.

Seated off stage, the monastic musicians play a multitude of simple pieces. Some feature cascades of rattles and other percussion instruments accompanying drummers holding up a vertical set of drums on a long handle. Just above the level of their own heads, they strike the drums' leather surfaces which are stretched by a clamp shaped like a question mark.

On the grass all across the huge park, families and groups of friends sit eating, chatting, following the performance, or else sprawl dozing on the grass, giving the whole scene the incongruous feel of a pop music festival.

When we leave later by the avenue behind the gate with dozens of little stands selling things, we are treated to the same sight as we had coming in: a squad of 30 soldiers in combat fatigues carrying billy clubs and shields and drawn up in a square formation. They belong to a special anti-riot unit, as shown by their plain black uniforms with no markings, insignia or badges identifying them. They do not look very relaxed – in fact they appear to be mobilized and ready to attack if necessary.

In contrast, the thousands of visitors at the festival maintain an ambience of naïve good-child conduct, showing a large measure of concentration and discipline which comes close to quiet heroism. For the Tibetans, this is part of a non-violent battle for their culture and for their faith. In the park, educated people and illiterates, rich and poor alike, all rub shoulders united in brotherly relaxation. Like a big family sharing the same values, they insistently exercise their limited freedoms, benign but vital.

Am I wrong in imagining that, during this Shmo Shenmo exorcism, its skeletons and demons arouse in the minds of the audience a precise and direct image of the soldiers who are guarding the gates?

Back in the city, a Chinese Shigatse without the slightest touch of local color, the security lockdown is just as strict as in Lhasa, with the same deployment of deterrent force, but with its own nuances. Here, there are no checkpoints at intersections, no incessant foot patrols, but instead convoys of huge khaki-colored trucks full of armed soldiers. They drive non-stop across the city. Each has a jeep driving in front with a beacon light, honking to remind everyone of their existence, in case they have not been noticed. For them, the festival has no meaning and they have nothing whatever to do with the Tibetans who are celebrating it – except in any worst case scenario to resort to body blows or bullets.

12:00 – the silversmith

We make a brief stop at the workshop of Laba Qiongda, a silversmith. Inside, 18 men who tap, shape, solder and

engrave silver all day long. These 18 artisans toil in rather rough conditions: 56 hours per week, seven days a week for ¥1,360 per month. Laba concurs that this wage is not enough to meet the needs of a family. So the wives add in cash or kind each month the proceeds of cultivating their little gardens, raising chickens, or a pig... Apparently jobs here are so sought after that Laba Qiongda is able to impose strict conditions of employment. An apprentice must agree in advance that once trained, he will not leave the enterprise to go and start up his own business.

Technically, the creations we see slowly being formed are faultless. But it is hard to like them because they lack originality. There are alms bowls and jugs, rosaries, necklaces, and religious objects cloned since their introduction from Nepal in 1740.

On one wall of the workshop is a poster that had its ephemeral hour of glory in 2002, displaying the now faded faces of Mao Zedong, and Deng Xiaoping with Jiang Zemin, the last president who regarded himself as their equal. The choice of the *Waiban* to have us visit this shop is easy to understand. It stems from the officials' obsessive need to demonstrate to us the close alliance between the Party and the Tibetan people. This optimistic vision of the political ties between them is undoubtedly not 100% false. How many in Tibet are loyal allies, supporters of China and Communism? Fifteen percent? Thirty percent? In any case a minority on which the regime is building its future.

Ganzi/Jiangtze: the Citadel of Sad Fortune

Five pm. From Shigatse we arrive at Ganzi, the place which like a door-lock controlled access to the kingdom a century ago.

The former gateway city looks out over a broad fertile valley where nowadays wheat and soybeans are grown. Inside its surrounding city wall Ganzi boasts the rich Palcho monastery, famous for its hexagonal pagoda. High above the city, on a neighboring mountain peak, is perched the stronghold of Tzongshan.

Before the onset of evening we visit that eagle's nest. In Tibet's collective memory, this mountain fortress is an exceptionally important place. Within its ramparts the kingdom lost its independence, following the defeat there of the Dalai Lama's troops. They were dramatically under-equipped in the face of the 3,000 British soldiers led by Colonel Francis Younghusband, armed with modern rifles and 24 Maxim machine guns of terrifying effectiveness. Several weeks later on 3 August, 1904, Younghusband's column reached Lhasa.

For decades, the Dalai Lamas had been able to repulse every attempt by westerners to enter their realm, chasing away or in some cases even executing any European audacious enough to infiltrate their borders. Alexandra David-Neel claims to have been the first Western woman to make her way to Lhasa, in 1924, disguised as a pilgrim.

Twenty years before her feat, the British army had before its incursion used the reconnaissance of a Sikh who like her dressed up as a Tibetan religious devotee. On foot, the spy plotted the principal access routes, counting his steps

on his rosary, adjusted to hold 100 pearls instead of the usual 108 (a traditionally sacred number). He memorized the distances and place-names and each evening wrote them down on a scroll, which he concealed in his hollow walking stick. The maps subsequently drawn from his data proved to be remarkably accurate.

From India, England had designs on Tibet as well as Xinjiang. From its strongholds in Kunming (in Yunnan Province) and Hanoi in Indo-China, France had the same idea, as did Russia from its consulates in Urumqi and Kashgar, 2,000 and 1,000 kilometers to the north respectively. But by far the greatest influence was China, with its permanent "resident" (representative) in Shigatse. In a role much more influential than that of a consul, he issued instructions to the Panchen Lama, the highest ranking vassal of the Dalai Lama.

With regard to relations between China and Tibet and the question of Tibet's historical independence, all seems less clear to me today than before this journey. Through the centuries, Tibet never had the profile of a nation state, but simply that of a kingdom, that is to say, a loose collection of provinces and cities controlled by nobles or the religious orders. Bent under the yoke of taxes and the tithes of the Lamaist monasteries, the local populations hardly had any chance to develop a truly national consciousness.

The Lamaist clergy did not necessarily enjoy the best of relations with the local population. When Catholic missionaries, French and Swiss for the most part, came during the same epoch to evangelize in the foothills of the Tibetan area in what is now Sichuan Province, they were welcomed with open arms. The largely peasant population there held out the hope that they would come under the authority of another religion that was less demanding in the matter of taxation.

Younghusband's military success had no lasting effect. Due to a lack of logistic support, he soon marched away, abandoning the territory he had conquered. Three years after his almost unplanned victory here, Beijing became in turn the real master of Tibet and its "resident" immediately imposed the restrictions on the movements of foreigners that Sven Hadin complained of, in his written account quoted earlier in this narrative.

Then in 1909 a Chinese general, Zhao Erfeng, retook the whole region, but in just as random and scarcely convincing fashion as the Englishman. He left in 1913 as abruptly as he had come, while at the same time the exiled 13th Dalai Lama returned and seized the opportunity to declare the country's independence. Tibet preserved its freedom until 17 October, 1950, the day the key fortress at Chamdo capitulated to the assault of 40,000 men under General Zhang Guohua, dispatched to Tibet by Mao. The leader of the new Chinese communist state could now pick the ripe fruit of a Tibet that had failed to take the opportunity to exploit nearly half a century of reprieve to develop for itself sufficient financial means and technology to uphold its independence.

After the second phase of its conquest in 1959, China rushed to denounce the colonial invasion of Younghusband and to laud the heroic resistance of "*the people against the foreign invader.*" Today in Ganzi nothing is left to chance:

neither street names nor the monument to the "heroes of the resistance," most prominent among them the statue of the Tibetan garrison commander who is said to have thrown himself from the tower of his fortress when its walls were breached.

There it stands before us today, a statue that has been almost completely restored; witness of an invasion that failed but concealing another – the one that succeeded.

Return to Lhasa

Friday the 3rd and Saturday the 4th afford us the most beautiful countryside seen during the whole of our journey. Traveling across plateaus, past lakes, peaks and mountain ranges in eternal snow, we drive on winding but very well maintained roads towards Lhasa from the south, after having taken the northern route for our outward journey to Ganzi. Passing close to Mount Karola (7,900 meters), we reach altitudes none of us had ever previously experienced. The mountain slopes are grey and mauve, the colors of their slate rock strata and of bare terrain as nothing can grow at this altitude. For tens of kilometers we drive past a man-made lake whose intense blue-green waters reflect here and high-tension electricity pylons artfully converted into stupas, with multicolored flags and garlands. A special kind of beauty!

Overcome with emotion in the face of the scenic grandeur we see at every turn, I confide to Sanmu, "*Wo ai ni de guojia*" (I love your country). This is a mistake, because the little pest is quick to detect (or believe she can detect) a trap of some sort in my words. After a couple of

seconds, back comes the politically correct response: "*Bu shi wo de guojia, shi wo zizhiqu*" (It's not my country, it's my autonomous region)!

At 4,808 meters, the height of the top alpine peak, we tip our hats emotionally to France's Mont Blanc. Its summit would be one meter below our boots as we climb up to a *chorten*, a pile of slate blocks on which are hung white strips of cloth floating in the wind. From this high point we admire the view of the reservoir forming a sort of heraldic design in its beautiful cluster of valleys, hemmed in by a stiff corset of rising peaks. At this altitude, we have only half as much oxygen as we breathe at sea level. Perception of the three dimensions changes. As I struggle to keep my balance and measure my steps to avoid the real possibility of breaking my neck, a thought which seems incongruous in these surroundings crosses my mind: "Tibet and China each find what they are looking for. Tibet finds purity and China finds power."

Five hundred meters below, we spot the remains of a monastery, built at the likely cost of a thousand lives, on a bare hillock where it could guard the road to Lhasa. Today, with its foundations under water, ruined and abandoned (isolated by the waters of the reservoir after construction of a dam), it bears witness to the vanity of human enterprises: *sic transit gloria mundi…*

Twenty to thirty kilometers further on, the countryside changes completely. A barren plateau accommodates two austere villages, built in the straight lines of military design in a totally unsmiling landscape without any sign of human life. They are surrounded by fields of thin weak looking

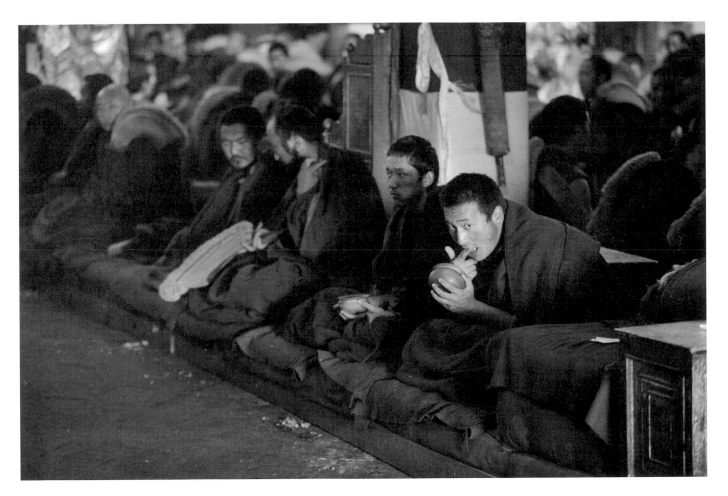

Resident monks gulp their meals during a religious ceremony at the Gelupka monastery, Drepung.

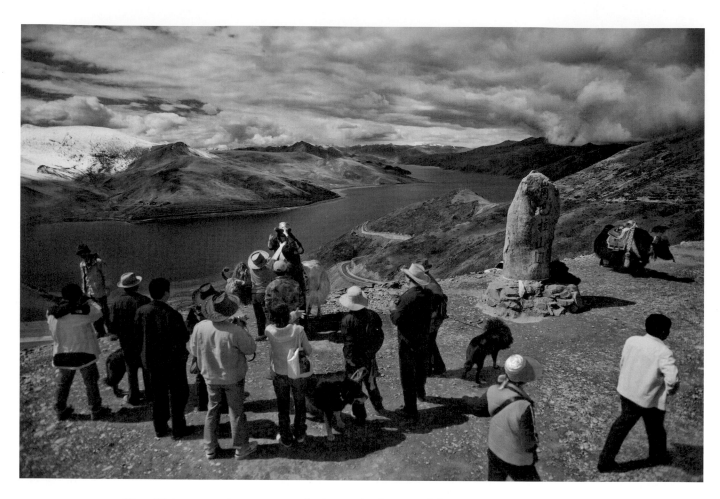

Han Chinese tourists pose, perched on yaks decorated for the occasion, for their friends at the Gampa pass overlooking the sacred lake Yamdrok-Tso. Tamalung.

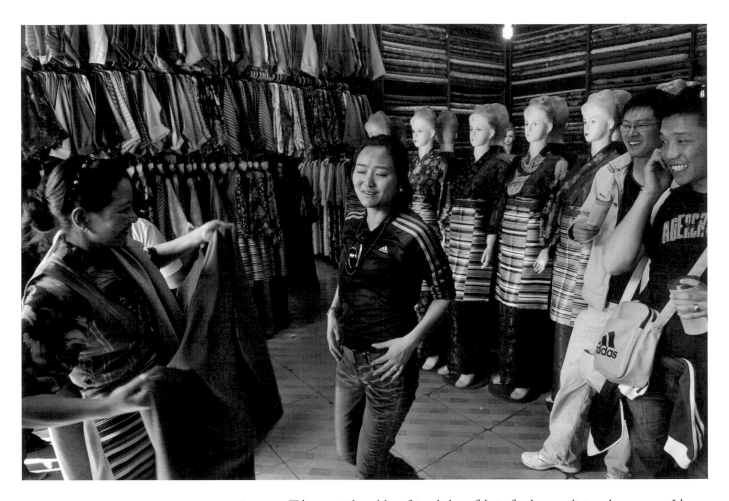

A young Tibetan girl and her friends buy fabric for her traditional costume. Lhasa.

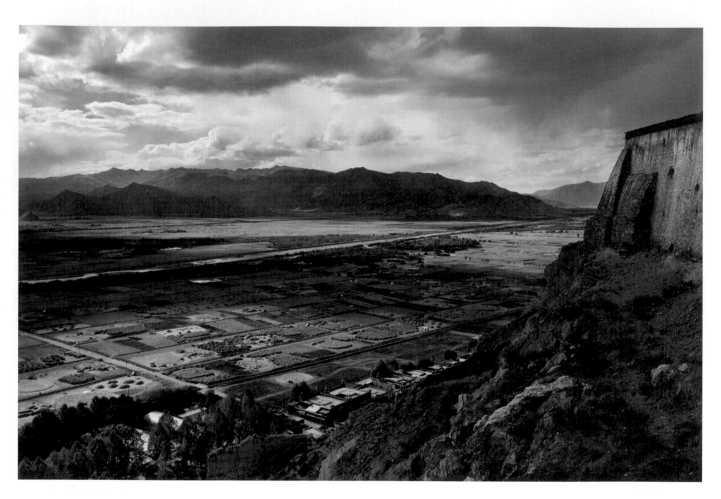

Harvests at the foot of the Gyantse fortress.

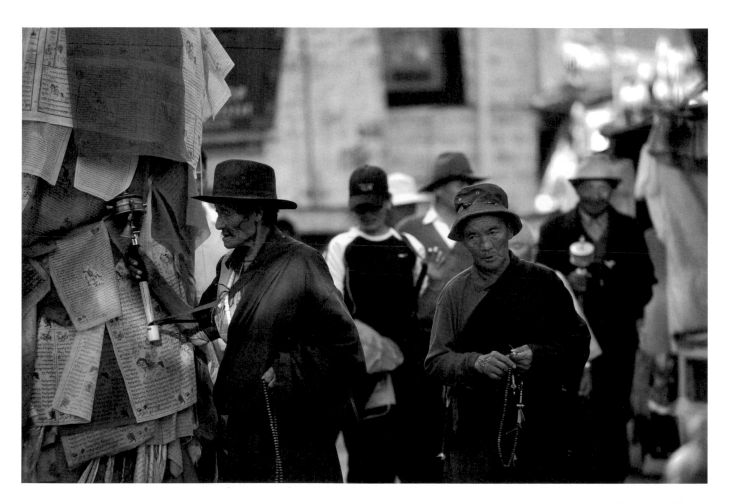

Pilgrims circle around the Jokhang in Lhasa.

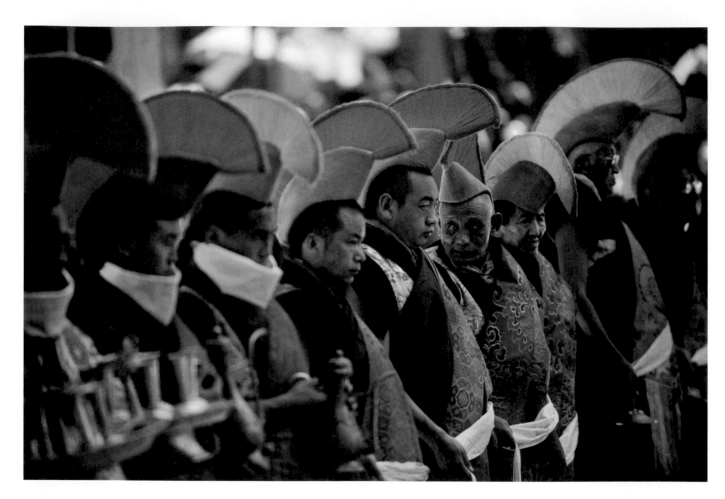

Shmo Shenmo festival at the Tashilhunpo monastery, Shigatse.

Hot springs at an altitude of 4,200 meters at Yangbajing.

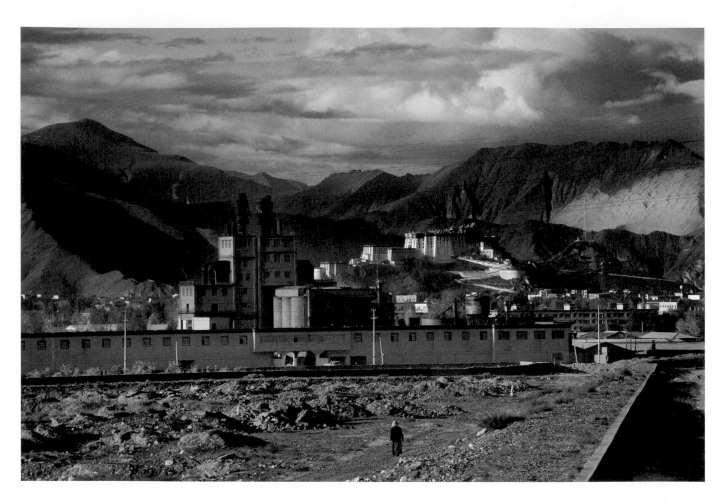

The industrial outskirts of Lhasa.

rye, which is still green – in contrast to Ganzi where, when we left this morning, the harvest was being completed. But here this is an impressive effort; even at 4,450 meters there is no let-up in the drive to grow crops.

Further on at Lake Yamdrola, at the same altitude, we discern dotted on distant snowy slopes scattered black and white spots, in fact yaks grazing on what is left of the grass after the hay harvest had been stored for the winter.

The Gambala Pass (4,974 meters) is a tourist stop. Snow is falling in a blustery wind. A short distance from a tongue of the glacier, peasants walking yaks with their horns decked in little turbans as if for a wedding party, call out to us in the (vain) hope of earning a few yuan by letting us take their photos. Hawkers have spread out a thousand miscellaneous items for sale. Some have a certain value: lumps of crystal and yellow amber with insects inside, ammonite fossils, and statuettes of Tara (Bodhisattva Avalokitesvara), the goddess of travelers, carved from the femurs of yaks. And also the inevitable Little Red Book of Mao quotations (in poor condition at this altitude), Mao medals, and trinkets and mementos of his one-time deputy, Marshal Lin Piao. Revolution and Buddhism: the vendors on this pass pragmatically have something to offer for every taste. But half the travelers, overwhelmed by the cold and altitude sickness, stay in their buses and remain unaware of the genius of the place and the bizarre kitsch of its souk.

Resuming our drive, we find conditions becoming milder and less harsh as we lose altitude. At 4,200 meters, we see our first full herd of yaks, at 4,000 meters the first tree, at 3,800 meters the first fields of grass, then reach the valley floor at 3,650 meters, the altitude of Lhasa where we arrive around 17:00 after having according to plan dropped Brigitte off at the airport. It's the end of the trip for her, as she needs to return to Beijing.

We then head for our good old Hotel Brahmaputra/ Shenjiang. Our dear Sanmu leaves us at the reception, mission accomplished, promising to rejoin us tomorrow morning for our last walk in Lhasa and our final purchases in the shops. We mark the formal end of her assignment in a somewhat limited manner; we have warm words for her seriousness, reliability and and sense of duty, but we stop short of the usual French "*bise*," the peck on the cheek. The day and our whole trip draw to a close.

An unforeseen escape

How in these conditions to explain that an hour later, instead of being in our rooms writing, taking a bath or playing cards, we find ourselves barreling along at high speed on mountain asphalt, heading straight to new adventures, sitting in a different vehicle that has replaced our minibus and grumpy driver?

We have deserted our hotel. A surprising series of lucky breaks has inspired us to turn round and make off like escaping bandits.

While we were waiting our turn at the reception desk to re-register, two vacationing Germans were praising to us in irresistibly glowing terms the beauty of Lake Namtso, a pilgrimage site three hours to the northeast from which they had just returned.

We quickly discuss and agree. Our official program is over, since under the pretext of unavoidable delays the Waiban had not provided any follow-up to our requests for further meetings and visits. Nothing and no-one across the vast expanse of Tibet expect us, other than our airplane the day after tomorrow. And we have already spent quite a long time gaining sufficient knowledge of Lhasa, where we stayed eight long days. Our official pass authorizes us to travel in three counties, including the region of Lake Namtso. Also, and above all, it must be added that Laurent, our photographer, Li Feng and I are longing to do something ourselves, independently and in complete freedom.

Using our mobile phones, we call the travel agency to reserve a fresh car, smaller but better adapted for this escapade, and off we go.

After an hour of straight road, while passing camps of nomads in the process of migrating before the winter (returning to Qinghai), with their tents, herds and little articulated trucks, we suddenly all feel, one after another almost simultaneously, our mobile phones vibrating with arriving text messages from an unknown source.

By tacit agreement and without saying a word, we shut off our phones and carry on with our brave driver Wang – that is his name – a native of Tianjin, 5,000 kilometers from Lhasa. This affable character is 44 years old and proves to be a big help, positive and cultured too. Delighted to have a car full of foreigners who can speak his language, Wang makes one scenic stop after another and enriches them with his commentaries. He did not share the urgent

concern of his predecessor who used to hurry on like a horse racing back towards the stable in anticipation of his expected feed bag of oats.

At each stop, we are surrounded by poor, hungry children. Without getting annoyed at all, Wang opens the glove compartment and takes out candy which he distributes to them, speaking in their language (which he has learned perfectly) as if they were his own kids. It is clear that Wang has made Tibet his new country, the first Han we have seen this who loves the plateau, for itself and its people. This seems to us to augur very well for our excursion.

At 9:15pm in pitch darkness we come to Damxiong, a town of 38,000 inhabitants if one includes migrant herdsmen passing through during the summer. We decide to stay overnight at a hotel called the Golden Pearl, which seems to be the best in town. We order our dinner. One of us thinks of the telephone so we all casually and mechanically turn on our cell phones, an action which triggers the transmission of an avalanche of pandemonium and panic.

We now realize that the text messages of a few hours ago were not the usual offers of new Beijing residences on the real estate market, fake legal invoices for sale, or other spam. No, they were all from the Waiban and the Ministry, some even from offices in Beijing, high officials trying hard to locate us. Having discovered our disappearance, they sounded a code red alarm. The first messages we received demanded "Where are you?" and ordered us to reply "now."

Subsequent messages bitterly upbraided us for leaving "clandestinely," or reiterated a whole litany of threatening warnings: do not interview any monks, do not photograph any military or strategic installations; in brief, we were firmly told not to do anything that would have been forbidden for us while we were under the command of Sanmu.

Then in the third series, worded in the concise terms of a final judicial ruling, they formally listed our names and informed us that from that moment onwards we must bear the sole and total responsibility of our actions: we were alone in the face of the sharp blade of the law.

It is a serious moment. It must be stated that from their point of view the situation looks like real and exhausting trouble. Two international journalists have just disappeared into the void, in a turbulent region during uncertain times.

I do not have time at this hour to read the final long message sent to me from the Ministry of Foreign Affairs in Beijing, transmitted late in the night, long after their normal working hours. Suddenly, a phone call arrives on a mobile phone and is handed to me as the leader of the expedition.

Seated at our round table piled with dishes of food produced for us by the kitchen chef, who had been called back urgently because of our late arrival, and between mouthfuls of tomato omelet and yak stew, I must explain myself to try to clear up any misunderstanding. I say that we voluntarily answered their call as soon as we became aware of it, that we are in an officially recognized tourist area and that we hold all the necessary authorizations and permits. A few hours ago, we turned off our phones only from a desire for peace and quiet during a precious few hours of vacation. In sum, we have not committed any infraction and are not trying to hide.

Our explanations are immediately accepted without reservation, and – even though I am not totally persuaded that we have cleared up all suspicions – the incident is pronounced closed.

After this tumultuous dinner, we go out to one of the town's two night spots, trying to taste and appreciate our freedom and the fresh air. In the half-light under a ceiling complete with a mirrored disco ball and fake vine plants, about 15 boys and girls aged about twenty are dancing in the round, in total innocence, with big arm gestures like those made by small children. Some are wearing folkloric Kazakh clothes, with big tunics, large silk belts and riding pants. One veiled girl is obviously Muslim. The others are Tibetan or Hans in blue jeans and T-shirts, the obligatory outfit for the modern look in the small town. Rather than keeping to themselves, these youngsters give us a rousing welcome. Half an hour later, Laurent and I find ourselves dancing in the circle with them, hand in hand. One student of English and Chinese in Lhasa offers to take us home tomorrow to meet her family.

It is eleven o'clock and outside the stars shine with such brilliant intensity that we seem to be able to pluck them by hand. We enjoy the naïve friendliness of these provincial youngsters. But it is hard to appreciate all this while living

in the now: tomorrow is not just another day. We already have one foot outside Tibet.

Saturday the 4th at Lake Namtso Park

In the pale dawn, at 7:30 in the morning we leave while Damxiong is still sleeping at the foot of its mountains. Once we have passed through the last control post, we eat up meters of altitude as the road climbs into the Nyenchen Tangula mountain chain, first cousin of the Himalayas.

Lake Namtso is a region of nomads. But they cannot be seen now, Mr. Wang explains, since they have gone back home starting in October to their native Qinghai, having already sold their fattened animals here during the warmer season. Ninety minutes later, we are in the light of day on the Nakhenla Pass, which according to our GPS is 5,207 meters above sea level, a record for our trip. In the snow and lichen, we see five heavy vultures of the kind that pick the bones clean of human corpses. Their long, bare necks are featherless down to their dirty wings. They are in the process of eating a dead dog's belly, ignoring the frost. A honk of the horn gets these repugnant predators to lazily move over several meters for us to pass.

It is a fairy tale sight: along the road the land is yellow and the mountains are white with snow, in contrast to the deep blue of Lake Namtso, the second largest (192 square kilometres) and the second highest (4,200 meters) salt water lake in the world. Near its shores, innkeepers – a few Tibetans but mostly Hans – accommodate in big metallic cabins the most hardy and audacious travelers: backpackers from Chengdu, Canton or Shanghai. The

tourist season will close in two weeks before the extreme cold of winter sets in. Trucks will pick up the dismantled cabins to be stored in a dry place at Damxiong. We have a lunch of instant coffee and bowls of rich, nourishing yak yoghurt.

The banks of the lake are decorated with thousands of elegant *mani,* pebbles sculpted as "*Om Mani Padme Oum*," the mantra of compassion. Mani denotes stone that has been religiously modified by humans. By means of the mani, men glorify the purity of the lake and create a perfection which they admit is ephemeral. For nature follows its course: during the day the sunlight thaws and expands the rock surfaces and at night they refreeze and contract. The snow water works its way into cracks in the rocks. This daily expansion and contraction of the water in the rocks' fissures causes them to break apart, so that they slowly turn to dust and change into another geological formation after millions of years. These cycles follow their predictable rhythm, somewhere between mathematics and meditation. Later, long after we are no longer of this world, this powdery rock will get recompressed into new pebbles, then reduced to powder again in one cycle after another until the end of time.

The view is majestic and overwhelming. A small monastery on the banks on the lake upholds the shore's role as a place of worship. A mound about 100 meters high drops to the lake in the form of a little cliff which is spotted with plaques of material looking like congealed paper: the remains of thousands of white rayon *hatas* blowing in the breeze, stuck to the steep slope and gradually decomposing.

Whether Chinese or Western, visitors are critical of what they regard as negligence among the faithful; for them, throwing scarves to the wind creates pollution unworthy of such a sacred site. But from the local point of view, this action serves to bless the land across the sands of time, and is a release of total energy, matter, and form.

Hundreds of Tibetans of all ages, male and female, wander around begging for money from visitors. Their quest for alms seems here to have a certain theological meaning, in harmony with the mineral nature of the surroundings. Even if, as Jean-Paul Ribes would remind me later, allowing begging was not the case 60 years ago, and now denotes a decline of discipline in Tibet and in its ability to police its own people.

Along the shore, big boats with sewn skin hulls pulled across wooden skeleton frames await passengers.

Lake Namtso perhaps puts into practice the dream of conciliation and rapprochement between the peoples, shared by the government and at least some Lamaist abbots alike. The hotel staff and visitors come from both races. They are all young, educated and entrepreneurial. In our tavern, Hans and Tibetans mix good-naturedly, capable of sharing the place, the jobs and the opportunities of the new economy.

Our road has come to an end. Above and beyond the tensions and dreams of power, we have seen many splendors and illusions (or disillusions) of both separate realities.

Here these peoples have nothing to say to each other, but they associate with each other anyway. They build together and are maybe creating a synthesis composed of their pasts, of their coming together, and of modern technology. At least neither is preparing for confrontation and cataclysmic destruction. It seems to me that no-one on either side has a clear idea of where all this will lead them, of their future direction. Some are more tolerant, others more furiously hard-line. The micro-system we see here by the lake can therefore be regarded as a symbol of Tibet as a whole, with its options and chances, its possible future courses, all depending on the choice of its clans – for peace or for conflict.

This is the end of our journey. Tibet's journey continues into a future engraved in its magical sky and in its distinctive clouds, both more intense than anywhere else on Earth.

AFTERWORD
A DIALOGUE WITH THE HAN PEOPLE

During our journey, we were able on a daily basis to experience personally the attitudes of the Hans, of the Tibetans, and of the minorities. We got our fill of hearing the regime's opinions and, less frequently, those of its often intimidated detractors. But what about the views of the non-aligned, of the man in the street in China? This question can prove vital, because ultimately on the answer depends the ability of the country to recognize the Tibetans' right to be different, to reconcile Tibetans and Hans by means of courageous political actions and by deliberate steps like those which fifty years ago launched good-neighborly relations between France and Germany.

With that question and answer in mind, I invited a group of Chinese friends to talk about Tibet, as a postscript to this book. These were active people with a good level of education but no intellectual pretensions, typical representatives of contemporary, urban China.

I read them the preface of this book, the scene on board the T-27, where the two small time Han businessmen verbally attacked some young Tibetan passengers. I asked them how they felt upon hearing this story and generally, about the situation in Tibet and its relations with China.

I promised them anonymity, the indispensable condition of their open participation in the discussion. So their words have been presented as the voices of two persons, whom I call A and B. Admittedly a writer's little game. But life is not a game, and certainly not in China.

This arrangement may appear naïve or goody-goody. But if one bears in mind the Chinese tradition of non-confrontation with the state and the intolerance of the latter towards boldly outspoken independent opinions from its citizens – especially about Tibet, a subject with a strong emotional charge that stirs nationalist heart-strings – one can better appreciate the open words of these witnesses, freely expressing their opinions to a foreign journalist.

What these young people say shows instances of nuance, is sometimes critical and always distinct from the official line. They reveal a rapid maturing of the Chinese soul, anxious to affirm itself in the face of a party that is already an anachronistic monolith. They also show that if the powers that be are dramatically incapable of change, popular opinion is much more open. These young Hans give hope for an evolution in Sino-Tibetan relations, in the direction of greater cooperation.

Eric Meyer: How do you feel about what I just read to you?

A: It doesn't shock me because it is so current and real. As I was hearing it, I was saying to myself that this is not

some invented scene. At least the young Tibetans were intelligent in making their retreat in the face of a conflict that they could not win. As for the Hans being so aggressive, they show that they were completely incapable of feeling the effect of what they were saying on the Tibetans.

B: It was surely a provocation. The conversation with the Tibetans was cut off by the Hans. This scene is emblematic of everyday life. The ideas expressed by this Mr. Zhang and his behavior must be considered as normal in this country.

A: Not really normal, but universal. Even so, a little shocking since these guys are so arrogant.

B: What strikes me is their lack of politeness. Because in China normally, we let others speak, if only for them to not lose face. We do not even have to consider accepting their point of view. But here, these Hans, they almost immediately cut them off.

EM: One thing that really struck me: Zhang immediately adopted political language, praising the Communist Party. But normally, this kind of task is reserved for people within the governing apparatus, especially in the presence of foreigners, isn't it?

B: What he said demonstrates above all the merging in the minds of most Chinese of the government and the Party. Most people do not realize that there are two systems, the Party and the government. Those guys are not very well educated.

A: In China, as is true the world over, a spirit of parochialism pervades. Beijingers make fun of Shanghainese who mock Guangdongers. When they get together, they immediately criticize each other quite openly. But, as for the Tibetans, that is a quite another matter altogether, just like the Uighurs, the Huis and other minorities. With these people, we feel like we are in the "majority," a bit superior, and we see differences between us as their defects. We reject those who do not assimilate, "You are not a part of the group, we do not like you…"

There are also the phenomena of ideological battering and the alienation of work. People like this Zhang and this Wang work hard, and don't have the time or the cultural means to reflect on the slogans with which they are constantly bombarded. They see on TV and hear on the radio a hundred times biased stuff about the goodness of the Party and the ingratitude of the Tibetans. It is not surprising that when a foreigner turns up, they dish it all up to him again, nice and hot! It's Pavlovian.

B: But they live in Lhasa, the capital of the Tibetans. They could want to get to know neighbors, learn the language, understand their customs, try their cuisine…

A: No, they only went there to make a living. That does not make them like the place. They feel like outsiders there. They feel superior too, but at the same time insecure. In other words, this has not been an especially great time for them to have experienced, with all those riots that caused them to leave.

EM: They are telling the truth in part when they say "China has done a lot for the Tibetans…" But in fact, what is China trying to do in Tibet?

B: It's a question of definition: what does development mean? When the train track reached Lhasa, for most of us Hans that was a symbol of development and economic growth. It is the best we have to offer. The Hans are convinced they have acted generously, as a function of their materialist viewpoint. But for the Tibetans, things can look very different, viewed through their own philosophical prism. They see something completely different.

There is a total difference between the Tibetans and us, in the sense of what is life all about. For the Hans, the goal is to work well and amass riches from day to day and convert the wealth into pleasure. As for the Tibetans, they have to work just as hard every day too, but their aim is a good life after death. So for them, a beautiful house, a pretty woman, cash and travel are not exciting. Between us and them, it is like two dreams in one bed.

EM: And you, A, do you agree?

A: Yes I do. But with a little nuance. Most Tibetans think that the work sites and social investments that we have provided for them are a good thing. I think the majority of the locals are not against them. But that is not enough. It is like putting a bird in a golden cage. Even fed and housed, the bird is anxious. Tibetans cannot be satisfied because they are not masters of their own land. It's the Hans and the Party who take all the decisions, not them. And their leader, the Dalai Lama, is in exile in India. Also, the good material life is not everything.

Then there is the problem of identity, between the majority and the minority. I think back to the attitude of the two groups face to face on the train and it is very clear: the Hans acted the way they did because they knew that 80% of the people on that train belonged to their ethnic group, including the police on board. Never in a thousand years would they know what it would feel like to be in the others' shoes, to be dominated by the Tibetans who had conquered their country and imposed their laws on it. And it's just the same for Tibetans. They are very careful not to voice any protest like, "You Hans, why did you come here in the first place? We did nothing to you!" The fact that they keep their mouths shut reveals the scope of their disarray.

EM: Maybe that's their non-violent method of resistance, Gandhi-style… like that of the young people on the train. It also could have been a tactical choice to retreat… reject provocation and violence…

A: Not clear. We have the same rule in Chinese Buddhism and we don't apply it, any more than they do…What seems certain to me is that on that train, the renunciation by the Tibetans to defend themselves in the face of Han arrogance is symptomatic of colonial feelings.

EM: Even so, when Mr. Zhang interrupted our conversation on the train with the young Tibetans, he showed that he did not want to share the riches of that moment, the time with us foreigners. Between superior beings, they thought, it was they and only they who should be talking to us… maybe that is a symbol of

something else altogether: a refusal to share with the Tibetans the mineral riches of the plateau!

B: I do not think this Mr. Zhang can represent the majority of the Chinese. First, there he is part of a minority (the Hans) in Tibet, whereas everywhere else in China, we are the overwhelming majority. Also, his situation and behavior cannot serve as a model for the whole of our people.

EM: Basically, what does it mean to be Tibetan, in the eyes of the Hans?

A: Not anything of great value, I'm afraid. On the internet, 60% of the people have the same kind of attitude as our Wang and Zhang. But to be honest, one must assume that all the people of the world nourish these kinds of crude and populist prejudices about their neighbors. It is not easy to evolve. To change your mind, if you are wrong, you have to come to terms with that. For example, I do not know whether in France national identity cards define ethnic details of the bearer like "French Breton" or "French Alsatian." Here, ours say "Chinese Han," "Chinese Mongolian" or "Chinese Tibetan." That is what divides us and prompts feelings of rejection between us.

EM: How can relations between the Hans and Tibetans be improved? What can be done?

B: I can't even come to terms with the idea of a Sino-Tibetan conflict, and what kind. I spent a week in Tibet. That is obviously much too little to understand the place, but I saw a lot of different people: pilgrims in the mountains who throw themselves to the ground while repeating their *Om Mani Padme Oum,* fervently devout Buddhists. I saw in a village a big, beautiful house constructed of stone and wood. A woman invited me in to visit. I felt absolutely no ethnic rancor while I was there.

I wasn't expecting such a level of prosperity on the plateau. Her family had received government aid, a cash loan and wood planks to frame the roof. This lady complained about her children being too lazy to go to school. That was the case for many Tibetan children, she added. Yet this did not prevent her family from receiving each year a government grant of ¥600 per child as a contribution to the cost of their studies. In sum, there is a bit of everything in Tibet and its relationship to China cannot be seen as monolithic.

EM: A maximum 30% of the Tibetans consider themselves to be Chinese and are happy to feel that way. But as for the other 70%, how do you reconcile them? And the question of religion, so suppressed in its development, how can it be worked out? What kind of accord can be found with the Dalai Lama?

B: From this point of view too, the picture is quite diverse. Beside the very pious faithful I saw corrupt monks at the Potala. My Han guide talked with one of these robed guards, who then took our group to a secret hall, normally never open to the public. But this supposedly famous place was not at all interesting – and yet the guide and the monk schemed to make our group pay extra for

it. I was really surprised, since it all happened in this place that is one of the most sacred of their church…

A: Right now, the Potala is empty of its monks[52]. Those who are occupying it are the *wenwuju*, the Bureau of Relics and of course the military… So, the palace of the Dalai Lama has become a godless place. If the people occupying it wear monk's clothing, then they are impersonating.

B: It's the same thing at *Dazhaosi*[53]. A monk proposed to read our fortune. Just like at *Ta'ersi*[54]. A priest touched my head, gave me his benedictions, incantations and predictions and then demanded a big tip, which I refused to pay. All of this is for me a commercial mentality that is incompatible with the religious fervor that is the traditional image we have of the Tibetan people.

A: In the temples, the monks are not supposed to be performing this kind of bogus show. So these monks you saw were charlatans.

EM: This mercantilism in the temples, is it a traditional behavior, or is it something new that has emerged since the occupation of '59?

A: Hard to say. In Tibet, like everywhere, there are egoists and greedy people disguised as monks. Han or Tibetan, one no better or worse than the other. It is like a virus. It is not because you are Tibetan that you are going to be immunized against corruption. But in Tibet, I personally never ran into that kind of false prophet.

EM: Between the spiritual Tibetans and the materialist Hans, is there a chance that we could leave them to

manage their lives on their own together up in their mountain terrain for 50 years, and that they could end up creating a synthesis of their moral qualities, a new culture, a model for all the rest of us? Between these two people, is a marriage possible?

A: What a challenge… Between Indians and Americans, Quebecois and Anglo-Canadians, it has never worked. We are no more gods than anybody else! The solution might lie in Buddhism. But even then, we would all have to agree on how to follow the rules. And as long as we don't, there will never be peace up there. In order for there to be reconciliation between the two, both sides need to want it. Finally, you say the Tibetans are more naïve or philosophical and we more down to earth. But these same qualities exist in the other camp too, although not necessarily applied to the same areas.

B: I think reconciliation between the two peoples is possible over the long term. But the odds are onerous. For the time being, we have two cultures in competition and the Tibetan one is much weaker. As a comparison, just look at the last three centuries and the culture of Brittany in France… the Breton language is almost extinct, because of its inability to resist advance of your national language…

Now if we look at the Chinese in France, they are obviously far less numerous than the French, but they get along really well with them. I saw on TV that during the Chinese New Year in 2009, there were street festivities just as beautiful as in Beijing, and Parisians joined in. I see here an indication that our Chinese tradition has taken root in

France precisely because our culture is strong enough to make progress, instead of disappearing.

Tibetan culture has very beautiful festivals and admirable traits, making it well deserve to survive. The whole question is whether Tibet has the means and ability not just to maintain but to but to promote its culture. If so, we Hans will have much to learn from it, and with great pleasure!

EPILOGUE

Since our journey ended, four years have passed. In Tibet, the situation has evolved in a worrying manner. The authorities' campaigns of ever tougher discipline and tightening the grip on freedoms have followed one after the other, punctuated by clumsy or futile attempts at reconciliation, including the installation of exercise equipment in the monasteries and promises of social security and health insurance for the lamas, announced in the Chinese press at the beginning of 2012.

Starting in 2011, a serious phenomenon has spread: the self-immolation of Tibetans. It first started among lamas in temples outside the present borders of Tibet" (Kham and Amdo in neighboring provinces), and then spread to Lhasa, even openly on Barkhor Square. Today, the victims include nuns, even lay people, mothers of families and restaurant employees. In other words, the scourge now affects the entire Tibetan society. At the time of writing, the number of victims is approaching forty, and there is no reason to hope that the trend will soon be reversed and the numbers drop, despite even the pleas from afar by the Dalai Lama to follow the religious tenet of respect for life. This collective suicide is described by the locals as the ultimate path of resistance to the arbitrary decisions being made about their future, without their being consulted, or having anything properly explained. What the Tibetans seem to be rejecting above all else is the ban on the return of their spiritual leader, whom the authorities contemptuously describe as a "wolf in monk's clothing."

This is all politics, which is not what this book is about. But the consequence of the politics is to delay any chance of reconciliation. As long as the Dalai Lama is alive, negotiations remain possible. An accord could be signed granting limited rights to an independent and autonomous ecclesiastical organization and allowing the return of a number of exiles.

If an intransigent regime fails the test and misses its rendezvous with history, which it seems at present tempted to do, the country will face decades of violence, just like so many other powers before it (England in Northern Ireland, Spain with ETA, Russia and Chechnya). However, remembering our journey encourages us to maintain hope; not optimism for its own sake, but hope based on our memories of meeting marvelous people along our way, people of goodwill – Buddhists AND members of the Communist Party – Tibetans, Hans and foreigners, discreetly campaigning and cooperating for the cause of peace.

Notes

1 They are not related. The name "Hu" is very common in China, a country very short of family names.

2 Every foreign journalist accredited in China has a designated contact person at the Foreign Ministry's Information Department responsible for keeping up their file. In their (Chinese) trade slang, journalists call the ministry contact "*popo*" or "*laopo*", meaning "mother-in-law."

3 *Le Monde*, 2 August, 2009.

4 At Changdu, also on the Tibetan Plateau, China holds the world record for the highest altitude airport: 4,334m, as well as the longest runway, 4,500m, needed to compensate for the very thin air.

5 Votive paintings on canvas, sometimes very old.

6 White for living quarters, ochre for buildings used for study and prayer.

7 Companions and disciples of Buddha, some of whom lived centuries after him. I use here the Chinese term because, with apologies to purists, I do not know the Tibetan equivalent.

8 *le Tibet dévoilé* (Tibet Unveiled), Hachette, 1910.

9 Meaning "praise for the lotus jewel" and invoking the six transcendent virtues of generosity, ethics, tolerance, perseverance, concentration and careful judgment.

10 The smallest unit of Chinese paper money, equal to about one cent (of a euro).

11 Except for the monastic schools teaching only the Buddhist scriptures (sometimes even in Sanskrit) and accepting only boys, with the sole aim of training them to become lamas.

12 Not counting the historical regions of Kham and Amdo, immense areas now divided up into parts of the Chinese provinces of Gansu, Qinghai, Yunnan and Sichuan. Including the all Tibetans, "internal" and "external," who speak one of the three versions of Tibetan and who practice tantric Buddhism, we arrive at a total of six million.

13 Yes, in this country with 23% of the world's population, budgets frequently do indeed reach this magnitude. For example, for the 12th national Five-year Plan (2011-16), Beijing announced in December 2011 that nation-wide subsidies for new technologies would reach US$1.3 *trillion*.

14 *Immortalité et Incarnation* – Le Rocher, 1991.

15 Bon predates Buddhism, going back to the heritage of an earlier animist civilization, in the same manner that Islam and Christianity superimposed themselves on more ancient religions and adopted their festivals, dates and rites.

16 J.P. Ribes, already quoted in this book, draws my attention to the fact that the extensive knowledge and, for its time, advanced level of Tibetan medical practice owes

much to these dissections practiced by Lama surgeons on the majority of their co-religionists' dead bodies.

[17] It means "happy destination."

[18] At least for outward appearance. The regiments simply re-registered their commercial chains and industrial groups as civilian entities, and the generals reappeared as the principle shareholders.

[19] An old technique, the femme fatale or honey trap is still a method practiced by secret services to compromise troublesome foreigners. In the middle of the intimate rendezvous, which has been intentionally set up and manipulated, agents and cameramen burst in unannounced to witness and record the tryst of foreigner and lover. The result is invariably expulsion.

[20] Zhao Ziyang (then Prime Minister) and Hu Yaobang (Communist Party General Secretary).

[21] Subject to confirmation, the door was believed to be open until the death of the Panchen Lama in January, 1989. But following the Dalai Lama's rejection of an invitation to attend the Panchen's funeral, citing concern about his security, the spiritual head of Tibetan Buddhism has been *persona non grata*, and will probably remain so forever.

[22] The equivalent of €12 billion. Part of this total includes the construction of the rail line. It is not known whether it also includes the cost of maintaining the hundreds of thousands of soldiers stationed here.

[23] Which languages were not specified: Tibetan or, more likely, Mandarin.

[24] This could be an accurate figure. But it still does not reflect the huge disparity in opportunity and income between Tibetans and Han living in Tibet.

[25] 2.7 million Chinese tourists came during the first half of 2009, an apparent return to normal levels. However, severe restrictions on foreigners remain in effect.

[26] In September, the *Times of India* reported that New Delhi had moved a division of 30,000 troops to Arunachal, following military exercises of 50,000 Chinese soldiers along the Tibetan frontier. Both sides are clearly nervous.

[28] Notice that the breakfast in this establishment, which aims to be in the Tibetan style, consists of a dish typically served everywhere in China. In any case, the customers are Han and if they were asked to take in their morning sustenance in the form of *tsampa* or rancid butter tea, they would protest vehemently (as would we, to be honest).

[29] Wikipedia in English maintains that between March and August, Drepung was shut down in retaliation for its massive participation in the riots. The monks were sent home to their families or to lay centers (something like barracks) to put them back on the officially correct ideological track. Eighteen months after the riots, other Tibetan sources claimed that two brothers "disappeared", and the body of one of them was sent home to his family in the summer of 2009. This has not been confirmed.

[30] The long and complicated selection process involves several infant candidates, who take a series of tests designed to evaluate their degree of familiarity with personal objects, idiosyncrasies and attitudes of the deceased, with the boy who is deemed to have come closest elected. The selection

took place in Tashilumpo, the historical fiefdom of the Panchen Lama.

[31] However, ideological subservience aside and from the point of view of the arts, Tibet really is more beautiful and aesthetically refined than any other region in China that I have visited in my two decades in the country, including even Fujian and Guangxi, two of the loveliest provinces. The parks, the villages, the architecture and statues, everything here is more refined, due possibly to the combination of faith, theology and the altitude.

[32] Starting in November, 2011 until 20 January, 2012, at least 20 monks and nuns chose to commit suicide by self-immolation. Neither the government nor the police were able to stop them.

[33] A Tibetan name, indicating Kashmir, their place of origin before migration.

[34] Local title for "imam."

[35] Check his website: http://www.saudiaramcoworld.com/issue/199801/islam.on.the.roof.of.the.world.htm

[36] According to Yakub – but it could be the great Persian sage, Abu Nasr al-Farabi.

[37] To learn more, see the website http://www.itmonline.org/arts/tibherbs.htm

[38] Like the generation of historical Chinese revolutionaries, Mao and Zhou Enlai, sons of educated and land owning parents.

[39] The schools of Gelugpa, Kagyupa, Sakyapa and Nyingmapa.

[40] Whereas green is associated with hats and symbolizes conjugal misfortune.

[41] Slang term for foreigners.

[42] In Chinese administration, the Number 2 is the real boss. The post at the top is often an honorary one.

[43] For example, one such French laboratory in Tianjin produces a traditional Chinese medicine which it coats in a material that slowly releases the active principal ingredient over three, six, or nine hours, instead letting it act all at once, immediately after being swallowed.

[44] Beijing and most big cities have a Tibetan hospital and even a specialized medical faculty.

[46] Beijing announced in December, 2011, in the midst of a wave of self-immolations by 12 lamas and nuns, the passage of a law that the entire monastic population on the plateau would be covered by the social security system, including health, retirement and unemployment – but realistically for those following the monastic way of life the term social security makes no sense. Whatever doubts there may be about this political act, with all its cultural implications which are difficult to evaluate, the decision really was taken and will have an effect on relations between the Lamaist clergy and the central government.

[47] Traditional Tibetan medicine dispensaries. The six-year study cycle is spent in a medical school deep in the countryside, at the foot of Mount Kailash. At a cost of ¥5,000 per year, three doctors have already qualified and three dispensaries opened.

[48] Her actions are perfectly in harmony with the wishes and social objectives of the regime. But in a China where the law is still in flux and not evenly implemented, private initiatives like hers remain precarious. She fears publicity

and prefers to stay out of the limelight so as not to risk upsetting higher-ups. This situation justifies my prudence and my decision to keep her semi-anonymous in this book.

49 See the website, www.globalnomadltd.com

50 That contradiction applies equally to me. With both of us looking for a fair and balanced overall assessment of Communist China, we very quickly agreed after just a few minutes of conversation on the need for transparency, and a refusal to pass judgment or condemn and instead analyze and seek understanding. We share that preoccupation.

51 Web address: www.braillewithoutborders.org

52 Apparently false information, to judge from what we were able to see during our visit. But in the autonomous region, the Chinese are ill-informed, even misinformed, by hyperactive censorship.

53 The name of the Jokhang, in Mandarin.

54 A famous monastery of Yellow Hats, in Xining, Qinghai Province.

Acknowledgements

This book owes its existence to a network of goodwill that supported us. Thanks first to Kickstarter for its precious existence; to Diego Alonso, the Argentinian art gallery owner in Madrid who inspired the Spanish edition; to Begoña Ruiz, for her infallible eye on the Spanish translation; to the translators Florence Baranger Bedel and Jeff J. Brown; to Dirk Meyer (no relation), the Adobe expert for his support; to Pierre Béland, the Quebec author who gave us much strong and friendly advice; without forgetting Alexandra Pearson, the efficient founder of Bookworm (the literary English bar in Beijing) who introduced us to our publisher in Hong Kong; also Corinne Tapia, of the gallery "Under the Stars" (Broadway, New York City).

And thanks of course, again, to our 222 sponsors, who are listed below (except those who prefer to remain anonymous):

Philippe Accarias, Brigit Alexander, Manuel Alonso, Amanda Millet Sorsa, Marie-Josée Aubin, Anne-Marie Aubrespy, Bertrand Augras, Colette Austin, David Backler, Bernard Bahout, Claire Balavoine, Dominique Balavoine, Laurence Ballevre, Isabelle Barailler-Fulda, Corinne Barbat, Philippe Bardol, Valérie Barki, Marc Beaugrand-Champagne, Florence Bedel, Pierre Béland, Marcel Belleville, Beraha, Jean-Marie Bergman, Michel Bissonnette, Hélène Blondel, Clément Bo, Jean-Yves Bodin, Matthieu Bodin, Éric Bodoulé Sosso, Marianne Borderolle, Annette Borla, Matthew Borowick, Bruno Boucher, Laurent Boursier, Claudine Brenner, Yann-Olivier Bricombert, Frederic Broutet, Edgar Broutet, Florence and Jeff Brown, Daniel Burdman, Sophie Carré, Anne Cesalli, Jean-Daniel Chabas, Laurent Charpentier, Henri Charpentier, Sara Chatterjee, Thierry Clement, Babette Cohen, Thomas Coutrot, Muriel Cultot, Cunin, Isabelle Cyr, Annie d'Amours, Claire-Lise Dautry, Denis et Isabelle Degache, Gérard Deleens, Caroline Deleens, Remi Delforge, Bruno Demeulin, Thomas Déron, Thomas Deschamps, François Deschamps, Jacques Deschamps, Virginie Deslandres-Ollendorff, Serge Desloges, Marie Dilly, Dominique Drouard, Anne Dufetel, Ludovic Ehret, Chenoa Everett, Marie Favre, Jean-Luc Fievet, Barbara Finch, Alain Follet, Aime Fried, Claude Foulon, Bernard Franchel, Agnès Fried, Gary Joseph Cohen, Pascal Gauch, Catherine Geeurickx, Sylvie Gentil, Véronique Girard, Robert Giroux, Claudine Godet, Gerard Grasa-Vidal, Aude Grasset, Jean-Pierre Graulet, Laurent Guichardon, Hortense Halle, Thomas Helmer, Neil Hodge, Francine Hollard, Anthony Hopwood, Laurence Huret, Eric Hutter,

Nedim Imre, Richard Jannekeyn, Cyrille Javary, Olga Jonas, Hélène Joyeux, Nils Joyeux, Alison Keys, Blandine Klein, Isabelle Klobukowski, Mei Ling Knibbe, Marc Lallier, Philippe Lamontagne, Camille Lasserre, Louise Le Beau, Libin Le Grix, A.-M. Lê Huong, Susan Le Blanc, François Ledard, Francois Leduc, Jean Leproprio, Patrick Li, Lili, Jean Longeot, J.-Marie Lopez, Sandrine Lopez de Arias, Valérie Louys, Evelyne Macera, Olivier Maligne, Olivier Marcou, Denis Mareuge, Antoine Mariaud, Patrice Maurein, Anne-Valérie Mazoyer, John McDermott, Lisa Mehdi, Aníbal Merlo, Paolo Mestre, Héloïse Meyer, Dirk Meyer, Jérémie Meyer, Josiane Milôme, Regina Monfort, Cécile Montreau-Aveline, Helmut Morsbach, Nathalie Murray, Andreas Mutz, Fred Nauleau, Catherine Nicolas, Cyril Nicolas, Jean Nicolas, Paule Nicolas Lallier, Emma Nikitina, Françoise Objois, Sylvia R. Pager, Christian Pascual, Sophie Paviot, Marie Paviot, Pelagatti, Ariane Pelé, Gaelle Pelé, Pelé, Coralie Perez, Antoine Pernod, Julia Petit, Marie-Noëlle Peyre, Gabriel Peyré, Xenia Piech, Pierre, Didier Poveda, Paul Pritchard, Rasmussen, Jean-M Renaud, Anne Ribstein, Pierre Ribstein, Line Richer, Irmy Romeis, Ropton, Anaelle Rouche, Jean-François Rousseau, Caroline Sapriel, Laura Saravia, Frédérique Saurat, Bill Schiller, Jean Sévery, Dirk Seyfert, Cheryl Sheridan, Donna Sheridan, Sigot, Sigot, Yaron Silberman, Joseph Silberman, Elli Sorsa, Piritta Sorsa, Vincent Soyez, Pascal Stefani, Gabriel Suborromée, Alex Sudan, Gilberte Szivo, Solange Tabary, Michèle Terminet Schuppon, Benoit Terminet Schuppon, Rodney Topor, Nathalie Tran, Jean Trepanier, Chantal Viry, Véronique Vobaure, Tammy Winand, Claude Whipple, Philippe Yong, Anna Zani, Zeller, Nadja Zivkovic, Nicolas Zylberman, Naxhieli Zylberman, François Zylberman, Geneviève Zylberman, Marion Zylberman, Sophie Zylberman.

EXPLORE ASIA WITH BLACKSMITH BOOKS

From retailers around the world or from *www.blacksmithbooks.com*